The Hidden Sense

LEONARDO

Roger F. Malina, Executive Editor
Sean Cubitt, Editor-in-Chief

The Hidden Sense

Synesthesia in Art and Science

Cretien van Campen

The MIT Press
Cambridge, Massachusetts
London, England

For information about special quantity discounts, please email special_sales@mitpress .mit.edu

This book was set in Garamond and Bell Gothic by SNP Best-set Typesetter Ltd., Hong Kong

Printed and bound in the United States of America.

Library of Congress Cataloging-in-Publication Data
Campen, Cretien van.
 The hidden sense : synesthesia in art and science / Cretien van Campen.
 p. cm.—(Leonardo)
 Includes bibliographical references and index.
 ISBN 978-0-262-22081-1 (hardcover : alk. paper) 1. Synesthesia. I. Title.
BF495.C36 2007
152.1′89—dc22

 2007000983

10 9 8 7 6 5 4 3 2 1

Contents

Series Foreword

The arts, science, and technology are experiencing a period of profound change. Explosive challenges to the institutions and practices of engineering, art making, and scientific research raise urgent questions of ethics, craft, and care for the planet and its inhabitants. Unforeseen forms of beauty and understanding are possible, but so too are unexpected risks and threats. A newly global connectivity creates new arenas for interaction between science, art, and technology, but also creates the preconditions for global crises. The Leonardo Book series, published by the MIT Press, aims to consider these opportunities, changes, and challenges in books that are both timely and of enduring value.

Leonardo books provide a public forum for research and debate; they contribute to the archive of art-science-technology interactions; they contribute to understandings of emergent historical processes; and they point toward future practices in creativity, research, scholarship, and enterprise.

To find more information about Leonardo/ISAST and to order our publications, go to Leonardo Online at <http://lbs.mit.edu/> or e-mail <leonardobooks@mitpress.mit.edu>.

Sean Cubitt
Editor-in-Chief, Leonardo Book series

Leonardo Book Series Advisory Committee: Sean Cubitt, *Chair*; Michael Punt; Eugene Thacker; Anna Munster; Laura Marks; Sundar Sarrukai; Annick Bureaud

Doug Sery, Acquiring Editor
Joel Slayton, Editorial Consultant

Leonardo/International Society for the Arts, Sciences, and Technology (ISAST)

Leonardo, the International Society for the Arts, Sciences, and Technology, and the affiliated French organization, Association Leonardo, have two very simple goals:

1. To document and make known the work of artists, researchers, and scholars interested in the ways that the contemporary arts interact with science and technology
2. To create a forum and meeting places where artists, scientists, and engineers can meet, exchange ideas, and, where appropriate, collaborate

When the journal *Leonardo* was started some forty years ago, these creative disciplines existed in segregated institutional and social networks, a situation dramatized at that time by the "two cultures" debates initiated by C. P. Snow. Today we live in a different time of cross-disciplinary ferment, collaboration, and intellectual confrontation enabled by new hybrid organizations, new funding sponsors, and the shared tools of computers and the Internet. Above all, new generations of artist-researchers and researcher-artists are now at work individually and in collaborative teams bridging the art, science, and technology disciplines. Perhaps in our lifetime we will see the emergence of "new Leonardos," creative individuals or teams that will not only develop a meaningful art for our times but also drive new agendas in science and stimulate technological innovation that addresses today's human needs.

For more information on the activities of the Leonardo organizations and networks, please visit our Web sites at <http://www.leonardo.info/> and <http://www.olats.org>.

Roger F. Malina
Chair, Leonardo/ISAST

ISAST Governing Board of Directors: Martin Anderson, Michael Joaquin Grey, Larry Larson, Roger Malina, Sonya Rapoport, Beverly Reiser, Christian Simm, Joel Slayton, Tami Spector, Darlene Tong, Stephen Wilson

Acknowledgments

Writing is solitary labor, but making a book is social work. Numerous people have helped me in the last decade. In alphabetical order: Simon Baron-Cohen; Jos ten Berge; Greta Berman; David Bisschop Boele; Richard van den Brink, the Cleophasschool, Utrecht; Richard Cytowic; Sean Day; Robbert Dijkgraaf; Patricia Duffy; Frans Evers; Bulat Galeyev; Beata Franso; Ed Hubbard; dr. Hugo; Robert Hulsman; Florence Husen; Amy Ione; Myra Keizer; the editorial team of *Leonardo: Journal of the International Society for the Arts, Sciences and Technology*; Stephen Malinowski; Peter Meijer; the Dutch Society for Study on Colour (NVvK); Rick Schifferstein; the editorial team of *Psychologie* magazine; Katinka Regtien; Noam Sagiv; Anne Salz; St. Lucas College, Boxtel; Carol Steen; Peter Struycken; American Synesthesia Association; UK Synaesthesia Association; Jamie Ward; Peter Werkhoven; and all synesthetes who reported to me, invited and uninvited, their experiences. Two individuals who have illuminated my thoughts more than anyone else are Clara Froger and Marcia Smilack, both artists in color and light. Raised in a culture of Dutch light, I was probably very sensitive to the perspectives they opened for me. I would like to thank you all. We have made this book together.

The Hidden Sense

1

Introduction

How does it feel to hear music in color, or to see someone's name in color? These are examples of synesthesia, a neurological phenomenon that occurs when a stimulus in one sense modality immediately evokes a sensation in another sense modality. Literally, "synesthesia" means to perceive (*esthesia*) together (*syn*).

When synesthesia is mentioned in the media, it is usually described as a neurological defect. Similarly, neurologists consulted by synesthetes often inform synesthetes that their synesthesia is probably a congenital brain defect. They explain that in synesthesia, regions of the brain that normally do not communicate, such as the visual and auditory cortexes, show signs of what is known as "crosstalk." As a consequence, these synesthetes experience the world in a different way from the rest of us. For them, it is hard to imagine that others cannot hear music in color; they wonder what it must be like to see someone's name without colors.

When I first read descriptions of synesthesia, I was immediately drawn to the phenomenon. How nice it must be to put on a CD, relax in an armchair, and see as well as hear beautiful music pass by in fascinating images. Or to go for dinner in a restaurant to try out not only new tastes but new colors as well.

I did not then, nor do I now, see music in colors. At that time, I thought of synesthesia as a skill or a trait possessed by a small and special group of individuals who perceived other dimensions of reality.

I wanted to meet these synesthetes. In some respects, they seemed almost like extraterrestrials to me. Did they perceive a different world from the one

I saw? Was a cloudless sky not blue for them? Did they live in another reality, with colored music played on harps by cherubs? Did they taste wine in a bouquet of a thousand flowers that transported them to a vision of glimmering ballets and shimmering, rustling gossamer?

The synesthetes whom I met told me that other combinations of sensory impressions occurred for them as well. Some synesthetes perceive tactile forms and textures when tasting food, while others hear sounds from the smell of fragrances. Cases have been reported of synesthetes who feel colored pain, hear odors, hear tastes, taste sounds, feel sounds on their skin, hear images, and taste images. In addition, some synesthetes respond to symbols with their senses. In fact, the most commonly reported type of synesthesia is hearing or seeing letters in color. Vowels, and often consonants, too, have very specific—and fixed—colors for the synesthetes who see letters in color. For the synesthete Katinka Regtien, for example, the vowel *E* is not simply red but a specific translucent red with a hint of orange. In collaboration with the designer Beata Franso, she created a painting of her colored alphabet. Figure 1.1 (see plate 1) is an approximate representation of her "letter colors." In reality, however, the letter colors of synesthetes are so specific that they often find it difficult to reproduce or describe them; this may be because the colors they see are colored light rather than the colored pigment.

For the synesthetes who see colored letters, the colors normally remain the same throughout their lifetime, though older synesthetes recount that the colors sometimes become paler in their later years; they remember the colors being brighter in their youth. The colors are so obvious to them that young synesthetes believe that everyone sees letters in color; many synesthetes only discover later that this is not the case. A common response when that occurs is: "Gosh, I didn't know this experience had a name, I always thought everyone has it."

Sylvia Roukens received an inkling after she handed in an exercise in elementary school. As a seven-year-old, she wrote the following little story in her school exercise book:

The Magic Butterfly and the Alphabet
Once upon a time, there was a butterfly. However, it was not a common butterfly, it was a magic butterfly. One day he thought it would be nice to fly around. Then he met the letter *A*. The *A* was yellow, but the butterfly didn't like it, and so the butterfly changed the yellow *A* into a red *A*. Then he flew on. Then he came across

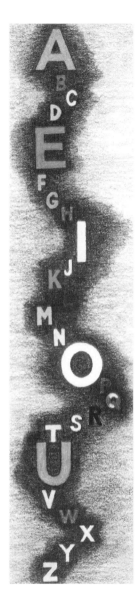

Figure 1.1 Synesthete Katinka Regtien perceives the alphabet in colors and spatial forms. In collaboration with designer Beata Franso she created this visual representation. (Reproduced with permission.) See plate 1 for color version.

a green *B*. The butterfly did not like that either and changed the green *B* to a purple *B*. And so it went, until the butterfly had been round the whole alphabet. Then he was tired and when he got home, he fell asleep at once. In the middle of the night, the whole alphabet came to the butterfly's house. "Why have you changed our colors!" they shouted angrily. "All right, I will put your colors back, the butterfly said." The end.

In the exercise book, the teacher wrote that she had found it a very original story, but Sylvia didn't understand her teacher's remarks, because to Sylvia it was not that strange. It was only later, when she discovered that not everyone sees the letter *A* in yellow and the letter *B* in green, that she understood her teacher's remark. When she was about fifteen, she read the French poem "A noir, E blanc, I rouge, U vert, O bleu" (A Black, E White, I Red, U Green, O Blue) by Arthur Rimbaud. Did he have the same experience as she did? But if so, why did he see other colors for the letters? She decided to do some research on the subject for a school essay, and that was when she discovered that this phenomenon had a name: "synesthesia."

Over the past few years, many synesthetes have told me about their "colorful" experiences. These people were not the extraterrestrial dreamers full of wild fantasies that I had originally pictured. Why did I imagine them that way? Is it because synesthesia comes dangerously close to fantasy? Or was I skeptical because there is no shortage of people who, yearning for attention, try to obtain it with spectacular stories?

It is probably for both these reasons that for a long time, synesthetes were not taken seriously by researchers. Synesthesia was considered a folly. When synesthetes insisted that letters have colors, researchers attributed it to their strong imagination—even when the person concerned showed little imagination in other areas of life. In other cases, it was felt to be a learned association: as children, these people had probably played with colored letter blocks and now they were remembering the colors of the blocks. This latter explanation does not stand up for long, though, when one considers that virtually every child has played with colored letter blocks, yet only a few become synesthetes. Also, synesthetic brothers and sisters who certainly played with the same letter blocks generally perceive the same letters differently, that is, they see them in different colors.

Another frequently heard explanation for synesthesia is that the colors of letters are not perceptions but are rather a type of associative metaphor. The

word "sea" would thus be associated with a blue color because the word evokes an image of the sea for the inner eye. However, a synesthete may tell you that the word "sea" has red, yellow, and purple colors. The letter *S* may be red for this person, the letter *E* yellow, and the letter *A* purple. The fact that for the synesthete there is a separation of the word into colored letters makes it clear that it is not the meaning but the physical appearance of the word that evokes the colors. Many synesthetes perceive the colors of words and letters only when they read them in written or printed form.

Brain scans of synesthetes have finally removed the doubts of the skeptics. They provide proof of the neurological existence of synesthesia. Experiments that compared the brain activity of synesthetes with that of nonsynesthetes reveal that there are neurological differences in their responses to the same stimulus. In one test, a synesthetic person was blindfolded and placed in a recording tunnel of the brain-scanning apparatus and wore headphones that produced spoken words at regular intervals. Figure 1.2 shows the results: activity in the areas of the brain responsible for hearing and color vision occur simultaneously when a blindfolded synesthete hears a word. Under the same

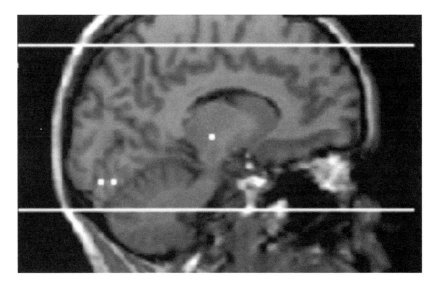

Figure 1.2 This brain scan taken from the right side of the head of a blindfolded synesthete shows activity in the color vision center of the brain at the back of the head (left) when she hears words. This activity is absent in nonsynesthetes. (Aleman et al. 2001. Used with permission.)

conditions, the brains of nonsynesthetes generated activity only in the areas known to be responsible for hearing. These experiments represented a breakthrough in the study of synesthesia. Almost two centuries after the first scientific descriptions of the phenomenon, physiological evidence had been found that left little room for doubts: synesthesia exists!

How can we explain neurological synesthesia? After reading a number of neurological studies on the subject, I thought I knew the answer, but after interviewing synesthetes during the last ten years, I became unsure; I recognized that the scientific descriptions were not always compatible with the stories of the synesthetes I met.

For example, a well-known theory is that synesthesia is a brain impairment that causes a kind of short circuit between the areas of the brain that process colors and sounds. Yet calling it an impairment implies that it is a process against nature; an "impairment" suggests something that does not work properly. In the language of a mechanic, it refers to an electrical breakdown that needs to be repaired. But do synesthetes want or need to be repaired or helped? Do they suffer as a result of their "brain breakdown"? Do they experience synesthesia as a disability that impairs them in their daily lives?

Synesthetes often tell quite a different story, saying how useful they find their ability to see letters and numbers in colors, for example, when they have to remember names or telephone numbers. Some look pityingly at non-synesthetes who have to live without those beautiful colors and patterns in music. Synesthesia actually offers them advantages in their daily lives. Now that scientists have provided the scientific proof of the existence of synesthesia, synesthetes have become a rich source of information on the advantages this perceptual ability offers them.

Does synesthesia have a function? Of what use is it? What are its benefits? We know that our five senses all have functions in our perception; hearing, for instance, is responsible for detecting relevant sound patterns in our surroundings. We also know that a loss of hearing can create danger. But what is the function of synesthesia in the perception of our environment? Similarly, does a lack of synesthesia cause harm?

What makes synesthesia such a fascinating phenomenon is that it raises questions that scientists cannot answer at present. Synesthesia is not an isolated phenomenon in human perception. It is not a fantasy, nor can it be marginalized as an unimportant by-product of a human brain process gone

awry. The synesthetes to whom I have talked regard it as essential in their lives. And since the phenomenon really exists (as has been demonstrated), studying synesthesia just might turn our common image of the senses on its head. Reorganizing our concept of the sensory channels of the mind can change our view of the human mind, and possibly of the physical world.

Looking back, I would say that in my explorations of synesthesia, I allowed intuition to prevail over reason. Put simply, I could not reconcile myself with the idea of the five senses and synesthesia as merely an aberration created by a neurological breakdown. So I set out on a tour that might lead me into a murky, marshy area between the senses, an area that had as yet hardly been explored. For over two centuries, scientific disciplines have focused on just one of the sense organs at a time: the eyes, the ears, the tongue, the nose, and the skin. Rarely has scientific inquiry concerned itself with all the senses at the same time. The same can be said of the arts. Music and the visual arts have produced experts and critics for centuries, but the domain connecting music and the visual arts has been increasingly explored only in recent decades.

Driven by curiosity, I embarked on a quest to explore synesthesia. As I went along, the object of my study puzzled me and gave rise to all sorts of questions. How are my senses organized? Do they work in the way that I thought they worked? Looking back at my naïve ideas at the beginning of my journey, I now realize that it is not only my ideas about the senses that have changed, but also my senses themselves.

Like a nineteenth-century armchair scholar, I let my reading set my mind adrift, and searched for my answers like a classic naturalist for examples of this special species. I explored the world of synesthetes in the same way I enjoy roaming through a city center, venturing on a whim or intuition into alleys and stumbling across unexpected views of the city. When I search cities, I first read the guidebook word for word; but when I embark on the actual search, I leave it in my pocket, since it can only lead me to known locations. I have explored the phenomenon of synesthesia in the same way. Having first done extensive reading on the subject, I wanted to be surprised by what I might encounter. I relied on my instincts and intuition, gathering information by talking to people who referred me to other routes and other people I would talk with.

In addition to looking for an answer to the basic question of "what is synesthesia?" I was guided by a second question: "What is the significance of

synesthesia in people's daily lives?" In other words, is their synesthesia useful? Do synesthetes benefit from perceiving synesthetically, or does synesthesia only bring them confusion or harm? My explorations led me along many unexplored paths and brought me into contact with many different people, including synesthetes, children, educators, neurologists, psychologists, philosophers, artists, poets, dandies, and drug users. In the end, their hints brought me to an unexpected but well-known source: the hidden sense.

I

Perception

Music Video Clip without TV

This exploration starts with the experience of synesthesia. How does it *feel* to be a synesthete? How does a synesthete perceive the world? For instance, how does it feel to see both your visual surroundings and ambient music in color?

When it is silent, I see a black space, somewhere at an angle above me, but it looks different from the things that I perceive with my eyes. The forms that I perceive are often colored lines that disappear from the left and right of the image. Some sounds sculpt the lines into three-dimensional forms giving them depth, so to speak. Not all lines acquire depth. For instance, I see *plop*-sounds as circles, which is entirely logical, of course. That's why I always thought that everyone perceived sounds in this way. All of them look so logical.

For most people, it is *not* logical at all to perceive images in front of their eyes when listening to music—unless they are watching a music video clip on TV. However, Patrick Heller does see images as soon as he hears music or sounds. He doesn't need to watch MTV to have the most beautiful video clips presented in front of him.

The imagery made by Patrick's brain differs from that of regular MTV video clips, in which singers, musicians and dancers star. Patrick's mental video clips consist of moving colored lines and forms that look more like abstract art in motion. On a Dutch radio show, Patrick described his images live while listening to a fragment of ambient music played on a synthesizer:

I see dark red three-dimensional "bars," flat and wide, in the distance. I see the bars or strips sideways and they run from left to right, and I don't see their ends. In fact, the bars are dark red but in the distance almost transparent.

Also, in Patrick's perception people's voices have colors, ranging from brown to yellow. A low voice sounds brown while a high-pitched voice sounds yellow. The voice of his girlfriend is described by Patrick as orange-yellow when she talks, but when she laughs the sound turns to a dark blue color.

Patrick notices that the source of the sound mainly determines its color and form. Voices have brown-yellow nuances, laughter is blue, and in music, the instruments account for their colors. Sounds of synthesizers are often red-orange and guitar sounds have blue-white tones. He perceives the sounds of synthesizers as wide bars and that of electric guitars as many thin lines. He assumes that this difference has something to do with the fact that synthesizer sounds are constructed from one or only a few frequencies, whereas guitar sounds have background noises like the clicking of a plectrum on the strings.

Patrick is a fan of the music of Prince because he sees the most beautiful images when he listens to this music. His description of this experience is rather long, but insightful. Reading it, it is easy to get caught up in the marvelous musical experiences of a synesthete.

Since my twelfth year, I have been a fan of Prince. Now that I know about synesthesia, I better understand that my preference for Prince's music emerges from the beautiful, sensual images that I see when listening to his music. Anyone familiar with Prince knows that he often writes music for other musicians, often under a pseudonym. I can recognize his style from the images I see in the music. I will explain how.

Heavy percussion and bass sounds are dark brown–colored circles on a black background to me. The circles are comparable to the ones you see in the water when you drop a stone in it, with one difference: each drumbeat creates only one expanding circle. The heavier the sound, the bigger the circle and the thicker the edge of the circle. Lighter percussion creates smaller and brighter little circles. If a drummer uses a brush, I see countless little white or light blue circles. All percussion instruments in between, from xylophone to piano, produce circles with magnitudes that are in between the two and the colors tend more to orange and red. If a tone sustains for a long time like you hear after a touch of a piano, then a kind of transparent smudge or smear remains in the color of the circle (which itself has disappeared by then).

Synthesizer sounds appear to me in tight horizontal bars, flat but in depth. In the music of Prince, the bars are always very straight and are orange or red in color. They disappear left and right out of the image, so I don't see a beginning or an ending of a bar, though they do have broadness and thickness. The thickness is minimal and the broadness a bit vague. The front of the bar is sharp but not in depth. The more it appears in the background, the more transparent the bar gets. And though the bars are nearly always orange or red, I can always spot some very thin yellow lines throughout. Seldom are the bars exactly horizontal; from left to right, they almost always run a bit upward or downward.

The lines produced by guitar sounds are jagged and blue in color. The higher the pitch, the lighter the color, tending towards white. Also, these lines disappear left and right from the image. The more strings sound together, the more jagged the lines that I see become. When Prince lets his guitar 'scream,' I just see one or a few lines that are quite straight instead of jagged. The lines become also thicker then.

Prince is a master of "leaving it black." In other words, he knows how to use silence to create a void or emptiness in his music. One of the best examples is the song "If I Was Your Girlfriend," on the album *Sign 'O' the Times*. The percussion is heavy, the synthesizer is compelling, and the guitar is almost absent. Between the percussion and the synthesizer are moments of silence. If you listen to it, you might not notice but I see very clearly lots of black. The percussion does not sustain long; the circles are only visible for moments. The sounds of the synthesizer are super straight and the bars almost tumble over each other downward, though they are also only visible in moments. The result is a hypnotizing beauty.

Looking Around in Sound Images

Music-induced images change not only according to movements in the music itself but also according to where the attention of the synesthete is directed. Floor Eikelboom analyzes his synesthetic experiences of music-induced color and form. He writes that he sees every sound in a color pattern, but that since music normally contains a lot of sounds, he sees a complex network of colored patterns so complicated that it is hard for him to describe it in words. He does notice, however, that his attention selects parts of the music and focuses on the corresponding images; also, that it makes a big difference whether he listens to the whole composition or to the wandering course of a bass line. In the latter case, the colors of the bass are more dominant in the image.

The musical preferences of Floor and Patrick are guided by the images that music evokes for them. Floor explains that he likes electronic music because the colors of computer-generated music are more beautiful than the colors made by acoustic instruments. The colors of electronic music are radiating and intense, like the lantern light around a light source. In contrast, he finds the colors produced by acoustic instruments, in particular piano, more boring; they are duller, mostly black and white, sometimes with a tinge of golden-brown colors.

Floor also participated in the Dutch radio program and listened with Patrick to the same fragment of ambient music. Floor described his images as follows:

It starts with a white sound that looks somewhat like a half parabola. In the middle, the form continues into a straight line and then fades away. The line is a bit thick. The upper side is clearly a line, but the lower side fades away. This line stays in my image all the time, but it flickers without completely disappearing.

After a few seconds, a purple parallel form that is much smaller appears in the middle of the parabola and then it disappears again. It corresponds with the particular sound that increases in loudness. That *wah-wah-wah* kind of sound is a shining orange oval for each *wah*. The form pops up and disappears very quickly. The moment it disappears, it has briefly a silver silhouette, though this so subtle that I really have to watch closely to see it. These ovals show up at the beginning of the white form.

These reports by Floor and Patrick show that the same music fragment evokes completely different images for different people, though in both cases, the evoked images are abstract, moving, and three-dimensional. In my interviews with synesthetes, I found that music-induced images are never the same for two people. Their brains produce colors and forms that are strictly personal.

Just like nonsynesthetes, Patrick and Floor have personal musical preferences and even different listening styles. For instance, Floor, who is a lover of electronic music, sees much richer forms in the synthesizer sounds than Patrick does.

The differences remain even when the two men listen to the very basic, simple touch of a harpsichord. Patrick sees, on one spot in his image, a number of short, thin, jagged lines in a hard red color set against a large black background, whereas Floor sees the bass notes as two golden-grained lines that transform into a thicker black line. For him, the black line is visible against

the black background because it glimmers, and when the bass sounds ebb away, a fading, quivering golden-grained line reappears.

Two-Way Traffic

Floor and Patrick experience music in color, but when they look at colors and patterns, they don't hear music. For them, synesthesia seems to travel in one-way traffic between the senses. Most synesthetes that I spoke with experience it that way. However, the synesthete Marcia Smilack experiences sounds in images and images in music. Everything she hears—including voices, environmental sounds, and music—has shape, pattern and color; and she can also hear sound from color and shape.

Marcia noticed early in her life that her synesthesia travels in one direction, from sound to image. When she was a child, the first note she played on the piano was green. Not until she was an adult, however, did she notice that her synesthesia travels in the other direction as well. She made this discovery one day when she was walking past a pond surrounded by trees. When she glanced over and saw the reflection of the trees on the surface of the pond, she heard bagpipe music. Her feeling of startled surprise at being able to "hear with her eyes" immediately reminded her of the first time she played the piano and discovered she could "see with her ears." Although the two experiences were opposite in direction, she intuitively knew they were connected and inverted versions of the same phenomenon.

She is a fine art photographer on Martha's Vineyard, Massachusetts, where she uses her synesthetic gifts to create her images. When she began to use a camera, she did not know anything about photography, nor had she ever studied visual art. But she had noticed that when she looked at reflections on the surface of moving water, she heard sound. So she decided to use her synesthesia to teach herself photography and began to use it as a guide for her compositions. For some reason, she trusted those responses and listened on them as reliable signals to tell her when to take a picture. She would wait until she had a synesthetic response from what she saw, and at that moment, take the picture.

She explains how images evoke sounds by her work *Vibrato Bridge* (figure 2.1, plate 2). Now, when Marcia looks at this picture of a reflection of a bridge over a canal, instead of seeing a bridge, she first hears a vibrato, which is produced by the shape of the reflected bridge:

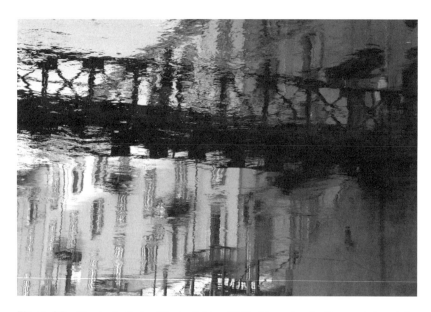

Figure 2.1 Marcia Smilack, *Vibrato Bridge*, 2004. (Reproduced with permission of the artist.) See plate 2 for color version.

When I look at this image, I hear a vibrato. How? From the shape of the bridge; by both the braided form and the indistinct or fuzzy edges. The colors influence the sound I hear because they are responsible for the instruments that might produce the sound of the vibrato—browns typically produce a lower-register sound like cello.

Her synesthetic processes in both directions do not mirror or match each other. Each direction has its own peculiarities. As she explains:

It isn't a loop: the colors that elicit sound are not the same colors that sound elicits, although they are colors in both cases; and the sounds that colors elicit are not the same as the sounds that elicit colors, and yet they, too, are also really sounds. There are distinctions and differences in both, depending on which side of the experience they are.

Until recently, scientists assumed that synesthesia is a one-way process. In 2005, new scientific experiments produced evidence that synesthesia can be a two-way process. It was discovered that information is exchanged between sensory domains, which contradicts the assumption that in synesthesia

information is transported from one sensory domain to another in just one way.

Three independently performed experiments in Switzerland, Israel, and the Netherlands (which I will discuss in chapter 5) showed that for synesthetes who experience numbers in colors, the colors also helped them to recognize numbers. What is striking is that the synesthetes were not aware of the latter exchange. They consciously perceived colored numbers, but were not aware of the fact that colors evoked a sense of numbers, too. They only found out when the researchers showed them that they had executed certain calculation tasks better than nonsynesthetes because of this unconscious perception.

It is likely that these experiments have revealed something new about synesthesia. The reports of most synesthetes led to the belief that synesthesia was a perceptual process that runs in one direction only. However, these inventive experiments show that synesthesia travels instead in two-way traffic occurring at a deeper level of information processing than most people are aware of.

Becoming conscious of synesthesia could be a layered process. As synesthetes explore their synesthesia more consciously, they become familiar with new aspects of their sensory abilities. Patrick and Floor were aware of their perceptions of colored patterns in music, but only after they became more conscious of it did they also became aware of how their attention can spotlight specific parts of the music. In the same way, they might discover one day that movies of colored patterns can evoke music for them. Some synesthetes, such as Marcia Smilack and the composers Olivier Messiaen and György Ligeti, whom we will meet later in this chapter, were aware of this reciprocality of synesthetic experiences already.

Synesthesia, Drugs, and Rock and Roll

Some rock musicians have claimed that taking drugs such as LSD can induce these synesthetic experiences. In the sixties and seventies, this idea inspired so-called psychedelic rock bands like Pink Floyd, Soft Machine, and the Velvet Underground to use overhead projectors, liquids, slides, films, strobe lights, and backlights onstage to suggest synesthetic experiences. It is said that the band Pink Floyd experimented with effects like those of synesthesia. Their use of synthesizer sounds and simultaneously played light projections were intended to suggest that sound and image were merged

on the stage. Another band, the Grateful Dead, similarly hired a "synesthetic" animator to visualize their music. Several visual artists have created light shows for art events and rock concerts since the mid-sixties. Nowadays, video jockeys produce digital-directed light projections to evoke audiovisual atmospheres.

Apart from the presence of abstract colored patterns, however, these light projections have little in common with true synesthetic experiences. Unlike hallucinations, which are temporary and unstable, the perceptions of colored music by synesthetes are permanent and consistent. Listening to a particular sound or note, synesthetes normally see the same color every time that sound or note is played.

Synesthesia is personal, and every synesthete sees his or her own repertoire of colored patterns. Furthermore, the synesthetic experience is not added to how they hear music, as in the rock-and-roll and veejay shows, but rather, it is part of the musical experience of synesthetes. Sound and images are immediately and inextricably perceived as one whole. Floor says of pop-music video clips:

I don't like to watch channels like MTV. What irritated me the most is that I cannot recognize the sounds in the images and the images are not synchronized to the music. That is why I have a feeling that something is not right. If a clip is interesting to watch, I get totally absorbed by the visuals and forget the sounds. I liked the light show of Pink Floyd—that was outstanding. I find the work of most veejays and video clips rather mediocre compared to my own images. The same goes for computer programs like Windows Media Player, which translate sound into images. They are really poor.

Romantic Landscapes

The Hungarian piano virtuoso and composer Franz Liszt (1811–1886), who in nineteenth-century concert halls of continental Europe gained fame comparable to that of a contemporary rock star, was one of the first composers of the Romantic era to create a form of visual or colored music. At first glance the result may look like synesthesia, but on closer inspection it turns out to be something different.

According to a journalist of the *Neue Berliner Musikzeitung* (*New Berlin Music Newspaper*), when Liszt was a new conductor at court concerts in Weimar, he

used to surprise his orchestra musicians with directions such as "Gentlemen, please a bit more blue! This key demands it!" and "This is deep violet. I beg you to focus on that! Not so pink!"

By nature, many synesthetes see music in color and form. An often-heard response among nonsynesthetes to the phenomenon of synesthesia is something like "Yes, but I too experience images when listening to the classical symphonies. Listening to the *Pastoral Symphony* of Beethoven, I see green meadows; I associate the *Scottish Overture* by Mendelsohn-Bartholdy with the blue and white colors of a rippling torrent; and while listening to Vivaldi's *Four Seasons*, I visualize white snow, rust-colored autumn leaves, and a radiating yellow sun."

In fact, these associations do not compare to synesthetic experiences. Such musical works are known as "program music," which is defined as instrumental music that is associated with poetic and dramatic themes. Composers of that time sometimes wanted to express musically a subject or the scene of a thought. Examples include Hector Berlioz's *Symphonie Fantastique*, Listz's symphonic poems, Richard Strauss's *Also sprach Zarathustra* (*Thus Spoke Zarathustra*), and Claude Debussy's *La Mer* (*The Sea*). Thus, midway through the nineteenth century, a new poetic form of musical composition emerged that was different from adding music to a libretto to create an opera.

The "program" in program music can be a philosophical thought, a poem, or a literary theme. Sometimes the music imitated the song of a bird or the sound of a storm with musical instruments, as Vivaldi did; sometimes the musical expression reflected a philosophical idea like Nietzsche's *Also sprach Zarathustra*, by Richard Strauss.

What are the main differences between a synesthetic color experience of classical music and a color association with classical program music? First, synesthetic experiences are evoked immediately by auditory stimuli. With program music, it is the associated thought, say, of a bird or torrent, that evokes the idea of color in the listener. The color is evoked indirectly by an idea, not directly by the perception of the musical notes. Thus, Mendelsohn's *Scottish Overture* evokes memories of a Scottish mountain landscape, and within this memory, one may also see colors. Also, a composer can evoke memories of a rippling torrent or a twittering bird by imitation of the sound; from that sound, one may see in the mind's eye (introspectively) the colors of a current or the feathers of a little bird, but that also is the result of an association. Another difference from synesthesia is that someone listening to program

music can "turn off" the association and its colors; he can deliberately not think of torrents and birds. But synesthetes say they cannot turn off their color experiences; at most, they can let the colors play in the background while they give attention to other mental activities at that moment. But as soon as they attentively listen to the music again, the colors return at full intensity.

Synesthetic Composers

As we have seen, the experience of synesthesia does not compare to the doped experience of light shows of psychedelic rock bands; nor does it compare with the visual associations produced by classical program music. But is there something "out there" that is like synesthetic music? If so, who are the composers writing this music?

Unfortunately, we can no longer determine whether composers of the Romantic era such as Liszt were synesthetes or not, because we lack autobiographical information and medical records. However, there some twentieth-century and contemporary composers—Olivier Messiaen, György Ligeti, and Michael Torke are three of them—about whom we are better informed, because they recognized synesthesia themselves and spoke about it in interviews. Let's have a look at how they used their synesthetic gifts in composing music.

Olivier Messiaen

The French composer Olivier Messiaen (1908–1992) saw music in colors and forms and heard music in colors. He used his synesthetic gifts to develop a unique composition technique of modes of limited transposition. Each mode corresponds to a color image. Thus, according to Messiaen, mode number three normally consists of orange and gold with milky white nuances. Messiaen compared the colors of the modes with the colored light from stained leaded windows in churches.

He used his composition technique to capture visual impressions in music. During a visit to the United States, Messiaen was impressed by the magnificent display of colors in the canyons in Utah, in particular the Bryce Canyon. He wrote about this experience:

Bryce Canyon is Utah's most cherished gem. It is a gigantic amphitheater formed from red, orange and violet rocks which, over the years, have taken on fantastic shapes:

castles, square turrets, rounded towers, natural windows, bridges, statues, columns, whole towns and the occasional black bottomless pit.

One day during his visit, the composer—a bird-fancier who studied birdsong extensively—spotted a Steller's jay, a dark blue–tufted bird that flew through the valley of the canyon. The flight of the bird with its blue feathered belly, long tail, and black tufted head along the richly colored slopes of the reddish mountains inspired Messiaen's musical imagination; that response later became part of the composition *Des canyons aux étoiles* . . . (*From the Canyons to the Stars* . . .). In the composition's seventh movement, entitled Bryce Canyon, Messiaen tried to capture the color picture he had seen. To performing musicians he gave the following schematic instruction while referring to the colored modes:

Woodwind and brass, the massive theme of red-orange rocks. "Contracted chordal resonance"(red and orange), mode three 1 (orange and gold), "transposed chord inversions" (yellow, mauve, red, white and black) convey the different colors of the stones.

The modes were not only a composition technique for Messiaen but also a way to capture special color compositions in musical form. And although the average listeners of *Des canyons aux étoiles* are not aware of Messiaen's color impressions, they will certainly get a musical impression of the display of colors, the huge natural architecture of the Bryce Canyon, and perhaps the miraculous flight of a little bird.

György Ligeti

The Hungarian composer György Ligeti (1923–2006) was born in a Romanian village. Already, by the age of three or four, he used to imagine music in pictures, a practice that continued all his life. His sketches and notes show how Ligeti sculpted and composed music (see figure 2.2).

Later in his life, Ligeti worked in Budapest, until the Russian invasion of 1956, when he fled to Vienna. His international breakthrough as a composer came with electronic works such as *Apparitions* and *Atmospheres*, which he composed around 1960. Parts of the second piece were used in Stanley Kubrick's film *2001: A Space Odyssey* in 1968. The music in the movie was visualized by artists who were inspired by experimental animators who also made the light shows for rock concerts.

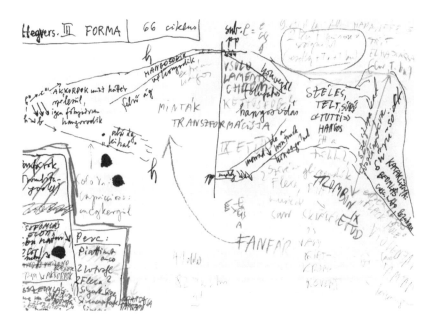

Figure 2.2 Ligeti's notes for movement III of his *Concerto for Violin*, 1990.

When he was composing, Ligeti used his synesthesia as one of his sources of inspiration, along with others that included literature, poems, science, and daily life. He argued that he was not composing program music, because he did not want to give musical expression to a thought or image. Rather, he explained that he thought synesthetically—sounds always had forms just as forms always had color:

The involuntary translation of optical and tactical impressions in acoustical ones happens to me frequently. Color, form, and substance almost always evoke sounds, just as in the opposite direction, every acoustic sensation evokes form, color, and material qualities. Even abstract concepts like quantity, relationship, cohesion, and event appear to me in sensual form and have a location in an imaginary space.

His synesthesia was reciprocal between sound and image; as with Messiaen and Smilack, his music is also visual and his pictures are audible. Also, time evokes an image, as Ligeti described nicely:

For me, time is misty white; it flows slowly and continuously from left to right, while it raises a very soft *hhh*-like whispering. In this impression, "left" is a violet-colored spot with a tin quality and ditto sound; "right" has an orange color with a wooden surface and a muffled sound.

Sounds were tangible for Ligeti. Of his composition *Atmospheres*, he spoke not only in terms of high and low, or loud and soft, but also of "thick and thin tones." Ligeti's music easily generates tactile impressions. With little effort, even nonsynesthetes can probably feel fragility and robustness, or heaviness and lightness in *Atmospheres*.

In general, electronic music seems very well suited to evoke tactile impressions. The Dutch composer Jan Boerman (like Ligeti, born in 1923) writes about this in an explanatory note to his electronic work *Tellurisch* (*Concerning the Earth*) from 1991:

The sound material is chosen with the help of a diagram. The noise sounds dominate and are often supplied with high tone resonances. I have assessed the color of the sounds on something that can be described like "material granularity," like the "skin of the sound." The sounds are primitive, terrestrial, and conjure up associations with grinding, drilling, and grating. The title *Tellurisch* is related to this and means "concerning the earth": the earth as volcano, as void, but also as a vulnerable organism.

Michael Torke

The New York–based composer Michael Torke (born in 1961) sees sounds, letters, days, months, and years in color. He deliberately uses these colors while composing music, for example, naming parts of a composition for ballet as different shades of orange.

Torke normally keeps his synesthetic perceptions as a private source of inspiration that normally remains unknown to the public. He is wary of using synesthetic colors as a gimmick and doesn't want to have light shows at performances of his music. According to Torke, the public doesn't need to know the colors he hears in order to appreciate the music he composes. The colors are of interest to him when he creates the piece, but are not essential to the performance.

So far, these three synesthetes who compose classical music all say that they don't compose "synesthetic music." Synesthesia is a source of inspiration or a

technique they use to create music but is not necessary for their public to see or understand. The music should speak for itself.

Bach in Colored Bars

Not only synesthetes use color to appreciate music. You don't have to perceive music in color, like a synesthete, to better understand music in color. This sounds like a paradox, but in fact, a traditional practice of music teachers in the music education of children is to use colored patterns to clarify difficult pieces like classical works.

Stephen Malinowski and Lisa Turetsky, of Berkeley, California, wrote a software program, entitled the Music Animation Machine, that translates pieces of music and shows them in colored measures. So that the children do not have to puzzle with complicated staves, including flat and sharp signs indicating keys, they instead see colored bars that scroll across the screen in time to the music they hear. The vertical positions of the bars on the screen represent the relative pitches, while the color can represent instruments or voices, thematic material or tonality.

Figure 2.3 (plate 3) shows a still from the Music Animation Machine software that represents the first ten bars of Bach's organ work *In Dulci Jubilo*. Johann Sebastian Bach (1685–1750) loved to apply complex mathematical structures in his music. They are not easy to disentangle on the first hearing of the piece. The piece contains a double canon, which means the same melody is repeated with a time shift. In plate 3, one can see that the dark green

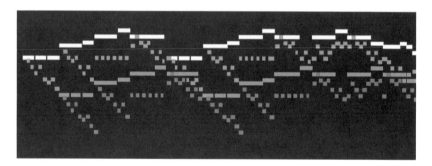

Figure 2.3 First measures of J. S. Bach's *In Dulci Jubilo*, from *Das Orgelbüchlein*, as shown in the Music Animation Machine. (www.musanim.com; reproduced with permission.) See plate 3 for color version.

pattern is followed by the light green pattern while the blue-violet follows the red pattern. When they are synchronized, the sound and image are easily linked in our perception. Musical structures like Bach's canons or his many-voiced compositions thus become understood and accessible by means of a visual aid.

Not everyone knows the beginning of *In Dulci Jubilo* by heart, so I will show a second, more common, tune, the beginning of the Fifth Symphony by Ludwig van Beethoven (1770–1827). Many people, even the ones who don't know Beethoven, will have heard this tune in a rock version or as a ring tone on a cell phone: *Ta-ta-ta-Daaaah Ta-ta-ta-Daaaah*, and so on. The way that tune looks in the Music Animation Machine is shown in figure 2.4 and plate 4.

Malinowski and Turetsky write on their Web site that three-year-old kids enjoy classical music when they can see the animation simultaneously. A study by the Russian music pedagogue Irina Vanechkina showed that children who have been drawing and painting classical music develop a better understanding of musical works and are better at analyzing musical structures later in life. She was inspired to undertake this study by the Russian composer Alexander Scriabin (1872–1915), who made an appeal to the natural human ability to understand music in color and form. By writing a score for a color organ in addition to the music for the regular orchestra instruments, he laid accents in the performance of his symphonic poem *Prometheus*, which I will discuss in detail in chapter 4, "Visual Music."

Synesthetes like Patrick and Floor have the advantage of a kind of built-in Music Animation Machine. They almost always see music in colored patterns and are more practiced in discovering its structures. As we saw earlier, Patrick

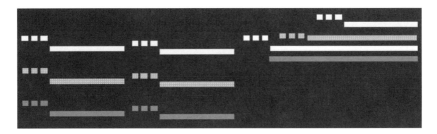

Figure 2.4 The first measures of Beethoven's Fifth Symphony as represented in the Music Animation Machine. (www.musanim.com; reproduced with permission.) See plate 4 for color version.

and Floor have little difficulty discerning different instruments and layers in pop music and are even able to analyze a chord, played on a harpsichord, that they had never heard before. Dorine Diemer, a student at the Amsterdam Academy of Music, found several advantages during her studies in her gift to hear notes in color:

As long as I can remember, I have always used colors to remember music. It has given me a good memory for music, which benefited me, of course. If people asked me how I could play pieces by heart after hearing them three times, I answered that I remembered the colors. They found that very strange. Unlike my fellow students, I don't need to remember names of notes or keys, but only color combinations. And as I perceive the colors always vaguely projected on the keyboard, it is not so difficult to reproduce the music. When I try to imagine how to study without colors, it all suddenly seems so indistinct to me. Each piece has its own color profile for me. How are other people able to tell things apart?

By nature, synesthetes who perceive sounds in color have a better insight into musical structures. But can they communicate their insights to nonsynesthetes? Some synesthetes have developed educational tools for the general public.

Tony de Caprio is an American jazz musician who was once an accompanist for Elvis Presley; he realized around his fiftieth birthday that he had always perceived tones in colors. Starting at that time, he began to translate chords in colors. Now, he plays melodies by heart by following the color changes in his mind's eye, for, as he says, "Color is much faster than thought." At the moment, he is developing a color notation system for educational purposes (see www.tonydecaprio.com).

Sandy Cohen, an English synesthete, worked as a perception psychologist at the University of Sheffield in the seventies; in the eighties he worked as a computer animator in New York, and later in the San Francisco Bay Area. In collaboration with a composer, he began to produce animations of music pieces, developing software for users to visualize their favorite music in a personal way. His X-Muse Player lets users choose a piece from a music library and then furnish it with colors and moving forms while they listen to the piece.

Cohen assumes that everyone has synesthetic gifts but is not always conscious of them. With the help of the software, you could try out several visual

patterns and choose the ones that best suit your musical experience. He argues that the X-Muse Player gives you the chance to express your personal synesthesia. The main difference between the X-Muse Player and the many musical visualizers that are offered on the Internet is that the latter are based on preprogrammed note-color algorithms, whereas Cohen's program does not fix these correspondences beforehand but lets users explore their own correspondences of tones, colors, and forms.

Vivaldi's Coils

To recapitulate, synesthetes have a special perceptual ability that permits them to see music in color and form. Yet, the specific colors and forms are different for each synesthete, even when they listen to the exact same tone. Despite these differences, there are some similarities that can fairly consistently be found in the reports of synesthetes. For example, a number of them see lines and abstract forms that change in space against a black background.

While it is true that few people have colored music synesthesia, it is also true that the rest of us, the nonsynesthetes, are not devoid of synesthetic gifts. How else does one explain how so many nonsynesthetic people can understand music by means of color and form? The answer must be that in one way or another, all of our brains make a comparison and find connections between musical and visual patterns.

One time I was lying in bed with a fever and spent the hours of my illness sleeping, reading, and listening to music. Half drowsy, I listened one morning to a classical-music channel. A concert of Vivaldi's *Four Seasons* was broadcast, and even though I had heard the piece many times before, only then did the spatial forms in the music appear to me in great clarity. Some violin solos came through the room as coils that I watched (in my mind's eye) unrolling downward from the ceiling—that's how I experienced it. And because I heard it but did not literally see it happen in front of my eyes, I perceived the coils better with my eyes shut. With my eyes wide open I just saw the ceiling and the cream-colored walls, while Vivaldi's music moved to the background. As soon as I closed my eyes, however, the images of Vivaldi's music reappeared in the foreground of my inner vision.

It was a fascinating experience, but I considered it a hallucination, caused by fever. I assumed that later, when the fever left me, this type of

experience would disappear as well, but that was not what happened. Even after I recovered, I found that when I listened to Vivaldi's *Four Seasons*, in a completely healthy and sober state, the coils again came tumbling down when I closed my eyes. I also experienced moving forms in other parts of the piece. In the autumn part, the scratching sound of bows on the strings looked like rough textures, and the more attentively I listened to the passages, the more clearly and in greater detail I could imagine the textures.

Since that time, listening to the textures, forms, and spatial movements of music has become a favorite pastime of mine, and not only with music. When I pass a building construction site and I hear sounds of sawing or the stacking of heavy metal plates, I stop for a moment to close my eyes and look at the textures and spatial patterns produced by the sounds.

Why did I never perceive this before? Had I become a synesthete in one day? What had the fever to do with my change? I remember seeing music in forms before, but less clearly and less explicitly, probably because my attention was directed to the sound of the music, which pushed the visuals to the background. Or perhaps I considered the visual forms merely culturally acquired and so didn't expect to see them. In a score, you can see, for instance, how the melody goes up and down in an undulating movement, and in our culture we have learned that classical music consists of patterns of repetition and symmetry.

Now, I realize that these culturally acquired forms had nothing in common with my perceived forms, which were not "classical" but wild, jumping, frayed patterns with rough and smooth textures. Also, they do not move from left to right, as in a score, but rather move in all directions. What I had assumed to be score patterns for a long time turned out be personal patterns. A touch of flu pushed me to that realization.

Discovering that synesthesia has many points in common with everyday perception does not make the mystery of synesthesia easier to solve. Why, for instance, do some people become synesthetes while others do not? Is the answer a genetic difference that is present at birth? Is synesthesia genetically determined? Or do synesthetic gifts develop in the course of a human life? In the next chapter I will continue my quest to discover the secrets of synesthesia in the early stages of human development.

3

Children Draw Music

How does a newborn child perceive his or her environment? No one can remember back that far because the earliest memories date back to about the third year of life. However, from the evidence of scientific research into neonates, we can draw a rough picture of their perceptual world, and that picture shows a resemblance to synesthesia.

Newborn babies perceive all their sensory impressions as a single whole, according to researchers. Babies do not differentiate between light, sound, taste, smell, or other impressions—something that is hard for grown-ups to imagine. However, there is one area where adults can still perceive a bit like a newborn baby. Taste and smell have never been completely separated in the development of sensory and brain functions. When we taste food, we use both the taste buds on our tongue and the olfactory receptors in our interior nose. The cooperation of the sensors in the mouth and the nose is so closely knit that we can hardly tell the difference between what we taste with our mouths and what we smell with our noses. It is only when we have a cold, and our nose is all stuffed up, that we become aware that as a result we lose some part of the taste of a dish.

So for adults to imagine the way babies perceive their environment, they can reflect on their own difficulty distinguishing taste from smell and on how hard it is for them to distinguish that which they perceive with their mouths from that which they perceive with their noses. Newborns presumably sense the environment as a blend of light, sound, smell, and other impressions. That is why some researchers have named the sensory impressions of a newborn a "sensory primordial soup."

Baby's Sensory Soup

A few years ago, in the Dutch documentary. *De smaak van moeders stem* (*The Taste of Mother's Voice*), I saw a beautiful visualization of how a newborn might perceive its environment, according to the latest scientific knowledge. The camera follows a mother who is pushing a baby carriage with her infant, who is just a few months old. As they travel along a busy street, the viewpoint of the camera alternates between the objective perception of a passer by and the subjective perception of the baby (restricted to sound and image, of course). In the baby's field of view—framed by its knees, the hood, and the bars on the side of the carriage—vague images appear of the street and of neon bill-boards as they pass by them. The objects look far away and more fluid than solid. The colors look pale and merge with each other. The baby is lying on its back and sees with an upward slant. Surrounded by heavy street noise, the baby sees the vague contours of high facades as they pass by in a pinkish haze. When a car honks its horn, the pinkish haze changes to a bright red color for a moment. When the baby hears the ringing bell of a bicycle, the color of the visual field becomes sea blue with abstract anemone-like forms. As soon as the ringing ebbs away, the original pinkish haze returns. Then, suddenly, the mother bends forward to the child and makes "coo-chie coo-chie" sounds, and immediately a new shape appears in the baby's visual field like a floating red plane with a space in the middle—a little joke of the animator—the vague forms of deep red kissing lips.

The Senses Separate

Daphne Maurer, a researcher at the McMaster University in Hamilton, Ontario, who studies the development of perception in early childhood, argues that the neonatal synesthesia of babies disappears slowly as their senses start to develop. The sight organs begin to specialize in images, the hearing organs begin to specialize in sounds, and so on. As a result of this, the organization of the child's brain begins to change during this process. The sensory life in the brain of the newborn presumably has little order to begin with. There is an abundance of neural connections, and everything literally touches every-thing else, which is why a single sound might evoke images, tastes, and smells all at the same time.

As the senses start to specialize into specific domains of perception, the idle neural connections between sensory domains are "pruned," as Maurer calls the process. This means that a great number of connections between sense modalities in the brain are eliminated so that specific connections within sense modalities can develop. According to this theory, most intermodal connections are eliminated in the first six months; the process becomes slower from the ages of one to eleven years.

However, the sensory development varies for each child, because each environment is different, and the environment of the child directs the pruning process. This is clearly demonstrated in the case of a congenitally blind child who develops sensory abilities (such as fine-tuned hearing) different from those that of a child who is able to see. Brain scans of blind people have shown that the visual cortex is active when they are reading in Braille. Similarly, according to brain researchers the auditory centers in the brains of congenitally deaf persons show activity in response to visual stimuli.

Psychologists, educators, and neurologists have assumed for a long time that the senses are already separate at the time of birth. That is a logical view because it explains how children learn to associate elements from different sensory domains. The image of a bee, for instance, is associated with the buzzing sound when a child perceives both stimuli often at the same moment. Later, the children can easily call up images of bees when they hear the buzzing.

Now, however, we know from the latest scientific experiments that the senses develop in a very different way in the first year of a child's life and that the senses of a newborn are not separate from each other at birth. From recent scientific evidence we now know that the senses start to differentiate only five or six months after birth.

Maurer presents the following example from her "baby lab." Suppose you darken a room and give a newborn a ball in the dark, let it feel it for a moment, take it gently away, and then turn on the light. When you show the ball and a cube to the newborn at a distance, the newborn will look at the ball instead of the cube. How is that possible when a newborn has not yet learned to associate tactile form and visual form? Somehow, the newborn is able to perceive the resemblance between the tactile impression and the visual impression.

This makes sense because the child is, of course, interested in the object, the ball. Instead of making a guess, the child will tune into energy patterns

that appear in the sound, touch, smell, and warmth of an event, in this case when they accompany the receiving of a ball. Probably the newborn cannot focus attention on the tactile or visual form as an adult can, but the baby can show interest in the "ballness" of the stimuli—the cube is missing this "roundness" quality.

It is remarkable that when the same test is given to babies of five or six months old, they do not do as well. They fail to look at the ball more than at the cube. Probably this is because they are in the middle of the process of the separation of their senses. They are beginning to lose the intersensory brain connections that allow them to recognize in the dark that the object was a ball and not a cube.

Newborns—despite how small and frail they appear—are able to detect common information from different senses very well. This ability seems to disappear when the newborns are about a half year old. Then, after about one year, the children start to perform better on the ball and cube test—but, they use a different strategy than the newborn to do this.

Around the age of one, children start to learn to associate sensory elements, like the bees with buzzing or a ball with the round tactile and visual impres-sions it creates. In contrast to the sensory behavior of the newborn, they use cognitive or reasoning behavior. A one-year-old child "knows" that a ball is smooth and that a cube has edges, a mental process that requires a different brain mechanism, one using other connections and functions that have more to do with reasoning than with feeling.

Nonetheless, the neural connections between sense modalities in the brain are never pruned completely. The intersensory connections can be temporarily activated in adults, for instance, by the use of LSD. Evidence for those continued intersensory connections appear also in our language, for instance, when we refer to and understand the meaning of "dark" sound or "sharp" smell.

Everyone is probably born as a synesthete, although most people lose this perceptual ability in the course of the first year of life. In synesthetes, however, this ability is sustained in a limited and slightly altered form. You have already read some reports by synesthetes that show they have retained connections between the senses, but those connections are different from the synesthesia in the perceptions of newborns.

The synesthesia of newborns and that of grown-ups differ in some essential respects. Newborns perceive the world as a primordial soup of impressions.

In contrast, grown-up synesthetes perceive the world largely through separated sense channels. They see images with their eyes, hear sounds with their ears, and so forth, and in this respect, they are not different from other grown-up nonsynesthetes. In addition to these "normal" perceptions, however, they also have some extra perceptual experiences that seem to a rise from two, three, or maybe more sense channels that are linked to each other. Nonetheless, they are still aware of the different sense qualities and are able to distinguish them from each other. Newborns cannot do that. They perceive all impressions as a single whole without being aware of the sensory origin.

Grown-ups can experience synesthesia in one or two directions, say, from sound to color or from color to sound. In newborns, synesthesia does not have direction associated with it because the senses are not experienced separately; sounds and colors mingle in one impression. A last difference between synesthetic grown-ups and newborns is, of course, that newborns cannot perceive colored letters, numbers, or weekdays because they cannot yet know those concepts.

There is, however, one area where most grown-ups remain almost as synesthetic as a newborn: in the perception of taste and smell. As we said before, when you taste something, it is hard to tell where the boundary is between the qualities you taste with your tongue and the qualities you smell with your nose.

Children Discover Synesthesia

Between the synesthetic abilities of newborns and those of grown-ups lie some decades of an individual's development. Here I change perspective from the scientists' point of view to the subjective experiences of synesthetes. I have asked synesthetes what was their first experience of synesthesia that they can recall. Their answers show that none of them became aware that they were synesthetic in one day; for all, it was a gradual process. Many synesthetes only realize they possess a special ability when they learn that other people do not share their synesthetic perceptions. Johannes Koch describes this in the following anecdote:

For as long as I can remember, I have perceived vowels in color. I never asked myself if that was normal or not, until one moment during a language lesson in my fifth year of primary school. I don't remember exactly what the lesson was about, but it had to do with words. When it was my turn, I explained that words have colors for me, for

instance, that the word "suitcase" (which I had just learned in an English lesson) has a blue-yellow color (*u* is blue and *i* is yellow; *a* is red, but does not play a role in this color experience). My classmates were very surprised and rather unsympathetic, and even the teacher did not know how to react to my confession. She seemed a bit confused at that moment. After a while, she continued with the lesson, and she never returned to the subject. My classmates also were not interested in my colored words. They thought it was weird and did not know what to think of it. For me, the confession was a turning point in my life. From that moment on, I realized that most people do not share my perceptions of colored words.

Types of synesthesia such as perceiving letters and numbers in color can begin to emerge only when children learn to recognize letters and numbers. Obviously, synesthetes are not aware of colored letters or numbers before they learn the symbols. That is an important clue to the understanding of this type of synesthesia. It indicates that perceiving colored words relates to learning symbols. In addition, there is a difference between colored graphemes (letters) and colored phonemes (sounds of letters). Hearing phonemes in color often starts earlier in life, as Rymke Wiersma recounts:

I remember very well a moment in the daycare center, when I was three or four years old. We had to make a drawing of a story of love and hate. The result was not much more than some scribbling but I scribbled in well-chosen colors: red for love and yellow for hate. The teacher was very pleased with it, because she said red is the color of love and yellow is the color of hate. I did not express my astonishment to her, but for me, the colors did not match the meaning of the words but rather matched the sounds of the words! I remember telling this story to my little girlfriend at the time and at home to my parents. But it seemed to me they did not understand that the sound of words had colors, which was beyond my comprehension. Later, my parents asked me what color their names were and I could tell them exactly. I still know what colors I stated at that moment; I also remember the times when I was not sure, because some name colors differed from the colors that I associated with the person. For instance, the color of my own name is transparent and silvery, but at the same time, I think of myself as being a deep dark blue. I found it strange that the colors of names did not match my favorite colors, and some name colors I found a bit weird. But that very fact made it clear to me that I was not inventing the name colors. I found it odd that other people did not understand this color thing, though it was a bit special, too—a kind of funny secret world!

Several synesthetes have discovered their gift in childhood in conversations with their mothers. The novelist Vladimir Nabokov (1899–1977) has written beautifully about this in his autobiography, *Speak, Memory*. In general, mothers react two ways. The mothers who are themselves synesthetic are not surprised, but they might dispute the colors reported by the child, whereas the non-synesthetic mothers often ask in amazement what the colors of other words are. Judith Palinckx, whose brother and mother are both synesthetic, writes about this:

I remember that when I was about seven years old, I became really angry with my brother, who is two years older, because he saw the number three in red and the number four as orange, which was exactly the other way around for me. My mother did not see these numbers in orange or in red but rather in very different colors. Her colors, I could understand; but in the case of my brother, I really got upset because he saw it the other way around and I could not convince him otherwise. We still see our colored numbers as we did then.

As long as I can remember, words have had colors. The big difference between now and then is that I used to think that everyone perceived words this way. Because my mother, and my little sister, too, also saw words this way, they did not react funny to my statements like "I don't know its name, but it's something red." At most, there was some dispute as to what color a name had, but the fact that the name had a color was beyond discussion.

In another example of a mother and son, both synesthetes, David Bisschop Boele tells this story:

I always had vivid images of the days of the week. I thought everyone else had them, too, but one day, when I said something about it at the dinner table, I learned that my mother had entirely different color associations with weekdays; her colors happened to match those of my youngest brother. My eldest brother had not the faintest idea what we were talking about, so I found out that not everyone has colored weekdays. I don't remember ever mentioning it at school. I found it normal because the majority in my family perceived in the same way; in our family, it was common knowledge. When I asked a cousin about it, he appeared to have it, too, though his mother, my aunt, responded, "I did not know that. Why have you never told me?" He answered, "I thought everyone had it."

Two artists who nowadays use their synesthesia in their work both tell that they discovered their synesthesia early in life, but it took a long time before they consciously started to use it in their art.

Carol Steen, a sculptor and painter in New York City, remembered that when she was about seven, she mentioned to a classmate on their walk home from school that the printed letter *A* was a wonderful shade of pink. "She was quiet, and then she looked at me and she said, 'You're weird,' and I didn't say another word about my colored letters until I was twenty." Because of her classmate's strong negative reaction Carol became very aware that she perceived the world in a different way than others, but as a seven-year-old she did not want to be different and she stopped talking about her colored graphemes. Later, she found out that her father was synesthetic, too:

When I was twenty, I came back from college on the semester break and my whole family—mother, brother, father, and I—were sitting around the dinner table, and for some strange reason I don't understand, I said, "The number five is yellow," and my father said, "No, it's yellow ochre." And my mother and brother looked at each other like they're in a game but they don't know the rules. At that time, I also said I wasn't sure whether the number two was green and the number six was blue or was it the other way round. My father said, "Two is definitely green." Quickly, I said, "Thank you!" I wanted to ask him another question but he had noticed the confused expressions on my mother's and brother's faces and lapsed into silence.

Now her life is full of color because she not only sees letters, numbers, and words in color but also perceives sounds, smells, tactile sensations, and pain in color. Concerning the latter, curiously enough, injections like a shot of vitamin B12 or a preventive shot of tetanus vaccine have inspired her to create synesthetic paintings and sculpture.

Not only the often painful injections in Western medicine but also the painless insertion of tiny acupuncture needles used in Chinese medicine evoke for her beautiful color perceptions, strong visual images in her visual field that resemble the aurora borealis.

Acupuncture is an ancient Chinese medicine therapy in which very fine needles are placed at energy points. Since the needles are much finer than injection needles, the placement in the skin is hardly painful, though it will cause a sensation in the skin, and these were the initial stimulus of Carol's

color perceptions. On the whole, acupuncture is not painful for Carol, despite a very few isolated instances, when the pain seen was orange, but the color did not linger as the pain went away quickly. In general, Carol does see pain in color, and different types of pain have different colors:

For me, a tension headache is orange; a toothache, too; a sinus headache is green; when I wrecked my left knee everything I could see was orange—orange rocks, orange husband, orange sand, orange waves, just light or dark shades of the same orange. When the physical therapist helped me learn to walk again following surgery, I would see white if my muscles were stiff, blue if they were sore, orange if the graft in my knee was being overworked. When I have a cold, I see black. The black color moves, and that is how I know I'm actually seeing something.

In the 1990s, when Carol became aware that acupuncture sessions gave her many magnificent color visions, she knew she wanted to share what she saw with a wider public. She wrote in the article "Visions Shared: A Firsthand Look into Synesthesia and Art":

Visions (1996) is the first painting in which I consciously recorded a photism that I saw during an acupuncture session. I was lying flat on my back and stuck full of needles. My eyes were shut and I watched intently, as I always do, hoping to see something magical, which does not always occur. Some visions are just not interesting or beautiful.

The painting *Full View* (1999) is based on an especially colorful vision that occurred during an acupuncture session. [Figure 3.1, plate 5] Sometimes when all the needles have been in place for the full amount of time, and just as they start to be removed, the colors come full force and are utterly, completely brilliant. Moving colors, swirling around, one chasing the other and pushing the blackness all the way to the edge and sometimes just exploding out of there completely. This is what I call a full view.

Looking back at her career as an artist, Carol says she has always used her synesthesia in her work, though earlier she was not as aware of it as she is now. For most of her life she did not deliberately or explicitly use her synesthetic experiences and knowledge in the making of her art. It took the discovery of the science of synesthesia to help her to see and understand what she was using in her art. As she wrote in her article:

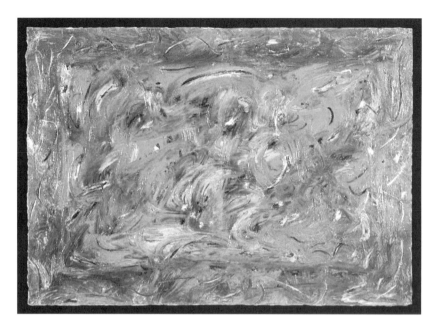

Figure 3.1 Carol Steen sees colors induced by acupuncture. The painting *Full View* reflects her experience while the needles are being removed. (Reproduced with permission.) See plate 5 for color version.

For many years I did not disclose or recognize much about the source of the subject matter of my paintings and sculpture. When I was younger I had reservations about letting other people know about my synesthesia because I had no information about it. I did not discover the word until I was in my thirties and knew of no scientific studies that could provide reassurance. In writing this paper now, I seek personal liberation. I no longer wish to conceal my abilities, my areas of experience, my vocabulary of colors and shapes and what I have observed to be their triggers.

The Dutch artist and color expert Clara Froger, in Rotterdam has perceived colors around her head since she was a child. She first saw the colors when she found herself in frightening and painful situations:

As a five-year-old, when I felt that I was left alone, I saw light blue around me. When I was afraid of someone, it became brown or orange. Back in a safe and homy environment, I saw soft pastel shades of color. Pain and being ill had specific colors when I

Figure 3.2 Clara Froger with felt hat, 2005. (Reproduced with permission.)

was seven years old: a sharp pain was blue or white, a stomachache was red or orange, a nagging pain was purplish, inflammations were yellowish orange, and fatigue was green-gray or sometimes a beautiful deep blue.

Color was comforting for her at these times. Today, she perceives the world in colors in almost every detail, not only those of the visual world but also the heard, tasted, smelled, and touched aspects of her environment. Some years ago, she started to turn her visualizations of what she calls the "colors around and inside my head" into felt hats (see figure 3.2). The colors and patterns on the outside of the hats are different from the colors and patterns inside the hat, because the colors around her head are different from the colors inside her head. In some parts of the outside of the hats, she makes cuts that allow

the layer underneath to be visible, which represents that sometimes colors from inside her head influence the colors of her surroundings.

Painting on Music

In order to observe "young synesthetes at work," Clara Froger and I did a workshop with children between the ages of four and six years in a fine arts project at the Cleophas School in Utrecht, the Netherlands. We converted a gym hall into a multimedia studio with painting tables and audio equipment. Our intention was to study how children respond spontaneously to music and how they translate these impressions into images. We chose three short pieces of music with different characteristic atmospheres: one calm, relaxed piece with a harp playing and a bird singing; one exciting piece from the *Nutcracker Suite*, of Tchaikovsky; and finally the sweetly soothing *Brahms' Lullaby*. We prepared the children by inviting them to sit in a circle and listen first to one piece with their eyes closed. Then they were free to dance a little to the music in the hall, where we gave them some instruction on how to handle the brushes, paint, and papers (to prevent them from mixing all the colors into one muddy color). Finally, when the children were ready, we asked them to listen to the music and paint whatever they felt, saw, or heard.

About forty children painted more than 120 paintings; some children were eager to do more than one painting for each musical piece (see figure 3.3). The children responded in very diverse ways to the music. Some painted what they would have painted without music: cars, houses, flowers, trees. One child painted a sky with the typical music symbol of a note with its little flag. However, a number of children painted nonfigurative forms that seemed to reflect the music to which they were listening. Some children even danced while they painted. We observed that the music took over the physical movements of some of the children as well as what they produced in paint on paper. They dotted the brush on the paper to the rhythm of the music or swayed the brush in long sweeps like a waltz as they listened to the music. Some of these paintings are pictured in figure 3.4 (plate 6).

Painting to music is an approved method in Russian and West European music education. Continuing the line of research that started in the beginning of the twentieth century in Vienna, where the method of "musical graphic" was invented, Irina Vanechkina and Bulat Galeyev of the Prometheus Institute in Kazan, Russia conducted a long-term experiment with children: they

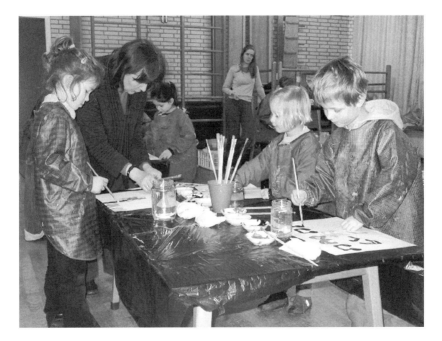

Figure 3.3 Children paint classical music under the supervision of artists.

| | Bird sounds
(tranquil) | *Nutcracker Suite*
(cheerful, energetic) | *Brahms' Lullaby*
(slow) |

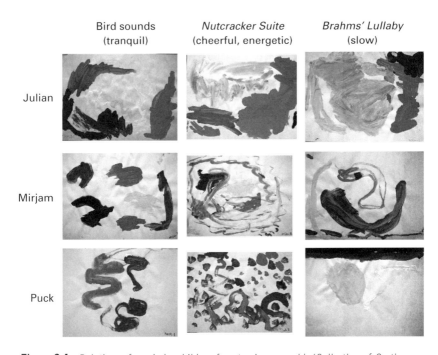

Figure 3.4 Paintings of music by children four to six years old. (Collection of Cretien van Campen and Clara Froger.) See plate 6 for color version.

offered two types of music education programs to two groups of children in primary school. One group was educated traditionally in musical notation and the second group learned to analyze musical pieces with the help of visual aids such as drawing and painting. After the programs ended, not only were the children in the second group more interested in music but they also had a better understanding of it. Five years later, it turned out that the children of the second group had acquired a more profound knowledge of music than the children in the first group.

Developing Synesthesia

To sum up, researchers believe that everyone is born a synesthete to some degree. The synesthesia of a newborn, however, can hardly be compared to that of an adult. Synesthesia appears to develop in the first years of life, but it is still unknown why some children hear music and sound in color while other children do not.

What happens in the developing child that interacts with its environment to produce a synesthete? Do synesthetes develop their gift because it provides them with certain advantages in daily life? For instance, is it possible that synesthesia is useful when learning the alphabet or learning to read? Does synesthesia offer a way to process complex impressions such as music or taste or smell?

I would guess that synesthetic children develop their gifts to come to grips with a fast-whirling world full of new impressions, emotions, and symbols. Can synesthesia be learned? I think that it can be developed, that one can become conscious or aware of it, but it is certainly not a trick that can be learned from an instruction book. I also think a child needs to be open and sensitive to synesthetic experiences.

I cannot remember ever using colors to understand things or cope with emotions. Nonetheless, I was aware early in my life of a particular sensitivity to forms, which I felt in my fingertips and the palms of my hand. I remember that at the age of six, I often daydreamed in school. I probably heard most of what the teacher was telling the class, but my hands distracted me. They had a special tingly feeling. I found that if I gripped the sides of my school desk, something amazing happened: I saw the desk grow to enormous proportions, so large that it only just fit into the classroom. In addition to growing, the desk also changed into a different form: a bendable organic form like

something you might see when you look through a camera mounted with a fish-eye lens. I felt myself become a part of the exaggerated bent forms. My visual field seemed to adapt to a reality that I felt in the palms of my hand. In my distorted view, the teacher also seemed to grow into a slanted, bent form that reached to the ceiling, as if she fit in with the rest of the classroom furnishings. I remember very vividly that the "felt" image was fascinating—so fascinating that I would not let go of it, to return to the normal reality. Even after I released my hands from the sides of the desk, the strange forms remained tangible in my palms. At the time I did not see the relevance or profit of this experience. The feelings in my palms were like a little toy or a little friend that sometimes, by surprise, came over to play with me. I was distracted for whole minutes at a time, which in retrospect may explain why I was a slow pupil in that year. In the next year, I had a different teacher who did a better job of keeping my mind on the lesson—but unfortunately, at the expense of my interludes of playing with my senses. At the end of the school year I was the second-best pupil in math and grammar, but I cannot remember any palm plays after that first year.

Perhaps, for most children, the discovery of their senses is similarly suppressed by the school system. Of course, children do not attend school in order to daydream or fantasize. But I wonder if the school system is not too focused on developing cognitive skills. After all, though it is true that children learn a lot in school, they also unlearn certain skills in school.

The senses are the little feet of the soul, the Dutch biologist and novelist Dick Hillenius once wrote. A more spontaneous (and less rational) development of the senses might teach children how to deal intuitively and instinctively with other people and events in life. In contrast, the rationalization of the senses—the conditioning of the senses as tools that process bits of information in an efficient way—certainly has advantages in subjects such as math and grammar. However, children can have a wider repertoire to use as they become acquainted with the world in which they live. Their senses contain more ways of knowing than the school system may suggest, or allow.

Some famous artists have tried to return to the child's sensibility in order to produce original insightful art. The German artist Paul Klee (1879–1940) was one who tried to break out of the typical adult worldview and perceive like a young child in order to paint and make music with this sensibility. He produced a highly original œuvre in which music and images seem intertwined as aspects of one primordial experience instead of as products of two

separate disciplines in art. One can witness the successful results of his approach in many museums all over the world nowadays.

How can we develop the senses of children in a way that might give synesthesia more opportunities to grow? Making art while playing music is a classic method that has been used for over a century. Unfortunately, art education is often taught as a lesson, in cognitive skills and students are encouraged to learn the canon by heart. Instead, in art lessons children might become acquainted with their synesthetic gifts and enjoy the surprise that comes from experimenting with new art forms like "visual music."

In the experience of experimental art forms, one cannot rely on historical art knowledge alone, because the experimental experience does not fit into the well-known categories. Experimental art can sharpen the senses and open up unknown pleasures (and displeasures, of course). As I explore in the next chapter, the idea of "hearing music in images" is a cultural achievement that might have been relegated to the dark caves of human experience if not for the efforts of some artists who, in the sixteenth century, started to experiment with the interrelationships of sound and image. They produced an art form that has enriched our culture and sensibility with new forms of aesthetic enjoyment.

4

Visual Music

The interest in synesthesia is at least as old as Greek philosophy. One of the questions that the classic philosophers asked was whether color (*chroia*, what we now call timbre) in music was a physical quality that could be quantified. Pythagoras had already discovered that there was a mathematical principle behind pitch. He demonstrated that pitch was determined by the length of the string that produced the sound. Aristotle and his students tried to take his deductions about pitch one step further to find a similar mathematical explanation for the relationship between pitch and color; they assumed that the color spectrum, ranging from dark to light, could be matched to a spectrum of pitch, from low to high.

Identifying the mathematical principles behind pitch and color correspondences has been an age-old quest of philosophers, artists, and scientists. Once Pythagoras demonstrated that pitch in music could be measured by the length of strings; other philosophers wondered whether they could find a similar system for measuring the color of music. Their problem was that they had no method to quantify color. Instead, some philosophers used their imaginations and speculative theory to connect music and color. Plato wrote that the eight celestial spheres are colored and are accompanied by eight tones. Aristotle and his students had a more down-to-earth approach. They took just one aspect of color, its lightness, and ordered all colors on a scale from black to white. Then, they linked the lowest-pitched note to white and the highest pitched note to black. All notes in between, from low to high pitch, were linked to corresponding gray values, from light gray to dark gray. Unfortunately, it is

not known whether Aristotle and his students succeeded in realizing these thought experiments in empirical tests.

The first known experiment that tried to test this hypothesis of correspondences between sound and color was conducted by the Milanese artist Giuseppe Arcimboldo (1527–1593) at the end of the sixteenth century. He consulted with a musician at the court of Rudolph II, in Prague, to create a new experiment that sought to show the colors that accompany music. He decided to place different colored strips of painted paper on the gravicembalo, an early keyboard instrument.

How was he to determine which colors matched which notes? To find a solution, Arcimboldo deduced a system of correspondence between tone intervals in music and gray values in color. Like Aristotle, he linked high tones to dark colors and low tones to light colors, which may sound surprising to our contemporary Western ears because we tend to make the opposite connections. Arcimboldo used white for the lower-pitched parts, like the bass notes. The green and blue of the higher pitched parts colored the white; and just as color pigments placed on a white canvas become dark when mixed together, so the highest-pitched parts of the music appeared in the darkest colors.

The challenge of finding a mathematical system to explain the connection between music and color has both inspired and frustrated artists and scientists throughout the ages. Even when mathematical systems of optics became available at the end of the Middle Ages, scientists still had no quantitative way to connect them with existing systems for musical harmonies.

The seventeenth-century physicist Isaac Newton (1642–1727) tried to solve the problem by positing that musical tones and color tones have frequencies in common. He attempted to link sound oscillations to their respective light waves. According to Newton, the distribution of white light in a spectrum of colors is analogous to the musical distribution of tones in an octave. So he identified seven discrete light entities, which he then matched to the seven discrete notes of an octave (see figure 4.1).

Inspired by Newton's theory of music-color correspondences, the French Jesuit Louis Bertrand Castel (1688–1757) took the theory a step further when he designed a color harpsichord (*clavecin oculaire*). First, Castel changed the Newtonian scale of seven tones and light entities into a scale of twelve music and twelve color tones. He was following the work of his contemporary, the French composer Jean-Philippe Rameau (1683–1764), who had distinguished two orders of six consonances within one octave, which led to a scale of twelve

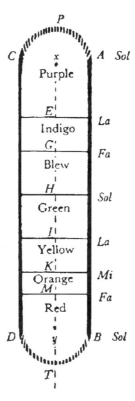

Figure 4.1 Sir Isaac Newton's illustration of the correspondences between seven colors of light and seven musical tones, 1675.

tones. Assisted by a instrument builder, Castel designed a harpsichord with colored strips of paper that rose above the cover of the harpsichord whenever a particular key was hit. Unfortunately, the colored strips could only be lit by candlelight and the instrument was never finished. There were other versions in development. A drawing of one of them by Johann Gottlob Krüger has survived (figure 4.2).

Comparing the sixteenth-century model of Arcimboldo with the eighteenth-century model of Castel, we can observe that the theories on music-color correspondences had become more refined. Renowned masters like Georg Philipp Telemann (1681–1767) and Rameau were actively engaged in the development of a *clavecin oculaire*. The practical performance of colored music, however, remained hampered by the technical impracticality of showing

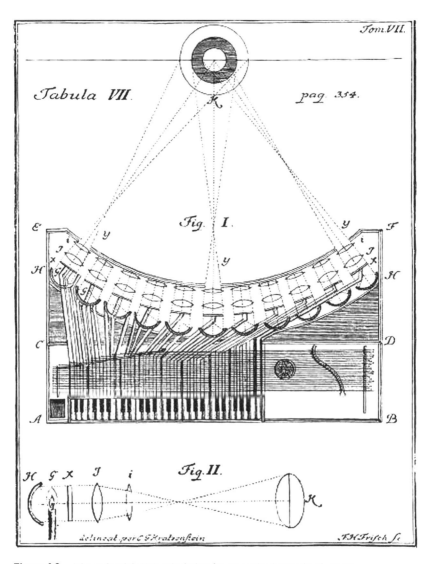

Figure 4.2 Johann Gottlob Krüger's design for an ocular harpsichord, 1743.

the colors to a concert hall. A set of strips of paper lit by candles lacked the power to evoke a convincing visual experience for the audience. The technical limitations made the experience very remote compared with what we can experience nowadays with light shows in concert halls. At that time, the colors of dawn or sunset in a natural setting came closer to the idea of the color projections that the inventors had in mind.

Color Organs

The invention of gaslights in the nineteenth century created new technical possibilities for the color organ. In England, between 1869 and 1873, the inventor Frederick Kastner developed an organ that he named a Pyrophone. He used thirteen gas jets to light crystal flasks while it played (see figure 4.3, left). In the United States, Bainbridge Bishop, interested in painting music, in 1877 constructed a machine that could be set on top of a house organ. It consisted of a half-moon-shaped screen on which colored light was projected with a series of levers and shutters that were operated by the organ player (see figure 4.3, right). The simplicity and mobility of the instrument attracted the attention of circus owner P. T. Barnum, who bought one for his home.

The British inventor Alexander Wallace Rimington (1854–1918), a professor of fine arts in London, was the first to use the phrase "Colour-Organ," in his patent application of 1893. Inspired by Newton's idea that music and color are both grounded in vibrations, he divided the color spectrum into intervals analogous to musical octaves and attributed colors to notes. The same notes in a higher octave produced the same color tone but in a lighter value.

His almost three-meter-high color organ (see figure 4.4) looks like a common house organ with a compartment on top of it with fourteen colored lamps. The light of the lamps could be controlled by the performer in gradients of color tone, lightness, and saturation. Rimington's color organ represented a giant step forward from the original harpsichord and paper strips of Arcimboldo. However, like most color organs of that time, Rimington's light machine did not actually produce musical sound; it was played simultaneously with an organ that did produce musical sound.

The *Musical Courier* of June 8, 1895, reports that Sir Arthur Sullivan improvised on the color organ, though with his eyes closed. A few days

Figure 4.3 Color organs by Frederick Kastner, left, and Bainbridge Bishop, right.

earlier, Rimington had demonstrated his color organ in London for an audience of a thousand people. Later that year Rimington played the color organ in four more concerts, accompanying music of Wagner, Chopin, Bach, and Dvořák.

Scriabin's Vision

Around the turn of the century, concerts combining light effects and musical performances were given quite regularly. Since most technical problems had been conquered, the psychological questions concerning the effects of these performances came to the fore. The Russian composer Alexander Scriabin (1872–1915) was particularly interested in the psychological effects on the audience when they experienced sound and color simultaneously. His theory was that when the a color was perceived with the correct matching sound, "a powerful psychological resonator for the listener" would be created. Scriabin

Figure 4.4 Alexander Rimington standing in front of his color organ, 1893.

was invited to London to explain his ideas and his synesthetic experiences to an experimental psychologist named Charles Myers, who was very interested in the phenomenon. In a letter written after a concert in London, Scriabin wrote: "Tomorrow A.N. and I are driving to Cambridge where we will spend the entire day at the invitation of two professors [one was Myers]. They are interested in the color symphony and my ideas in general." Myers's interview with Scriabin was a unique event: for the first time, a major artist was undergoing a psychological examination of his synesthesia. Myers did not leave records indicating whether he conducted any tests on Scriabin in his lab, but he did report on parts of his interview with the composer.

Scriabin told him that he became aware of his synesthetic perceptions when he was sitting next to the composer Nikolai Rimsky-Korsakov (1844–1908) in a concert hall. Scriabin apparently noticed that the performed piece in D-minor appeared yellow to him, and he mentioned this to Rimsky-Korsakov whereupon his colleague replied that the piece appeared to him to be of a golden color. Scriabin said that from that moment on, he started to pay special attention to the color effects of different tonalities. He realized that he had spontaneous color perceptions while listening to pieces in the keys of C, D, and F-sharp. Music in the key of C corresponded with red, D with yellow, and F-sharp with blue. A single note apart from tonality had no color for Scriabin.

Scriabin explained to Myers that color played several roles in his music perception. First, when the tonality of a piece changed, the color changed: "The color underlines the tonality; it makes the tonality more evident." That is one way in which the addition of color projections to musical performances could intensify the sound effects of a piece. In fact, the music and the color could enhance each other simultaneously. Sometimes, Scriabin even anticipated the change in color before he heard the change in tonality.

Second, emotion played an important role. Normally, when Scriabin listened to music, he had a faint feeling of color, but when his feeling for the music got more intense and emotional, the faint feeling of a color changed into a clear image of a color.

Third, Scriabin reported that not all music was suited for color additions. Older music, such as Beethoven's symphonies, evoked little color in Scriabin, which he attributed to the fact that the music was too intellectual, saying "It has not the psychological basis of modern music."

Almost a century later, it is difficult to definitively say whether Scriabin was a synesthete or not. Some music critics have argued that Scriabin found inspiration for his color-key correspondences in the mystical works of Madame Helena Blavatsky (1831–1891), the founder of the Theosophical Society in 1875. Other critics and historians point to the different correspondence schemes that have been preserved in the Scriabin Museum in Russia to prove that he was in fact a synesthete. They showed that the composer noted two different synesthetic schemes: a "personal" one, which he did not use for public work, and a second one that he felt had more "universal" synesthetic connections and that any person could understand. For these universal schemes, he found inspiration in and possibly borrowed examples from the theosophical writings of Blavatsky.

Scriabin was a self-declared mystic and made plans for a large mystical show. He envisioned new modes of expression for the arts that would address unknown psychological abilities of the beholders. His ideal show consisted of an art form that united music, poetry, dance, light projections, and odors of incense, which he believed would create synesthetic experiences for the audience. He wanted the show, entitled *Mysterium*, to be performed on the peaks of the Himalayan Mountains, but his early death in 1915 prevented him from further elaboration of the project.

Scriabin's most famous synesthetic work, which is still performed today, is *Prometheus, Poem of Fire*. He used musical key–color correspondences for this work, and not the note-color correspondences that were commonly used by color-organ performers such as Rimington. In Scriabin's system, the color changed only if the tonality or key of the piece changed. In this way, Scriabin prevented the beholders from being overwhelmed by a bombardment of colors, as happened in performances by Rimington, where every played note was accompanied by a color. Scriabin kept a steady color in one tonality and only changed the color in transitions from one key to another, which made the experience of the colored music movements more durable and intense.

On the score of *Prometheus* he inducted, along with the other instruments, separate parts for the *tastiere per luce*, the "keyboard for light," or the color organ. There were two movements with parts for the *tastiere per luce*; in one the color organ "notes" looked consonant with the music and in one it looked dissonant. He intended to structure and intensify the experience of the beholders not by a servile imitation of the musical movement, but by giving the color organ an autonomous role so that color changes pointed and counterpointed at changes in the musical movement.

Scriabin's first opportunity to test his theory, in a concert performance in Moscow in 1911, unfortunately failed, because the light projector did not work. The first successful performance, in New York in 1915, came after his death, too late for the composer of the first synesthetic symphonic poem to enjoy. An instrument especially designed for this performance of *Prometheus*, called a *chromola*, was used at this concert. In recent years, several magnificent performances of *Prometheus* have taken place. After the performances of Luce Group in The Netherlands, the Dutch visual artist Peter Struycken developed a new visual idea of a "colored space." The public was shown projections of a journey, based on the color score by Scriabin, through a colored musical space, directed by the conductor Valery Gergiev and Struycken.

Musical Paintings

The concept of the painter's palette as a keyboard, which has become a commonplace in artistic parlance, was first mentioned in the art criticism of the nineteenth century. Visual artists considered music the highest form of art and believed that music approached the ideal of an immaterial art form. The French painter Eugène Delacroix (1798–1863), for instance, liked to whistle while he painted in order to catch the right mood. More than half a century before the start of the abstract art movement, when it became common practice to give paintings titles of musical compositions, Delacroix wrote the following on the subject:

A certain impression that results from a particular arrangement of colors, lights, and so forth—that is what one could call the music of the painting. Even before you know what the painting depicts—when you enter a cathedral and you are at a too great distance to perceive what it represents—that magical chord can strike you.

The Dutch painter Vincent van Gogh (1853–1890) told a personal anecdote about the music behind his own painting. The artist took piano lessons in 1885 to become acquainted with the subtleties of color tone. However, his elderly music teacher sent him away soon after he noticed that van Gogh was constantly comparing the sounds of the piano keys with Prussian blue, dark green, dark ochre, cadmium yellow, and other colors. The teacher thought his pupil was a madman. In his later writings, van Gogh compared painting with pencils to playing the violin with a bow.

He was not the only visual artist in the nineteenth century to experiment with painting and synesthesia. It was common for artists to sing or whistle songs while they painted to create paintings that approached a musical expression. The art historian Evert van Uitert has shown how, in the second half the nineteenth century, a tradition of musical paintings began to appear that influenced, among others, the Dutch symbolist painter Janus de Winter (1882–1951). A characteristic of symbolism is the frequent use of musical titles. In that respect, symbolism was a trailblazer for the synesthetic experiments conducted by later abstract artists, which I will discuss later.

Janus de Winter exhibited works with titles such as "*Musical Fantasy (Wagner)*" (see figure 4.5). In response to a request of the psychologist Ten Haeff to describe his synesthetic percepts, de Winter wrote to him:

Figure 4.5 The painting *Musical Fantasy (Wagner)*, by Janus de Winter (1916). (Centraal Museum, Utrecht, the Netherlands.)

Trombones, horns, trumpets vary from red to yellow; oboes, clarinets, and flutes vary from dark brown to olive green and dark green to light yellow green; cellos, from red or brown-violet to blue and purple; violins can express any color, which are always blended with silvery gray. Beethoven's music appears with lots of red, but also purple, violet, and exquisite green, silver and gray, while Chopin evokes dark colors.

In the first decades of the twentieth century, a German artist group founded in 1911 called der Blaue Reiter (the Blue Rider) executed the first synesthetic experiments that involved a group of painters, composers, dancers, and theatrical producers. The group had three goals: the unification of the arts by means of so-called "total works of art" (*Gesamtkunstwerke*); achieving freedom of expression through abstraction; and the expression of spirituality as the ideal of an immaterial art. The Russian artist Wassily Kandinsky's theory of synesthesia, as formulated in his pamphlet *Über das geistige in der Kunst* (*On the Spiritual in Art*) (1910), helped to prepare the ground for these

experiments. He described synesthesia as a phenomenon of transposition of experience from one sense modality to another, as in unisonous musical tones. Later, when he taught at the Bauhaus, he compared the human nerves to the strings of a piano, observing that if a note is struck on one of two pianos that are standing next to each other, the exact same note on the other piano will resonate. Kandinsky was well acquainted with the scientific debates on perceptual processes in academic psychology of the time and explicitly defended his theory of synesthesia against the counter arguments of psychologists.

Was Kandinsky a true synesthete? Some scholars doubt that he was and argue that he invented his synesthesia to serve his artistic ambitions. However, reading his autobiographical writings, I find evidence that suggests he was synesthetic. For example, in a description of a concert he attended as a youth, he explains that when he heard the performance of Wagner's *Lohengrin* in Moscow, the music evoked a fantastic vision of colors and lines. After this early discovery of his synesthesia, he later began to notice that the sounds of musical instruments had distinct colors for him as well: a trumpet and a brass band sounded yellow, a viola and a warm alto voice had orange colors, a tuba and drums evoked red colors, a bassoon sounded violet, a cello and an organ produced blue, and the sound of a violin evoked green. He played the cello himself and described the dark blue color of the instrument as the most personal spiritual color. We will never know if, according to current standards of scientific testing, Kandinsky would be considered a synesthete, but I find his descriptions quite convincing.

Kandinsky experimented with synesthesia in several fields, among others in his abstract compositions in the early years of the twentieth century, and in his collaboration with composers from the Blue Rider, which resulted in his theater piece, *Der gelbe Klang* (*The Yellow Sound*). In his lessons at the Bauhaus he taught his students to experiment with the relationships between visual form, color, touch, warmth, sound, and energy.

Kandinsky's interest in synesthesia can be observed in his well-known pictorial compositions painted from 1910 on, which also marked the beginning of abstract painting in the history of art. Kandinsky himself predicted this course of abstract art in his book, *On the Spiritual in Art*. Although the book marked a turning point in the history of art, the ideas in the book are also a logical consequence of a development in art started in the nineteenth century by the symbolists and others. They believed that the art of painting should approach the art of music because the latter was on a higher level in

the hierarchy of the arts. In contrast to painting, they considered music detached from the material world, while they considered figurative visual art to be based in the world of material objects. It was felt that instead of picturing the surfaces of the material world (or the superficial world), the modern artist ought to visualize the deeper spiritual world that touched the deeper layers of the human soul.

Kandinsky investigated two typical phenomena of synesthesia, in the experiments of the Blue Rider and then later at the Bauhaus, involving dissonance and temporality. Kandinsky and the Austrian composer Arnold Schönberg (1874–1951) were interested in the phenomenon of synesthetic dissonance, which also intrigued Scriabin. After Schönberg published his atonal theory of dissonant harmony in 1911, Kandinsky wanted to make use of these principles in his painting and in the theater. In his theater piece, *The Yellow Sound*, he experimented with the opposition of three types of movement: visual movement (film), musical movement, and physical movement (dance). Like Scriabin, Kandinsky wanted to alternate dissonance with consonance in order to intensify synesthetic perceptions, so they would, in his own words, have a "deeper inner impact." Together with the composer Thomas von Hartmann (1885–1956) and the dancer Alexander Sacharoff, (1886–1963) he experimented with synesthetic relations between the three types of movement:

I myself had the opportunity of carrying out some small experiments abroad with a young musician and a dancer. From among several of my watercolors, the musician would choose one that appeared to him to have the clearest musical form. In the absence of the dancer, he would play this watercolor. Then, the dancer would appear, and having played this musical composition, he would dance it, and then find the watercolor he had danced.

Kandinsky was not the only artist at this time with an interest in synesthetic perception. A study of the art at the turn of the century reveals in the work of almost every progressive or avant-garde artist an interest in the correspondences of music and visual art. Modern artists experimented with multisensory perception, such as the simultaneous perception of movement in music and film, as well as in static paintings, as the Dutch painter Piet Mondrian (1872–1944) has shown extensively. Mondrian and other modern artists considered painting a static art form, and they wanted to add other dimensions

to their paintings—not only the third dimension of depth, but also the fourth dimension of time, both of which they did by means of visual suggestions of movement.

Music, especially jazz, was an important inspiration for Mondrian. While Kandinsky studied the intellectual atonal experiments of his friend Schönberg, Mondrian looked to the forms of the popular music and he used those forms in his art. He wrote an article "De Jazz en de neo-plastiek" (Jazz and neoplasticism) in 1927 in which he explained that he chose jazz because it was a rhythmic art form.

For several decades, Mondrian studied the problem of the visual perception of movement in his apparently static compositions. The first paintings in which he used grids, around 1920, were a milestone in his oeuvre. However, according to Mondrian, these early presentations of universal proportions lacked the important characteristic of rhythm. He wrote that the perception of reality was chained inside the forms that are dictated by the classical art of painting. To liberate this perception from its chains, the visual form had to be destroyed so that rhythm could be released and given its freedom. Mondrian discussed the attempts of the futurists and cubists to provide space for rhythm in their paintings but concluded that they did not succeed in visualizing rhythm.

Mondrian's *Composition with Gray Lines* (1918), a rhombus painting contained a grid of squares and planes that criss-crossed each other, was an early attempt in this direction (figure 4.6). Mondrian systematically varied the thickness and

(a)　　　　　　　　　　　　　　　　(b)

Figure 4.6 Two musical paintings by Piet Mondrian: *Composition with Gray Lines* (1918), left, and *Victory Boogie-Woogie* (1942–1944), right. (Gemeentemuseum, The Hague, Netherlands.)

the gray tones of the lines to create the perceptual effect of a rhythmically moving grid. Since beholders' eyes were disposed to follow the lines of equal thickness and gray tone, their gaze was led through the painting in a movement like the quickstep dance, which was developed to ragtime jazz music.

The synesthesia of movement in visual grids, which remained a central theme in Mondrian's experiments, culminated in the Boogie-Woogie series, which he painted in response to the sounds of the music played in local jazz clubs in New York, where he spent his final and happiest years. Viewers of his work immediately recognized the rhythms in the pictorial compositions. In 1948, the art critic James Johnson Sweeney wrote about the Boogie-Woogie paintings:

The whole canvas now dances with variously sized rectangles of different colors. The eye is led from one group of color notes to another at varying speeds. At the same time, contrasted with this endless change in the minor motives, we have a constant repetition of the right angle theme, like a persistent bass chord sounding through a sprinkle of running arpeggios and grace notes from the treble.

Even the art historian Ernst Gombrich, who was not especially fond of abstract art, immediately understood what the Boogie-Woogie paintings were expressing: "I don't know exactly what boogie-woogie is, but Mondrian's painting explains it to me."

Mondrian was not a color synesthete in the sense of perceiving music in color, but in his work he certainly used his ability to perceive musical rhythms in linear patterns.

With today's knowledge and testing apparatus, we can determine with more certainty whether contemporary artists are synesthetic. By interviewing these artists, we are able to get some insights into the process of painting music. Anne Salz, a Dutch musician and visual artist, perceives music in colored patterns. A fine example of the expression of her synesthesia is her painting *Vivaldi* (figure 4.7, plate 7). Anne knows the music very well from her experience as a musician of the Baroque repertoire. Vivaldi's *Concerto for Four Violins*, which is one of her favorite pieces, inspired her to make this painting, which she describes this way:

The painting represents the opening of the concerto for four violins. I listen to the music while I paint. First, the music gives me an optimistic, happy feeling and I

Figure 4.7 Anne Salz, *Vivaldi*, 2003. (Reproduced with permission.) See plate 7 for color version.

perceive red, yellow, and orange colors in great variety with little contrast. It looks like a field of these colors. I perceive the color field as a musical chord. You can compare it with the colors of a blanket or a cover made of autumn leaves.

She explains that the painting is not a copy of what she hears; rather, when she listens to music, she perceives more colorful textures than she normal perceives and she is able to depict them in the painting. She also expresses the movement of the music, as its energy influences the pictorial composition. When I asked her how one should look at her paintings, she answered: "Look at my paintings as if you are listening, sound after sound, color after color. In

time, it gives an impression of how I see, hear, and experience the music." She goes on to explain how she perceives the painting:

The lively movements in the music become a stream of glowing shades of orange. The black structure provides cadence and reveals its significance and character. It is an indispensable foundation for the moving colors. The painting evokes my feelings again when I listen to the music again. I hear the melodies in my mind when I look at it.

Artistic explorations of synesthesia and scientific research into the subject have become closely intertwined in the last decade. Some contemporary artists are active members of synesthesia associations in the United States, the United Kingdom, Germany, Italy, Belgium, the Netherlands, and other countries. Within and outside these associations that house scientists and artists, the exchange of ideas and collaborations between artists and scientists has grown rapidly in the last decades. And this is only a small selection of synesthetic work in the arts. New artistic projects on synesthesia are appearing every year. To keep track of the artists who use synesthesia in their work, follow the Leonardo Online Bibliography Synesthesia in Science and Art (http://lbs.mit .edu/isast/spec.projects/synesthesiabib.html), which contains references to general Web portals, Web sites of artists, and hundreds of scientific articles and books on the subject that have appeared in recent decades.

These painters, sculptors, designers, and musicians have shown themselves to be well informed on the latest scientific insights into synesthesia. They combine this scientific knowledge and personal intuition in a range of artistic expressions. For instance they capture their synesthetic perceptions in painting, photographs, textile work, and sculptures. Besides these "classical" materials for making art, an even larger production of synesthesia-inspired works is noticed in the field of digital art.

The Digital Salon

In the era of Scriabin, Kandinsky, and Mondrian, the performance of sound and color compositions did not have the technical advantages we have today. Since the nineteen fifties, rapid advances in computer technology created new digital instruments and brought sound and color into a common digital domain.

Since the late 1950s, electronic music and electronic visual art have coexisted in one digital medium. Since that time, the interaction of these fields of art has increased tremendously. Nowadays, students of art and music have digital software at their disposal that uses both musical and visual imagery. Given the capability of the Internet to publish and share digital productions, this has led to an avalanche of synesthesia-inspired art on the Internet. Unfortunately, many projects are not well thought out. Using digital art to express synesthesia involves more than applying some computer algorithms that arbitrarily translate music into colors. Windows Media Player can already do that trick for you. The challenge is to find a form that truly shows some new aspects of synesthesia.

Perhaps one should study the "old masters" of visual music such as John Whitney (1917–1995) who made the animation for *2001: A Space Odyssey*, or Oskar Fischinger (1900–1947), who worked on Disney's film *Fantasia*, and even the seventeenth-century inventor of the first color-organ, Louis Bertrand Castel; all of them were limited in their technical opportunities, but they did a good job of relating music to images. Fred Collopy's Web site Rhythmic-Light.com, on the history of visual music, provides a well-documented introduction to the thinking and practices of these masters.

Finally, my excursions among the perceptions of synesthetes, children, and artists, which I have reported in the last three chapters, have made at least one thing clear: synesthetes perceive the world differently from the rest of us. Do they also think differently? I am particularly curious about synesthetes who see letters and numbers in color, where thinking must play a role. How do synesthetes think with colored words and numbers? Can they, for instance, calculate in color?

II

Thought

5

Calculating in Colors

Two is marine blue, five is orange, and seven is yellow. Numbers have fixed colors for Pauline Jansen. Even when numbers are printed in black ink in a book or painted in color on a billboard, they retain their fixed colors when she perceives them. In fact, the colored numbers on billboards may create confusion if the painted colors do not match "her" colors.

That might sound curious. Perhaps even more curious is the fact that her colors do not match the colors that other synesthetes perceive. Even within families, synesthetes see the same numbers in different colors. Loes and Wilma Meijs are sisters who both perceive numbers in colors, but in different colors. five is purplish blue for Loes and red for Wilma. As a result, they have different personal histories with colored numbers. Loes explains that as a child, she used to confuse the number 3 and the capital letter *E* because both have a green hue and because their forms appear to be mirror images of each other. For instance, she often read the name of Esso gas stations as 3sso. Now that she works as a teacher in a primary school, she sometimes helps the children with difficult numbers and letters by having them trace the same letters in the same colors. In this way, they learn to distinguish the forms of the numbers and letters more easily.

Colored numbers can have advantages not only for school children but also for synesthetes, as the New York journalist and synesthete Patricia Duffy learned when she interviewed the mathematician Geoffrey Chester for her book *Blue Cats and Chartreuse Kittens*. Chester amazes his fellow workers with his ability to memorize complex formulas step by step. First, he perceives

the numbers in color, which transforms the long mathematical formulas printed in black ink on white paper into a colored pattern in his mental imagery. This is an aid for him not only in memorizing them but also in the systematic categorizing of the deductions he makes. As a child, he remembers being faster than his classmates in learning the math tables because he perceived them in color.

Sometimes, however, a disadvantage in perceiving numbers in colors can become an advantage, as in the case of the synesthete Veerle Provoost, who says that she often took the wrong bus to work, until the number of the bus changed.

The city buses in Bruges, Belgium, each have their own number and color (shown on top of the front window). This is probably done to facilitate the identification of the buses for the travelers, because they see the color of an arriving bus much earlier than that they read the number. However, the colors of the numbers are obviously not "my" colors. So even after many years, I still cannot memorize the number-color combinations of the buses. Very often I run to the wrong bus. For instance, when I know that I have to catch bus number 9, I run to number 4, as that is indicated with the color green, my color for 4. However, there is one combination that fits my colored numbers, and that is bus number 6, which is a light blue color.

The pleasant side is that since we moved to another house, I have to catch this bus now. This lucky coincidence not only reduces my lost time in running to wrong buses, but it also gives me a good feeling: this bus looks the way it should look, the only right bus!

Most people do not perceive black printed numbers in color and they imagine that seeing numbers in color would make it harder, not easier, to memorize chains of numbers such as telephone numbers and bank pass codes. Some have to copy these codes digit by digit on paper to avoid making mistakes. Seeing the numbers in color would only distract and confuse them. Yet synesthetes state that for them, the opposite is true, and explain that they are able to memorize series of numbers more easily by means of their colors.

Hindry Schoonhoven, who has perceived numbers and letters in colors since childhood, uses his colors as mnemonic devices to help him memorize telephone numbers and other series of numbers. He explains that each number from zero to nine has a fixed color, and these colors remain fixed when they appear in compound numbers from ten upwards; the numbers do not change

in color even when combined. For instance, three is bright red, and four is light green. Thus, the number thirty-four consists of a bright red three and a light green four. A telephone number appears in Hindry's mind's eye as a discrete chain of colors.

Hindry discovered that the form of the character determines its color for him: the letter A and the number 4 have similar shapes, and both have bright almost fluorescent light green colors, while E and 3 are bright red, I and 1 are yellow, and the letter O and the number 0 (zero) are both white. This association of E and 3 because of their shapes was also reported by Loes Meijs.

Not all synesthetes who see colored numbers and letters benefit when it comes to memorizing a series of numbers. To the contrary, some synesthetes find it confusing. David Bisschop Boele, for example, wrote to me that he has more trouble memorizing numbers when the colors of digits in a series or compound number "clash with each other" or "are not in harmony," which he explains as follows:

All digits from zero to nine have fixed colors [see figure 5.1, plate 8]. The digits can of course form compound numbers. Some of these color combinations of compound numbers, however, are not harmonious, which means that the digits do not succeed in becoming a fine general color for the compound number or it is a combination of colors that I feel (by intuition) is not right. I have trouble memorizing these types of numbers. It seems they are not visualized clearly enough for my mind's eye. Harmonious colored compound numbers pop up immediately in my mind. Examples of harmonious numbers are 810 and 340. These numbers simply have a "good" combination of individual colored digits.

An example of a "clashing" number is 567. The image does not get clear in my mind. It looks to me as if the colors of the digits do not go together and as a result, erase each other. What I have drawn in the picture of this number [see figure 5.2,

Figure 5.1 David's colored numbers. See plate 8 for color version.

Calculating in Colors

Figure 5.2 David's colors of compound numbers. See plate 9 for color version.

plate 9] is a combination of three individual digits, but this is not exactly what I perceive mentally. When I look at it now, I feel I become physically restless and anxious. That does not happen when I look at the other drawings.

An example of a number that becomes a generalized color image is 338. The whole number becomes more or less dark red. The yellow eight is absorbed totally and I cannot find its color again.

For other synesthetes, two types of synesthesia may disrupt each other. For example, the synesthete Rymke Wiersma perceives numbers and letters in colors when she hears or reads them. However, the colors of the sounds and the written symbols do not match. She explains: "Reading the number eight, eight is dark blue, hinting to purple, but when I hear someone say 'eight' it sounds yellow."

It is difficult for nonsynesthetes to empathize with synesthetes, to understand how they perceive numbers in colors, or—as many nonsynesthetes admit they do—even to be convinced that synesthetes are not making up these colored numbers. At the University of California–San Diego, Vilayanur Ramachandran and Ed Hubbard developed a simple test to determine one type of colored number synesthesia that proves the phenomenon is genuine, however. If you want to know whether you have this type of synesthesia, look at figure 5.3. The picture has a hidden visual pattern. Many people will stare for a long time at the picture before they discover the pattern. Some synesthetes (not all) will see it immediately. For those who cannot find the pattern, the solution is pictured in figure 5.15, at the end of this chapter.

Such tests demonstrate that synesthesia is not a figment of synesthetes' imagination, but a true perception. The synesthetic colors appear automatically to synesthetes, like the green of grass in spring or the light blue of a cloudless sky. Another simple test that detects synesthetes who perceive numbers and letters in color is shown in figure 5.4. From left to right, one

Figure 5.3 Test for synesthetes who project colors on numbers. (Ramachandran and Hubbard 2001; used with permission.)

Figure 5.4 The sign in the middle can take different colors for a synesthete, depending on whether the characters are read from the top to down or from left to right.

reads A B C, and from top down, one read 12 13 14. For a number of synes-thetes, not only the meaning of the symbol in the middle but also its color will change, depending on the direction of reading. But not always. The Dutch physicist and synesthete Robbert Dijkgraaf reports, "When I read from left to right, the symbol in the middle is brown (because the letter *B* is brown for me), but from the top down, it becomes black and yellow because the 1 is black and the 3 is yellow."

At the University of Waterloo, Ontario, Mike Dixon and his colleagues did another test. In their laboratory they showed the symbols MUSIC and then 1234567 to a synesthete for a very short period of time—a few milliseconds. The synesthetes perceived the ambiguous symbol 5, which could be read as *S*, as a different color in the word than when it appeared in the number.

Another aspect of synesthesia that has been tested extensively is the confu-sion synesthetes experience when the color of a painted number or letter con-flicts with or does not match their synesthetic colors. Scientists had already figured out from the classic Stroop Test—named after its inventor, John Ridley Stroop—that everyone needs more time to recognize the word "green" when it is written in blue, red, etc., than when it is written in green ink or regular black ink. The color perception appears to interfere with the reading of the word for synesthetes and nonsynesthetes alike. This Stroop Test was adapted for use in several experiments with synesthetes, for instance at Goucher College in Baltimore, where Carol Mills and her colleagues showed pictures of colored numbers to synesthetes for just milliseconds. The synesthetes needed less time than the average person to recognize the number when the pictorial color matched their synesthetic color, but needed more time than average when the colors did not match. I wondered whether that might affect their speed in calculating, too. So I decided to ask some synesthetes.

Red Plus Red Is Black

Statements like "green plus green is brown" or "red plus red is black" may sound odd to most people, but for Hindry Schoonhoven, they do not sound strange at all. For him, the number three is red and the number six is black, so he calculates "red plus red equals black." This has nothing to do with mixing paint colors, but shows an aspect of a personal way of synesthetic thinking.

Several synesthetes told me that they calculate with color. Some do better than others as a result. Katinka Regtien, whose colored letters we saw in chapter 1, uses the colors of her numbers in mental arithmetic. When she makes a simple addition to create a sum, the color of the resulting number appears just before the symbol itself appears. The color seems to foretell the number, comparable to the experience of sensing a word on the tip of your tongue before it actually comes to your mind. Katinka clarifies how her colored mental arithmetic proceeds in her mind:

I cannot do arithmetic without visualizing the colors and the forms of the numbers. When I add fifteen and eighty-three, I see mentally first a cream white line (the color of ten) and a green line (the color of eighty). In that first moment, I already see that the outcome will be in somewhere around the brown line, which is the color of ninety. So I start the arithmetic with cream white, green, and brown lines, corresponding to ten, eighty, and ninety. Then, I zoom in to the place where the smaller numbers are, and the blue five of the fifteen gets more significance than the cream white one (which stands for ten), although the number fifteen is normally more white than blue. The same happens with the number eighty-three. The three is kicked three steps on top of the five and lands on the place of the number eight. And so the outcome is ninety-eight. If the sums are more complex, I put them on paper, of course, but still the same process happens in my mind.

Not all synesthetes experience these kinds of advantages with mental arithmetic. The synesthete Margreet van der Wardt says that at school she had difficulty with arithmetic because her attention was more drawn to the colors of the numbers than to the solution of the sums. Wendy Spijkers, too, remarks that she tested low when it came to doing sums and explains how the colors interfered: "When I have to multiply numbers, say, three times three—that is, yellow times yellow—which becomes a pink-red nine, I first have to let that sink in before I can proceed. If I go too fast in doing sums, I lose the colors and the numbers and have to start again."

The synesthete Helen Hills writes that as a child she had difficulty with the sum four plus four is eight, because four is blue and eight is green. She could not figure out how blue plus blue becomes green. Or why two plus two is four, because beige plus beige does not equal blue. As an adult, she is still slow in doing sums, as she has to look "behind" the colors.

Other synesthetes often make other mistakes—if, for example, the numbers do not have equally prominent colors. Some colors may have striking colors, others, pale colors, and some have no color at all. Rymke Wiersma often makes mistakes in memorizing the number of zeros that are present in a number and might therefore remember a number as being only one hundred instead of one thousand. According to Rymke, the reason for this mistake is that the number zero has no color, or, as she says, "In fact, it is air." Since it lacks any discernible color, she has no code for remembering it as she does with other numbers.

Although perceiving colored numbers is self-evident for all of these synesthetes, their anecdotes show that there are nonetheless significant differences in the ways they use this ability to perceive numbers in colors. Many of them use their colored numbers as mnemonic aids for memorizing telephone numbers and other series of numbers, which is clearly an advantage; but their colored numbers may either help or hinder them when they perform arithmetic calculations.

For the nonsynesthete, calculating with colors seems harder to imagine than memorizing phone numbers by means of color associations. A number of skeptics may not be convinced by the way in which color arithmetic is done. Fortunately, color arithmetic has been investigated by scientific researchers, with surprising results. Mike Dixon and his colleagues have tested this type of synesthesia in a series of experiments. Their article on this subject, published in the journal *Nature*, was titled "Five Plus Two Equals Yellow."

The researchers used a variant of the Stroop Test to test a synesthete who perceives numbers in colors. The number seven is yellow for this synesthete. That means that her recognition of a seven in blue ink is slower than that of a seven in yellow ink. Having ascertained that, the researchers proceeded with a more elaborate Stroop Test and measured her reaction times to do a simple sum. The synesthete was shown a series of slides. Each slide showed a symbol: first "5," then "+," then "2," then "=." The last slide after this series showed a color patch: blue or yellow. The synesthete had to name the color as quickly as possible. When the color chip was blue, her reaction time to say "blue" appeared slower than when the color chip was yellow—her color for seven—and she responded "yellow."

While this synesthete was making a simple addition, her mental arithmetic was influenced by colors. Or was the mental arithmetic influencing her color perception? Three recent studies have shown that perceiving colored numbers

is a bidirectional process. A synesthete may only be aware of the perception that numbers evoke colors, but on an unconscious level the colors affect his or her number recognition, too.

In three independent studies, undertaken in Israel, Switzerland, and the Netherlands, simple arithmetic tasks such as choosing the highest of two numbers and making random series of numbers were presented to synesthetes. The experimenters had colored the numbers, some in "right" colors, according to the participating synesthetes, and sometimes a "wrong" color. As was expected on the basis of earlier studies with the Stroop Test, the physical color of the numbers interfered with the synesthetically induced colors of the numbers and this affected the speed of recognition of the numbers. Numbers in the "right" colors were recognized faster than numbers in "wrong" colors.

What makes these experiments so interesting is that they proved that numbers not only evoked colors in the synesthetes but that colors also evoked numbers. In all three experiments the participating synesthetes reported that normally numbers evoke colors in them, but never the other way around. Their performances on simple arithmetic tasks showed that on an unconscious cognitive level the colors influenced their decisions. Though the synesthetes experienced their synesthesia as unidirectional (numbers evoke colors), it was in fact bidirectional (colors also suggested numbers to their minds). These experiments showed that the synesthetes did indeed use colors in arithmetic tasks.

All the numerical experiments that I have discussed so far in this chapter test reaction times by synesthetes. Sometimes synesthetes are quicker than nonsynesthetes in arithmetic, in particular when the color helps them, and sometimes they are slower, in particular when a physical color interferes with their synesthetic color. Arithmetic is based not only on counting but also to a great extent on insight and recognition of structures and patterns. Do synesthetes have different insights or ways of understanding than nonsynesthetes? To answer this question, we have to take an excursion into the basics of pattern recognition, which has been playing an intriguing role in human perception for many ages.

Arabesques and Pattern Recognition

Since the Middle Ages, Arabic artists and artisans have been masters of designing visual patterns, called arabesques, that "pull the wool over our eyes." The

intricate patterns in these designs are like curious visual riddles, seemingly without solutions. From the carved-stone windows of Mughal palaces in northern India to the glazed tile walls of the Alhambra in southern Spain, this art form can be seen. These designs keep the eye busy by means of swiftly shifting patterns.

Figure 5.5 is a drawing of an arabesque. After gazing at it for a while, you begin to detect hexagons, stars, and zigzag lines. The patterns alternate with each other so you are seldom able to see two of them at the same time—at least not in the same spot. It is possible, in a small area, to see simultaneously

Figure 5.5 Drawing of arabesque used in a hewn-stone window in a Mughal palace in Agra, India.

a star with a hexagon right under it in the upper left corner, but in a larger area, once you find a shape and let it become your focus, the other shape disappears. You will see either a star or a hexagon, but never both at the same time. Figure 5.6, a modern variant of an arabesque, was designed by a perception researcher, who used this figure in visual experiments.

The viewer can hardly get a grip on the constantly changing enigmatic graphics before it changes into something else, and standing back doesn't help you figure out the way it works, either: all you see then is a flat plane with lines.

When the human eye meets an arabesque, it turns into a restless searcher for order. Keeping focused on the arabesque, the human eye nonetheless continues to look, it does not stop its search; it continues to look for a different pattern, as if it expects to find a more dominant order. This tendency is not a flaw in human perception but rather a vestige of an earlier mechanism to survive in the bush. Walking through a thickly wooded forest in the twilight, the human eye acts in the same manner. You see a crisscross pattern of leaves, branches, twigs, and other visible lines, and try to create a sense of order out of the chaos of the multiple visual impressions. Once your perception had ordered the surroundings, a different formation might suddenly have fallen

Figure 5.6 Visual puzzle used in contemporary perception research.

into your eye. Just as you were having difficulty spotting what was out there, you might have seen the form when it runs away—and you recognize the shape as that of a squirrel. The eye seems satisfied and stops searching, for a moment.

The nature of human perception can be described as a process whereby we seek out patterns in our environment to help us understand our world. When our senses respond to our environment, we are presented with a multitude of sensory impressions. If we considered each impression with equal attention, we would be overwhelmed and unable to make sense of our experience. So, how do we transform all those impressions into an ordered and comprehensive environment? How do we convert those sensations into a pattern we can understand? Apparently we have an ability to select out the "right" details in order to form the pattern that is the basis of our understanding or perception. Throughout the ages, artists have played with this characteristic of human perception, as we saw with the ancient arabesques that tease our brains; they give us enough information to find one pattern but not before tricking us into seeing another.

Recognizing that perception is driven by this need to find order, a group of German psychologists around the turn of the twentieth century revived an ageold idea on how human perception works. They argued that the human perceiver should no longer be compared to a passive organ recording countless light rays, comparable to a camera (obscura), as had been thought for centuries. Instead, they postulated that the human perceiver should be understood as an active pattern-searching person.

They soon became known as the Gestalt psychologists, named after their main subject of interest, the *Gestalt*, which in German means "shape," "contour", and is a reference to the ability of the senses to detect patterns in the physical world. Examples of gestalts are the circles you perceive when you look at figure 5.6, or the melody you can hear in a succession of musical notes, or the colored number 810 that David can perceive. Essentially, the perceptible quality of a gestalt is more than the sum of its parts.

The ideas of the Gestalt psychologists are still influential, for instance, in the theories by eminent contemporary synesthesia researchers such as Lawrence Marks, Richard Cytowic, Vilayanur Ramachandran, and Hinderk Emrich.

To illustrate this process of gestalt perception, have a look at figure 5.7. At first, your perceptual system organizes the black lines on a white

Figure 5.7 Pattern that at first sight is seen as a left-right symmetry, but that also contains a vertical symmetry.

background into a symmetrical ornamental figure. You do not recognize any known shape in it. It is only when you cover the lower half of the figure with your hand that a form is organized that you perceive as the letter *W*. And when you do the same with the upper half of the figure, you see a form that you recognize as the letter *M*. The *M* and the *W* are the initials of Max Wertheimer (1880–1943), one of the founders of the Gestalt movement in science. He designed this figure to demonstrate how the perceptual system has a tendency to spot symmetries in the environment. More precisely, it demonstrates that our perceptual system prefers left-right symmetries to up-down symmetries. That is why you probably did not see the two initials at first, because the left-right symmetry appears stronger than the up-down symmetry, which reveals the letters. In general, perceiving left-right symmetries has evolutionary advantages as well, since many objects in a natural surrounding, such as trees or another person, are left-right symmetrical and are immediately spotted as meaningful "gestalts" in the flood of sense impressions.

By now you might be thinking, what do these reflections on pattern searching have to do with a study of synesthesia? To answer, we should first look again at figure 5.3, the experiment designed by Ramachandran and Hubbard in San Diego. In the sea of characters in the black-and-white picture, it is quite

hard for most people, particularly nonsynesthetes, to perceive the difference between the 5's and the 2's, and even harder to recognize that they form a triangle because of where they are arranged. For some synesthetes who perceive numbers in color, it is immediately and easily apparent because the gestalt of the triangle of colored 2's lights up in a different color against a background of differently colored 5's. For them the shape of the triangle is therefore easy to discern. Synesthetes recognize the triangle faster because their brains pass them an extra clue, the differently colored 2's and 5's. Nonsynesthetes do not get this color clue. They see the triangle once they distinguish the 2's and the 5's in the field of symbols (see figure 5.15).

We have seen that synesthetes can recognize some patterns more easily and more quickly than nonsynesthetes when they view these pictorial artifacts, but does that special skill affect other aspects of their lives? What is the profit of such a pattern-seeking skill in daily living, I asked myself. I was surprised when synesthetes told me they use patterns of colored numbers to navigate through long number and time series.

Numbers in Space

Synesthetes perceive series of numbers not only in color, but in spatial forms too. They describe magnificent images of stairlike, clockwise, spiraling or sloping number series, sometimes up to infinity, sometimes turning like a roller coaster, returning to the beginning. Just as with colors, no synesthete sees the same spatial form; each has a personal image of colored number forms. Katinka Regtien, whose letter form we saw in chapter 1, has drawn a part of her colored number form in figure 5.8 (plate 10) and gives the following description of it:

The number line starts at the bottom. Zero is the first number; up to the left, sits number one, and at the same distance apart, comes two; three is in a bend, and four stands above and to the right of three. All numbers below zero, like minus one, minus two, et cetera, are spatially under zero. Since the number form is principally infinite, it is impossible to view all numbers at the same time. I can view about twenty numbers simultaneously. When I want to see numbers between fifty and sixty, I zoom into that place. I know in which bend I have to look for them, because of the color; in this case, it is a blue area. First, I see the colored form and afterwards the numbers. The color of the numbers above twenty is determined by the first digit. In the case of twenty,

Figure 5.8 Part of Katinka's colored number form. See plate 10 for color version.

the two is yellow. Therefore, all numbers in the twenties have a dominant yellow color. The color of the second digit is of minor importance.

David Bisschop Boele, whose colored numbers we saw in figures 5.1 and 5.2, also perceives—days, months, years, and decades—in color. He presents some impressions in paint (figures 5.9 [plate 11] and 5.10 [plate 12]) and words:

The colors have been invariably the same for as long as I can remember. My mother and brother perceive colored weekdays, too, but in different colors. By the way, the

Figure 5.9 David's colored weekdays. See plate 11 for color version.

blue line at the left is the Sunday of the week before. It belongs to the image according to my feeling. When I think of my agenda for the coming days, I always see this image in my mind's eye and I can fit my appointments into it. It helps me to see the colored timeline and to know where I am in time.

The colors of the decades [figure 5.10] are associated with the colors of the numbers, but the colors are somewhat modified by feelings for the decades or how the decades felt at the time. The 1980s are muddy yellow because of the associations with Punk (black and blue), the neutron bomb (lemon yellow and black), unemployment (gray), and the futureless situation. My image of the decades has a kind of form. I am outside the shape, but my position in front of the different decades is not always the same. I look always backwards to the fifties, but ahead to the 1970s. I am standing below the [horizontal line of the] 1980s and on top of the 1990s and before the after-2000 line. So, my position cannot be defined by my year of birth or the current date. Furthermore, the seasons and the months of the year have colors too: September and December are greenish, January is transparent, February pale yellow, June and July are brighter yellow, August is dark red, May is blue, and March is a gloomy, dark gray-blue.

Figure 5.10 David's colored decades. See plate 12 for color version.

You don't have to be a synesthete to be able to perceive number forms and time forms. Some nonsynesthetes also perceive them. Rosanne van Klaveren does not perceive numbers in colors but has clear spatial representations of number forms (figure 5.11).

My number line is quite complex, on both the positive and negative side. The number 3,225, for instance, has another position in space than, say, the number 625. As long as I remember, I always had a kind of scheme in my head for everything that had to do with numbers, letters, or time units. I assume that it has developed along with my learning of the these digits and units.

When I learned the numbers one to ten, I threaded them on a my personal wire. The numbers eleven and twelve got their place at the right-hand side, where they filled the space together with other tens that I already knew. Now, all numbers have had their own place in the space for years, and I can zoom into or out of the mental image.

The number form is always present when I am doing sums. When I add 239 to 603, I immediately see their positions for my mind's eye. Numbers such as 600 lie much higher and more to the left than numbers in the beginnings of 200. First, I "jump" in my scheme to the 800, which lies higher and more to the right from where I start, and then I zoom into the image until I reach 842. That might sound very laborious and time-consuming to others. But for me it is not. It is an automatic process and it helps me. I don't think it is a mnemonic aid that I learned myself one day, because only later in life did I realize that other people were not using these types of schemes. Finally, I did not need to learn aids because I was not bad in arithmetic; in fact I was the best of my class, perhaps due to this scheme.

By the beginning of the twentieth century, the British scientist Sir Francis Galton (1822–1911) had started studying number forms. He included some examples of his subjects (figure 5.12) in his book *Inquiries into Human Faculty and Its Development*. He discovered that his subjects were using unusual number patterns—not the well-known straight mathematical X-axis—while they were counting and doing sums. Furthermore, he noticed that the distances between numbers varied and that important numbers such as multiples of ten and birth years had special places in the forms.

Now we know that many people, about one in ten, use these number forms in arithmetic—sometimes without being very aware that they are doing so. You can figure out whether you are using number forms by trying to imagine

Figure 5.11 Rosanne's number form.

Figure 5.12 Examples of number forms that were recorded by Francis Galton (1907).

a visual depiction of, for instance, the numbers 0 to 100. If you can draw it on paper you probably have a number form.

Visual Thinking

Colors and forms appear to be important elements in everyone's thinking, or cognition, not just that of a small group of synesthetes. I think synesthesia is linked to a kind of thinking that is called visual thinking. First I will

| Geometric Solution | Algebraic Solution |

$(a + b) (a + b) =$

$a \times a + a \times b +$

$b \times a + b \times b =$

$a^2 + 2ab + b^2$

a² ab

a a²

b ab

b²

Figure 5.13 Visual or geometrical, left, and algebraic, right, explanations of a mathematical equation.

explain what visual thinking is by comparing it with a more classical view of the thinking process.

Take the mathematical equation

$(a + b) (a + b) = a^2 + 2ab + b^2$

This solution to this equation can be taught in an algebraic way and in a geometric way; the former is shown on the right side of figure 5.13 and the latter on the left. Which one do you prefer? Which one more rapidly gives you a glimpse of insight, as in, "Oh, that's how it works!" The ones who prefer the explanation on the right side are "stepwise thinkers," whereas the ones who prefer the left side are "visual thinkers." If you belong to the latter group, you will have a preference or a tendency to visualize problems and puzzles when you are asked to solve them. Visual thinkers will use their visual sense but perhaps also other senses and feelings to order and solve the puzzle.

Two famous physicists, Albert Einstein (1879–1955) and Richard Feynman (1918–1988), used visual thinking to solve theoretical puzzles in physics. The psychologist Max Wertheimer, whom we met before, studied the productive thinking of his friend Albert Einstein, with whom he spoke for hours on the discovery of the theory of relativity. He asked Einstein what his original theoretical problem was and what choices he made in solving the puzzle. Einstein told him that he tried for a long time to solve the puzzle and even got depressed when he did not succeed. Finally he made a breakthrough, not by logical deductions but by visualizing the puzzle. He imagined the elements of time, space, and velocity in a spatial constellation in his mind's eye. He changed their positions several times. The final insight came from a so-called gestalt switch, a reordering of existing elements that suddenly produce a new meaning. A popular example of a gestalt switch is the duck-or-rabbit figure. The lines or elements of the drawing are the same, but suddenly the viewer can find the picture of a duck changing into a rabbit and back into a duck again (figure 5.14).

The American physicist and Noble Prize winner Richard Feynman perceived mathematical formulas in color long before he was aware of being a synesthete. "When I see equations, I see the letters in colors—I don't know why. As I'm talking, I see vague pictures of Bessel functions from Jahnke and Emde's book, with light-tan *j*'s, slightly violet-bluish *n*'s, and dark brown *x*'s flying around. And I wonder what the hell it must look like to the students."

Figure 5.14 Example of a gestalt switch. Perception switches between the image of a duck and a rabbit.

To the public, he was always well known and popular for his visual style of thinking.

The visual thinking by these two great scientists has a connection to the thinking of artists. Visual artists are often reorganizing visual elements to find new visual gestalts. Both artists and scientists try to solve technical problems by ordering the constituents in another way. Thinking and perceiving are very close in visual thinking.

To return to the gestalt theory, human perceivers are searchers for meaning and actively reorganize their impressions until they discover meaningful figures or objects. In fact, human perception is a creative faculty that tries to understand the person's environment by ordering and reordering, looking for meaningful gestalts. This is quite an automatic act, only partly influenced by the human will.

Several thinkers, including the neuropsychologists Ramachandran in San Diego and Hinderk Emrich in Hanover, Germany, have assumed that synesthesia is indeed a creative tool for human consciousness. Synesthesia shows new gestalts in the stream of consciousness.

A fine way to demonstrate this phenomenon is to look at a nonfigurative painting you have never seen before. The moment you remove your preconceptions of what you are going to see, you will start to come up with meanings you would not have not found otherwise. This automatic act of our perception brings us to something we all do, which is called "looking at things from a different angle" or "taking a second look," which is a basis of human imagination.

I seem to have wandered very far from the discussion of synesthesia, but in fact, I have come full circle and am returning to where this discussion started: the thinking of the synesthetes who were doing sums with colored number forms. Now, I realize that they have a special kind of visual thinking. They have reordered the elements of numbers, colors, form, space and logical relations into number forms as new meaningful gestalts for them. Like other visual thinkers, they have crossed the classical watershed of sensing and thinking. They are in a class of extraordinary thinkers.

Extraordinary Thinkers

How eccentric are synesthetes in their perceptions and modes of thinking? Unlike most people, many synesthetes perceive colored numbers, and some

synesthetes even use colored numbers to calculate and plan their agendas. Synesthetes can perform some tasks, such as the visual puzzle shown in figure 5.3, faster than nonsynesthetes because their colored numbers give them clues. When it comes to other tasks, such as mental arithmetic, some synesthetes are consistently faster at calculating where as others are consistently slower because of the same trait.

Although the synesthete's ability to calculate in color might seem like the skill of a mathematician from Mars, synesthetes actually use the same logic as nonsynesthetes. The difference is that the colors enable them to use more mental aids. Their method of reasoning is comparable to a kind of logic that is also used by many nonsynesthetes, called "visual thinking." I suspect that all synesthetes are visual thinkers, but not all visual thinkers are synesthetes.

Visual thinking involves the use of imagery to solve puzzles, and I think that synesthesia is a type of visual thinking that uses colored imagery to solve puzzles. As we saw earlier, Rosanne van Klaveren—who is a typical visual thinker, but not a synesthete—uses a number form in black and white to solve arithmetic tasks. Katinka Regtien, a synesthete, also uses number forms, but her numbers are colored. She uses not only the position of the numbers in the number form but also their colors to do mental arithmetic. Therefore, I would consider color synesthesia a special type of visual thinking: colored visual thinking.

Though I lack the gift of perceiving numbers in colors, I recognize visual thinking as a method of problem solving that I use myself. I understand complex scientific problems more easily when I draw them in elements on paper or when I can make a mental spatial representation of them. In my daily work as a researcher, I sometimes develop statistical models. When I try a new approach, I often first make sketches of the components of the models and the equations. I love to draw them in constellations that remind me of molecular structures or the Atomium building, built for the Brussels World's Fair in 1958. It is my good fortune that a new statistical software package has been released that offers users a tool to develop a statistical model by drawing spheres and arrows. When drawing, I order and reorder the elements and relationships of my model while the software does the calculations.

Even as a writer, I use mental forms to order and structure my text, especially when I am restricted to a limited number of words for an article. Once

I wrote an article on a complicated subject by keeping a grid painting by Mondrian in the back of my mind. Picturing its configuration helped me to organize the material. I have also borrowed the forms of crystal and diamond structures to get texts clearer, thorough, and, it is hoped, still sparkling. In those cases, I can feel the form in my hands, which reminds me of the tactile sensations I experienced on hearing the coils in Vivaldi's violin concerto as well as my tactile visions in elementary school. Now, I realize that I quite literally "grasp" impressions of scientific problems, music, non-figurative painting, odors, and tastes as I come to find meaning and understanding. Insight is the result of this experience of shaping a form that I can see in my mind and mentally feel in my hands or skin. I use a type of visual thinking that is similar to that of synesthetes, only mine has no color associated with it.

Visual thinking is related to metaphor and figurative thinking, which raises the question whether synesthetes can be considered metaphorical thinkers. In the next chapter, I want to find an answer to this question by consulting the specialists in the field of metaphor: poets and linguists.

Figure 5.15 Solution of Figure 5.4. People who project colors on perceived numbers see this pattern, or gestalt, immediately. (Ramachandran and Hubbard 2001, used with permission.)

6

Poetic Synesthesia

Could synesthesia be a kind of metaphor? Metaphors are verbal tools we use to grasp unknown experiences in terms of known experiences. Take for example, the statements, "God is love" and "The human memory is a computer." Religious experiences and the mysterious way that our memory works are both difficult phenomena to understand. People are able to get a better grip on such phenomena when they compare them with familiar experiences like the experience of love (in the case of God) and the basics of computer memory (in case of the mind). God is intangible; love we all know. The workings of the human memory are hard to comprehend, but we can understand the ability of a computer to retain data and store it on a hard disk. These metaphors have a cognitive function in our thought: they help us to understand, organize, and speak about experiences that are not well understood or easy to describe.

Synesthesia does not really fit into this description of metaphors. First, synesthetic perceptions are not verbal but experiential. For instance, synesthetes do not have to label sounds with verbal color names to experience colored sounds. Second, having synesthetic perceptions is not like having a theory of something. Synesthetes do not have a theory that sounds are associated with colors, they simply perceive sounds in colors. Synesthesia is a way of perceiving and not a way of conceiving. It does not resemble the deliberate constructing of concepts in metaphor use.

What, then, is the relationship between metaphor and synesthesia? A link may be a special category of metaphors, call them "synesthetic metaphors,"

that already exist in the language and that we take for granted, like "sharp cheese," "bitter cold," "loud colors," or "dark sounds." To make my initial question more specific: Is synesthesia a form of synesthetic metaphor?

Synesthetic metaphors are figures of speech in which meanings are transferred from one sensory domain to another. We all know what is meant by "a dark sound," whether we are naturally synesthetic or not. But only in a synesthete will the sound of a double bass evoke the perception of dark color.

So, is it the difference between understanding and perception that distinguishes synesthetic metaphor from synesthesia? For instance, is it the difference between having a theory that sounds are associated with colors and actually perceiving sounds in colors that makes the difference? In mystical theories of the universe, just to pick one example, color-sound correspondences are used as a theory in an attempt to understand the universe, whereas for synesthetes, the color-sound correspondences are directly perceived. Mystics can adapt their theories of color-sound correspondences, but synesthetes cannot.

So far, we can consider a synesthetic metaphor as a way of speaking that matches a feeling for a nonsynesthete, and that might be a true perception for a synesthete. This is an interesting thesis that I want to employ in the worlds of synesthetic and nonsynesthetic poets and novelists.

Synesthesia in a Character

I start with the world's most famous synesthetic poet and novelist, the Russian-American writer Vladimir Nabokov (1899–1977). What did Nabokov say about his synesthesia? And did he use it to generate literary figures of speech? Did he mold his synesthetic perceptions into synesthetic metaphors that he could use in his writing?

Fortunately, he left us a record. Unlike other famous writers to whom synesthesia has been attributed—including William Faulkner, Virginia Woolf, James Joyce, and Dylan Thomas—Nabokov described his synesthetic gifts in detail. He devoted a large part of a chapter to the subject in his autobiography, *Speak, Memory* from which I quote some passages:

As far back as I remember myself (with interest, with amusement, seldom with admiration or disgust), I have been subject to mild hallucinations. Some are aural, others are optical, and by none have I profited much. . . . I present a fine case of colored

Plate 1 Synesthete Katinka Regtien perceives the alphabet in colors and spatial forms. In collaboration with designer Beata Franso she created this visual representation. (Reproduced with permission.)

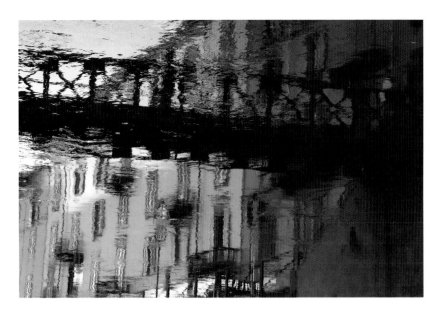

Plate 2 Marcia Smilack, **Vibrato Bridge**, 2004. (Reproduced with permission.)

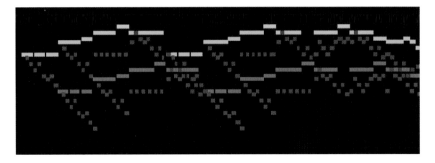

Plate 3 First measures of J. S. Bach's **In Dulci Jubilo**, from **Das Orgelbüchlein**, as shown in the Music Animation Machine. (www.musanim.com; reproduced with permission.)

Plate 4 The first measures of Beethoven's Fifth Symphony as represented in the Music Animation Machine. (www.musanim.com; reproduced with permission.)

Plate 5 Carol Steen sees colors induced by acupuncture. The painting **Full View** reflects her experience while the needles are being removed. (Reproduced with permission.)

Plate 6 Painting of music by children of four to six years old. (Collection of Cretien van Campen and Clara Froger.)

Plate 7 Anne Salz, Vivaldi, 2003. (Reproduced with permission.)

Plate 8 David's colored numbers.

Plate 9 David's colors of compound numbers.

Plate 10 Part of Katinka's colored number form.

Plate 11 David's colored weekdays.

Plate 12 David's colored decades.

color space =

color tone + saturation + lightness

Plate 13 Scope of perceivable colors, according to the Natural Color System and its constituent dimensions: the round system of color tones, the horizontal axis of saturation, and the vertical axis of lightness. (Adapted from www.ncscolour.com; used with permission.)

Plate 14 Colored letters. The sound of the nonsense word "stroep" painted by synesthetes Dorine Diemer, above, and Pauline Jansen, below. (Collection of Cretien van Campen and Clara Froger.)

Plate 15 Colored flavors. Paintings by synesthetes Wioleta Reglin, above, and Pauline Jan-sen, below, after tasting coffee. (Collection of Cretien van Campen and Clara Froger.)

hearing. Perhaps "hearing" is not quite accurate, since the color sensation seems to be produced by the very act of my orally forming a given letter while I imagine its outline. The long *a* of the English alphabet (and it is this alphabet I have in mind farther on unless otherwise stated) has for me the tint of weathered wood, but a French *a* evokes polished ebony. This black group also includes hard *g* (vulcanized rubber) and *r* (a sooty rag bag being ripped). Oatmeal *n*, noodle-limp *l*, and the ivory-backed hand mirror of *o* take care of the whites. I am puzzled by my French *on* which I see as the brimming tension-surface of alcohol in a small glass. Passing on to the blue group, there is steely *x*, thundercloud *z*, and huckleberry *k*. Since a subtle interaction exists between sound and shape, I see *q* as browner than *k*, while *s* is not the light blue of *c*, but a curious mixture of azure and mother-of-pearl. Adjacent tints do not merge, and diphthongs do not have special colors of their own, unless represented by a single character in some other language (thus the fluffy-gray, three-stemmed Russian letter that stands for *sh*, a letter as old as the rushes of the Nile, influences its English representation).

Nabokov discovered in his early years that he perceived letters in colors. Probably, after reading a medical article on the subject, he began to consider it a neurological abberation.

The confessions of a synesthete must sound tedious and pretentious to those who are protected from such leakings and drafts by more solid walls than mine are. To my mother, though, this all seemed quite normal. The matter came up, one day in my seventh year, as I was using a heap of old alphabet blocks to build a tower. I casually remarked to her that their colors were all wrong. We discovered then that some of her letters had the same tint as mine and that, besides, she was optically affected by musical notes. These evoked no chromatisms in me whatsoever.

Nabokov's mother was synesthetic too (as is his son, Dmitri), but Nabokov did not inherit all the synesthetic abilities of his mother, like hearing music in color. In addition, although they both perceived colored letters, they differed on the colors.

In his life as a Russian refugee, he lived in Germany, France, the United States, and Switzerland, and he wrote in several languages. Though he was a linguistic genius, he did not translate his synesthesia into synesthetic metaphors. Instead, his "aberration" sometimes pops up as an oddity of a character in his novels and poems.

In Nabokov's semiautobiographic novel *The Gift*, which explores his time as a refugee in Berlin in the nineteen twenties, the principal character, a young poet named Fyodor, discusses his synesthetic abilities and describes them with the French expression *audition colorée*, (colored hearing) which was the common scientific term for synesthesia in Europe in that time.

For instance, the various numerous *a*'s of the four languages which I speak differ for me in tinge, going from lacquered-black to splintery-gray like different sorts of wood. I recommend you my pink flannel *m*. I don't know if you remember the insulating cotton wool which was removed with the storm windows in spring? Well, that is my Russian *y*, or rather *ugh*, so grubby and dull that words are ashamed to begin with it. If I had some paints today I would mix burnt-sienna and sepia for you so as to match the color of a gutta-percha *ch* sound.

In his first English novel, entitled *Bend Sinister*, published in 1947, a character named Adam Krug explains that "the word 'loyalty' phonetically and visually reminds him of 'a golden fork lying in the sun on a smooth spread of yellow silk." In another of his English novels, *Ada*, Nabokov's main character, Van, has a special synesthetic sense of time: "I delight sensually in time, in its stuff and spread, in the fall of its fold, in the very impalpability of its grayish gauze, in the coolness of its continuum." Van calculates in colors, as with the colored intervals of the weekdays. He uses his time colors in planning and memorizing.

Nabokov used synesthesia as a characteristic for some of his characters who have synesthetic perceptions now and then. He certainly does not use synesthesia as a figure of speech, a type of metaphor, or a worldview. Synesthetic perceptions are facts for the characters in his novel, not ways to understand the unknown. Synesthesia is to Nabokov what it is to many neurologists nowadays, an aberration of the brain that produces peculiar but harmless perceptions such as photisms with the sounds of letters.

Have other self-declared synesthetic poets used their gifts as a metaphor? In my homeland, I came across the work of the contemporary Dutch poet Tsjêbbe Hettinga (born 1949) who writes in his local Frisian language. He once referred to himself in a lecture as "a chronic case of synesthesia." Later, the poet—who happens to have poor eyesight—told the journalist Corine Vloet about his synesthetic perceptions:

Since my early youth my senses seem to have lain very close to each other, so that sensory impressions interchange easily. At every sound, smell, feeling I get an image and a color. That has nothing to with bad sight; it is in my head.

The choice of words in his poems is influenced by the colors they evoke. In the Frisian phrase, *"slim simmer"* (cruel summer) in the poem "De blauwe havik van Wales" ("The Blue Goshawk of Wales"), he perceives the words as a "blaze of a silvery color"; in the following poem he sees the sounds of the letter *I* as "becoming thin and whooshing away into the light and disappearing, flying away." Below are the first sentences of the original Frisian poem and my English translation.

It is slim simmer,
En de sinne winkt dizze
middei mei it ljocht dat
earst
Op de griene harpen fan
'e heuvels syn grûntoan
fynt

It's a cruel summer,
and the sun hails this
afternoon with the light that
finds his tonic
just here
on the green shackles
of the hills.

Hettinga uses his synesthesia in choosing words for a poem but not in a metaphorical way or as a manner to produce metaphors. Neither Nabokov nor Hettinga has compared his synesthesia to metaphorical thinking. Nor have they used the advantage of being synesthetic to construct new synesthetic metaphors. The relationship between synesthesia and synesthetic metaphors is nonexistent in their work.

However, synesthesia does play a role in the use of synesthetic metaphors for nonsynesthetic writers who have explored it extensively. I will tap again the poetry of my homeland.

Arms on My Brains

If synesthetic metaphors do not flow from the floating pens of synesthetic writers, then how is synesthesia related to the use of synesthetic metaphors by poets? For ages, it has been the métier of many poets to find the right synesthetic combinations that best express sensory experiences. Poets like to use synesthetic metaphors because they provide a precise, concise, and pleasant way to express physical and sensory feelings, as the Dutch poet Hans Andreus (1926–1977) did in his book of poetry *Liggen in de zon* (*Lying in the Sun*), published in 1951 (my translation):

I hear the light the sunlight pizzicato
the warmth speaks against my face

Andreus was a member of the Dutch "Group of Fifty" (*De Vijftigers*) who revalued the sensory and the physical in poetry in the nineteen fifties. In their poetry they returned to sensual body impressions and studied them in detail, as if they were anatomists of human feelings. This resulted in a kind of poetry that had a disordering effect on the experiences of readers. They made experimental poetry in the true Latin meaning of the word *experientia*, which means "experiential" as well as "experimental." According to a member of this group, Gerrit Kouwenaar, their poetry is characterized by the premise that "the body, the sensory experience and all that is connected by a social, biological, and psychological rubber band." And they often encountered synesthesia on their path of experimental explorations of sensory experiences.

In his book *Lichamelijkheid in de experimentele poëzie* (*Corporeality in Experimental Poetry*), the linguist Hugo Brems even presents statistical proof for the statement that the Group of Fifty used more synesthetic metaphors than other poets in literary history. Brems provides many examples that contain correspondences between sensory impressions. In the case of Hans Andreus, the tactile sense is often the receiver of stimulation of other senses, as in the phrase "listening with the body," when the skin feels auditory impressions. Guillaume van der Graft describes the same feeling when he says "We listen with our hands." Jan G. Elburg tastes and feels thought in the line "Thinking with tongue and hands." Remco Campert feels images on his skin when he writes "Before the clear day moves its healing hand over my skin."

Hans Andreus is a champion in the sheer number of his uses of synesthetic metaphors among the Group of Fifty, according to the statistical analyses by Brems. Andreus's first publication of a collection of poems in 1951 is entitled, typically rather than coincidentally, *Muziek voor kijkdieren* (*Music for Looking Animals*). It contains a variety of synesthetic metaphors that, remarkably, refer less to correspondences between sight and hearing, as the title suggests, and more to the tactile sense in the skin.

The rain of call as you want no rain
is heard by no ear is heard by the skin

Besides the tapping of raindrops, which is felt so penetratingly on the skin, Andreus most often feels the visual impressions of light on his skin, as in the lines on the rythmically speaking sunlight. The poet slowly abandons the traditional distinction between the five senses and describes the mingling of sensory impressions: light is heard and speech is felt in the skin at the same time. The impression of light is received simultaneously by several senses, evoking perceptions of rhythmic sounds (pizzicato), speech sounds, or laughing sounds, as in the following poem.

Contagiously the Round Loud Laughter of the Light
Light
give me
to drink
of your
firewater
I am
dying of
thirst

According to Brems, the members of the Group of Fifty considered perception to be synesthetic in essence, in other words, sensory experiences are mingled and are not separate, as we are used to thinking of them. Instead, the senses form a unity like the single body of which they are part. If one part is stimulated, it is felt in other parts of the body, too, in the same way that a stone thrown in the middle of a pond ultimately causes a stir via expanding circles in all parts of the pond.

"No poet of this group denied the fundamental role of synesthesia in the recreation of the original bond of man and world," says Brems. Or, as one of the Group of Fifty poets, Simon Vinkenoog, states more specifically in his poem "Braille":

How green the grass is, one never learns by solely looking at it; its lushness, freshness, its floundering lust for life that permeates that greenness, should be felt by the fingers, as a whole and touched so deeply that the fingers become part of it.

This idea of the body as the source of perceiving and knowing the surrounding world was inspired by the then recently published philosophy of perception of the French philosopher Maurice Merleau-Ponty (1908–1961). Campert expresses the shared idea pithily in the phrase "I have got arms on my brains."

Merleau-Ponty states that synesthetic metaphors such as "loud colors" or "sharp cheese" are abstractions from a preconscious unified synesthetic experience. In his classic book, *The Phenomenology of Perception* (1945), he compares preconscious perception to a state of flux where all impressions are still a unity, something that with our current knowledge of neonatal research can be compared to the "primordial sensory soup" of babies (described in chapter 3). His ideas were inspired by the German theory of gestalt perceptions (discussed in chapter 5).

In fact, Merleau-Ponty assumed that every person is able to have synesthetic perceptions. According to him, synesthesia and synesthetic metaphors have a common ground in the unified preconscious perception. They are both gestalts that emerge from the preconscious flux into conscious perception. Though different in character, both types of perception are labeled by persons with distinct abstract words from the sensory vocabulary available ("sounds," "images," "flavors," and so forth). Merleau-Ponty argues that the moment we start to become conscious of our environment, we immediately start to abstract discrete sounds and colors from this flux of consciousness. To talk about synesthetic perceptions and synesthetic metaphors people use language that reflects the current theory of the five senses. The use of language separates the originally undivided experience into multiple sensory perceptions according to the distinct sensory domains of hearing, vision, touch, and so on.

To understand the experiential basis of synesthetic perceptions and synesthetic metaphor, we should first consider how and into how many sensory domains the human perception is divided by language and culture.

How Many Senses?

In common parlance, we do not refer to our senses as a single unit, as the Group of Fifty and Merleau-Ponty did. For ages, we speak of the senses as five separate channels (figure 6.1), each of which carries one type of impression into our brains: the optic channel carries our visual impressions, the ear channel carries the sounds, the channels attached to the tongue and mouth carry tastes, those of the nose carry smells, and the nerves under the skin carry tactile impressions to the brain. People typically attribute their impressions to one of these well-known five senses and take this classification for granted; but anthropological studies point out that this division is largely culture dependent.

Figure 6.1 Engraving of the five senses by J. Nathan. (Teylers Museum Haarlem, the Netherlands.)

In the 1980s, the Dutch physician Albert Soesman identified twelve senses. Inspired by the early twentieth-century anthroposophical ideas of Rudolf Steiner on sensory development in the child, Soesman described seven additional senses, including a sense of self-movement, a sense of equilibrium, a sense of temperature, a sense of speech, a sense of imagination, a sense of life, and a sense of the self. These labels may look a bit contrived, but are all very recognizable when he describes them. For instance, the sense of self-movement can be felt easily when you move with your eyes closed.

By scrutinizing daily sensory experiences, Soesman discovered, with apparent ease, twelve senses. Actually, we know from scientific research that there are even more human senses, over twenty at the least, according to a recent scientific article published in the *New Scientist*, and the number is even higher when animals are included. Surveying the range of possible senses, we may conclude that human experience is multifaceted—reflecting a true empire of the senses.

The common but rough classification of the five senses is based on physically visible sense organs: eyes, ears, nose, tongue, and skin. However, these external structures are only a small part of these five sense organs, which extend along nerves into brain areas. For instance, the eye we see does not itself see, nor does it experience visual impressions. The process of vision includes more body structures, starting with the eyeball, where an inverted image is registered on its inner posterior side; information on the image (not a picture!) is transported through the visual nerves to the visual areas in the brain, where it is processed with the help of memories, expectations, and emotions, and adjusted according to the position of the head and the body, before it becomes something that we can see: a visual experience. Many parts of the body are actually involved in the making of a visual experience.

The division of sensory experience on the basis of physical external characteristics (eyes, nose, etc.) into five sensory domains is somewhat misleading, to say the least. Twelve or twenty-two senses are arbitrary divisions, too. Soesman and other sense researchers stress that the senses cannot be isolated but should be considered and understood in their relationships to one other, reflecting Merleau-Ponty's idea of a common preconscious experience. They all cooperate—for example, smell, taste, touch, vision, and sound cooperate when you eat an apple.

Synesthetic Indians

Anthropologists have found that other divisions and elaborations of sensory experience obtain in non-Western cultures. In *Worlds of Sense*, Constance Classen relates how the Desana Indians of the Amazon area of Colombia regularly perceive the world in a synesthetic fashion. The notion of "color energies" is central to their cosmology. Color energies are a basic symbolic system that organizes sensory experiences. The Desana perceive their daily environment in categories of this system. Of course, the Desana know the sense characteristics of eyes, ears, and so on, but they do not separate them in their perception of the physical world. Instead, they perceive all sensory impressions in terms of the basic color energies. For instance, according to the Desana, smells are a composition of color energies and temperature.

Their aesthetic appreciation of good craftsmanship—say, of a braided basket—depends on the impression of its color energy, of an interplay of a sensory amalgam of qualities: weaving, texture, smell, taste, and so forth. Certain whistles, which the Western ear perceives as sound to the Desana comprise a mixture of a powerful yellow color, a very hot temperature, and a male odor, according to reports by tribe members.

Perceptual experience is not divided into five separated senses by the Desana, as it is for by Western perceivers. When a Westerner is exposed to a physical stimulus, say, a whistle, he or she "hears" a sound with the ears. The same whistle evokes in a Desana a range of impressions in different sensory domains. They not only "hear" the sound but also "see" its color and "feel," its temperature. Therefore, the Desana may be one of the few synesthetic cultures, where sensory impressions are more integrated, or at least less separated, than in the West.

By the way, the development of the typical sense system of the Desana may be related to the tribe members' daily drug use, which has paramount meaning in their lives. They ingest the *ayahuasca* vine, which contains a hallucinogen known for its enhancement of cross-sensory perceptions in nonsynesthetes.

These studies show that the division of human experience into two, five, twelve, or twenty-two senses depends on the culture one lives in and is hardly a natural or biological fact. The empire of the senses has been divided into provinces throughout history and in many places. That does not mean that people with different sense systems live in different worlds that do not communicate. Persons from cultures with different sense systems can

communicate on basic perceptions of images, sounds, and food. The differently named and represented perceptions often turn out to have a common ground. A visitor among the Desana may say that the food has a good smell and taste and the host may communicate that its color energy is good, but in the end, they agree that they have shared a good meal.

Channeling Sensory Impressions

Historical, anthropological, and biological studies have shown that the boundaries between domains of sensory experiences presumed by Westerners are not actually fixed but are flexible and are set by cultural practices. In the Western world, we have accustomed ourselves to the concept of five external physical sense openings where impressions enter the human body and, separate from each other, travel through nerve channels to the brain. Using that model, it is very difficult to imagine how synesthesia can happen. It looks like an error in the system of the senses.

A change of theory of the senses can shed a different light on synesthesia. While synesthesia is an abnormality in terms of the Western, channel, model of the senses, it is natural in the worldview of the Desana, where all sensory impressions are parts of undivided "color energies." Every impression in the latter model is essentially synesthetic.

Models of the senses vary across cultures. Various symbol systems have produced various divisions of the senses. The preconscious unified experience of the environment, as described by Merleau-Ponty, is mapped into two, five, twelve, twenty, or more sensory domains by our conscious perception, which is preprogrammed by the symbol systems of our culture. The preconscious experience of the environment is a synesthetic state without boundaries. It can produce synesthetic perceptions as well as synesthetic metaphors, which explains why the two phenomena are indirectly related: they have a common ground.

What is that mysterious preconscious experience? Do we have conscious access to this state? Can we become aware of it? In the next chapter I continue with discussions of poets, but I will focus especially on nineteenth-century poets who assumed they could reach the original state of synesthetic flux by using drugs and hallucinogens. Or, to put it differently, is it coincidence that the synesthetic outlook of the Desana is part of a culture that includes ingesting the hallucinogenic *ayahuasca* vine?

Exploring Drug-Induced Synesthesia

Do people start to perceive the environment in a synesthetic way when they take hallucinogenic drugs? And if so, does that mean that all users of hallucinogenic drugs become synesthetes? In my search for the nature of synesthesia, I asked myself this question: Is the condition of synesthesia a kind of drug-induced hallucination? And if it is, can drugs evoke or influence synesthetic perceptions?

The use of drugs is often associated with the consciousness-expanding experiences and heightened sensibility described in religious revelations and visions of utopia. The effects of depressant, stimulant, and hallucinogenic drugs on human perception and thinking is a well-studied subject, as evidenced by the large volume of publications. Browsing through this literature, one finds references to drug-induced synesthesia in two rooms of the library: the science and literature rooms.

In the literature room I was able to follow with delight the tracks of poets and novelists as they took their perceptual experiments to the edges of human experience, especially in nineteenth-century Western Europe, which is a rich period for material. Often I read wild-sounding descriptions by poets proclaiming the merits of their drug-induced synesthesia, and then I'd switch to science and read the pharmacology and neurology of the same experience and compare notes. The writings in both sections made it clear to me that there is definitely a special relationship between drugs and synesthesia, but that relationship turns out to be quite different from what I expected.

Opium Eaters

In eighteenth-century England, opium was considered a normal medicine and was used in much the same way that people use aspirin today: opium was considered a good remedy for pain, fatigue, and depression and could be obtained at the local shop. It was also the drug of choice for dealing with sleep difficulties. Not surprisingly, a growing group of opium addicts emerged in eighteenth-century English society who were as well known on the streets as drunkards.

Several English writers and poets of the Romantic period wrote about their opium experiences, including Thomas de Quincey, Samuel Taylor Coleridge, John Keats, George Crabbe, and Francis Thompson. Their descriptions sometimes include visions that remind me of contemporary reports by synesthetes. For instance, the poet and opium addict Francis Thompson (1859–1907) noted on one occasion that he saw the sun rise "with a clash of cymbals"; on another occasion, he described how "tunes rose in twirls of gold" when "light through the petals of a buttercup clanged like a beaten gong." He also heard "the enameled tone of shallow flute, and the furry richness of clarinet."

Many of these poets romanticized the virtues of taking opium. Samuel Taylor Coleridge (1722–1834), for one, proclaimed that his poem "Kubla Khan" was composed in a flush of opium-induced inspiration; when he woke up, all he had to do was write it down.

Thomas De Quincey (1785–1859) distinguished himself by studying the effects of his opium intake, which he drank in the form of laudanum, a tincture of opium. By means of this self-study, he introspectively investigated the effects of the drug on his perceptions, hallucinations, and daydreams and reported his "findings" in *Confessions of an English Opium Eater*, published in 1821.

De Quincey concluded that opium-induced visions were produced by the dream faculty in the human mind. He believed that the intake of opium stimulated the dream faculty, which in a waking person produced memories and emotions in symbolic patterns that are seen under the influence of the drug. He called those experiences "involutes."

According to De Quincey, an involute is a complex feeling made up of memories, impressions, and symbols that involuntarily appear to the mind's eye. The way he presents the "involutes" makes them sound to me like synesthetic perceptions in which sensory elements such as images and sounds mix

to form new perceptual unities. Unfortunately, however, De Quincey was not very specific in his descriptions, so they could be taken as either intellectual constructs or synesthetic perceptions. Fortunately, other drug-experimenting writers were more specific in their descriptions of drug-induced perceptions and I found some notes that resemble our current notions of synesthesia.

Murmuring Twilight

The writer Edgar Allan Poe (1809–1849), a contemporary of De Quincey who lived in various cities on the East Coast of the United States, produced an impressive oeuvre that explored the dark sides of human feelings, all the while assisted by the alcoholism and drug addiction that eventually led to his early death. Drugs played an important role in his explorations of the human soul and probably opened new perceptions and experiences to him, including his becoming aware of his synesthetic perceptions.

Already in his general descriptions of drug-induced perception he described a heightened sensitivity for sounds, tactile impressions, and odors that seem to shade into synesthetic perceptions. In his short story "A Tale of the Ragged Mountains," Poe describes, through his character Augustus Bedloe, the effects of morphine on his sensibility:

In the meantime the morphine had its customary effect, that of enduing all the external world with an intensity of interest. In the quivering of a leaf, in the hue of a blade of grass, in the shape of a trefoil, in the humming of a bee, in the gleaming of a dewdrop, in the breathing of the wind, in the faint odors that came from the forest, there came a whole universe of suggestion, a gay and motley train of rhapsodical and immethodical thought.

Poe's poems are dominated by sensory symbols for the human heart that include his use of darkness, night, cold, and sound (frightening knocks on the door and the squeaking of open windows). The darkness itself evokes synesthetic impressions in him. Poe hears sounds in the shades of black and gray. In his early poem "Al Araaf," this type of synesthesia steps forward and identifies itself in the second and last lines of the following excerpt:

Sound loves to revel in a summer night;
Witness the murmur of the grey twilight

That stole upon the ear in Eyraco,
Of many a wild star gazer long ago—
That stealeth ever on the ear of him
Who, musing, gazing on the distant dim,
And sees the darkness coming as a cloud—
Is not its form—its voice—most palpable and loud?

The murmuring of the gray twilight and the volume of the darkness is almost tangible. The darker the sky, the louder the sound. Poe's synesthesia shows similarities with the reports of synesthetes who perceive high-pitched sounds as light and low-pitched sounds as dark. Poe was well aware of his perceptual capacities, as evidenced by a footnote to part II of "Al Araaf": "I have often thought I could distinctly hear the sound of darkness as it stole over the horizon." He even seems to have been aware of the bidirectional nature of his synesthesia, for he wrote in the *Democratic Review* of November 1844: "The orange ray of the spectrum and the buzz of the gnat affect me with nearly similar sensations. In hearing the gnat, I perceive the color. In perceiving the color, I seem to hear the gnat."

Poe's "dark" poems and unconventional way of life inspired many poets, including the French poet Charles Baudelaire (1821–1867) in Paris some decades later. One of the themes that Baudelaire would elaborate on was that of drugs, sensibility, and synesthesia.

The Hashish Club

In France, Baudelaire's poem "Correspondences" in the volume *Les Fleurs du Mal* (*Flowers of Evil*), published in 1857, started a new romantic interest in synesthesia. The poem would become paradigmatic for poets of the Symbolist movement, who tried to discover a higher, spiritual reality by studying sensory correspondences.

"Correspondences"
Nature is a temple in which living pillars
Sometimes give voice to confused words;
Man passes there through forests of symbols
Which look at him with understanding eyes.

Like prolonged echoes mingling in the distance
In a deep and tenebrous unity,
Vast as the dark of night and as the light of day,
Perfumes, sounds, and colors correspond.

There are perfumes as cool as the flesh of children,
Sweet as oboes, green as meadows
—And others are corrupt, and rich, triumphant,

With power to expand into infinity,
Like amber and incense, musk, benzoin,
That sing the ecstasy of the soul and senses.

Baudelaire's idea of correspondences is slightly different from the current meaning of synesthesia. He related the perception of sensory correspondences to a state of mind where various sensory impressions (perfumes, colors, sounds) corresponded to one another. The perception of a perfume evoked, in other sensory domains, coolness, sweetness, and greenness. And although these qualities were physically distinct, in his perception they were related in the sense of corresponding or talking with each other. He interpreted these correspondences as a voice from a deeper spiritual level of reality.

Baudelaire was inspired by the philosophy of Emanuel Swedenborg (1688–1772), an eighteenth-century Swedish scientist and philosopher who believed that sensory correspondences in the natural world mirrored correspondences in the spiritual world. Sensory correspondences would reveal not only the unity of the senses but also the unity of the spiritual world.

But what role did Baudelaire reserve for drugs in this vision? In his book of essays, *Les paradis artificiels* (*Artificial Paradises*), of 1860, Baudelaire reported extensively on his investigations into the effects of drugs on perception. According to Baudelaire, the use of hashish brought a person into a state of mind that had an intensifying impact on sensory experiences. He wrote that in a drugged state, he was able to perceive more sensory details with a heightened emotional awareness. He believed that when the senses were more open to new stimuli—a state of mind that I would call "hyperesthesia," or hypersensibility—new correspondences could be revealed. Hypersensibility revealed a deeper layer of consciousness, one in which the sensory qualities had not yet been separated.

The effect of smoking hashish was to uncover them: he wrote that he perceived colors, smells, sounds, and tactile impressions more intensely and as interrelated when he was under the influence of hashish. Perceived correspondences such as colored sounds and musical colors that were placed in the category of temporary hallucinations by his contemporaries were taken as serious perceptions of a deeper layer of consciousness by Baudelaire. Intoxication created by drugs could lead to a mental state of hyperesthesia in which correspondences such as colored sounds and musical colors, appeared:

It is, in fact, at this period of the intoxication that is manifested a new delicacy, a superior sharpness in each of the senses: smell, sight, hearing, touch join equally in this onward march; the eyes behold the Infinite; the ear perceives almost inaudible sounds in the midst of the most tremendous tumult. It is then that the hallucinations begin; external objects take on wholly and successively most strange appearances; they are deformed and transformed. Then—the ambiguities, the misunderstandings, and the transpositions of ideas! Sounds cloak themselves with color; colors blossom into music.

Baudelaire participated in a unique experiment of the Club de Hachichins in Paris in 1845. A painter, poet, and musician named Joseph Ferdinand Boissard de Boisdenier (1813–1866) organized monthly gatherings that he named "fantasias" held in his luxury apartment in the Hôtel Pimodan on the île Saint-Louis. The French poet and journalist Théophile Gautier (1811–1872), who was a close friend of Baudelaire's, saved one such invitation. It reads: "Dear Théophile, next Monday the third of the ninth [1845] hashish will be taken at my place under supervision of Moreau and Roche."

Jacques-Joseph Moreau (1804–1884) and Aubert Roche were physicians who were studying the effects of hashish on patients and had published separate papers on the subject. Moreau was interested in using hashish to cure patients by evoking artificial psychoses while Aubert Roche wanted to use hashish to fight outbreaks of pestilence. The work of Aubert Roche has been—rightly—forgotten, but Moreau's book contains striking insights into modern pharmacology. In 1845, Moreau argues in his book *Du hachisch et de l'alienation mentale* (*Hashish and Mental Illness*) that mental diseases could be studied by evoking abnormal states of mind in healthy persons by means of hallucination-inducing drugs such as hashish.

He assumed that hallucinations are a result of stimulation of parts of the brain where imagination and memories are located. Moreau carried out the

drug experiments on himself and some of his patients. He also tried to convince his colleagues in the hospital to use hashish, but they refused. He found a more positive response from the bohemian artists in Paris, which is how the gatherings of the Hashish Club began.

The meetings were attended by many writers and artists of the day including Baudelaire, Honoré de Balzac, Alexander Dumas, Victor Hugo, Gérard de Nerval, and the painters Eugène Delacroix and Honoré Daumier. The meetings were made famous by an article by Gautier in the French newspaper *Revue des dee mondes* that appeared on February 1, 1846. The article was written in a rather sensational and exaggerated style that is not very reliable. A few years earlier, Gautier had written a better and more reliable article, "Hashish" ("Le hachiche"), on the effects of hashish on his perception that appeared in *La Presse* on July 10, 1843 and was later included in Moreau's book.

Gautier wrote that as he felt himself go under the influence of hashish, he noticed a strong urge to draw, and within five minutes, he had put down over fifteen sketches on paper. One sketch depicted Moreau in Turkish costume, seated at the piano. Gautier represented the synesthetic colors of the piano notes as curly lines above the instrument (figure 7.1). After consuming *"dawamesque"*—a green pasta of hashish, butter, pistachio nuts, almonds, and honey—Gautier reported his perceptions in time units as in a scientific report.

At the beginning of the experience, Gautier was seized by a general freezing sensation and his body felt as though it had become transparent; he felt his eyelashes grew and curled up as gold threads on little ivory wheels. Around him, color avalanches glittered as in a kaleidoscope. Half an hour later, he got into a second hashish flush with even stranger visions of billions of swarming butterflies whose wings made an intensely loud noise as if they were fans. Gautier finally described how his hyperesthesia produced synesthesia-like perceptions:

Giant crystal flower calices, enormous rose-mallows, golden and silver lilies mounted and opened around me with a crackling like bouquets of fire works. My hearing was developed extraordinarily; I heard the noise of colors. Green, red, blue, yellow sounds reached me in perfectly distinguishable waves.

Following the lead of Dr. Moreau, Gautier considered these drug-induced synesthetic experiences to be experiences of artificial psychosis. He described

Figure 7.1 Under influence of hashish, Théophile Gautier in 1843 made this sketch of Gustave Moreau in Turkish costume sitting at the piano. Over the piano he depicted his synesthetic perceptions of the colors of sounds. (Th. Gautier, 1843.)

it as the frightening experience of the alienation of his own body (which is, in fact, very different from how synesthetes describe their experiences nowadays). Contrary to Baudelaire, who considered sensory correspondences to be revelations of spiritual correspondences, Gautier plainly considered it a disruption in the brain.

Pharmacological Studies

As we have seen, the revelation of sensory correspondences by drug use was a subject of nineteenth-century literature. Some writers took it seriously, but others treated it as fun or a snobbish bijou. From two of the more serious

thinkers, however, two opposing views emerged on drug-induced sensory correspondences. The first view, exemplified by Baudelaire, was that correspondences were perceived in a state of hyperesthesia, a hypersensitive state revealing a spiritual unity of the senses. A second view, voiced by Gautier and Dr. Moreau, was that the drug-induced perception of correspondences was a hallucination resembling the hallucinations caused by a mental disorder. Who is right, according to the ideas of contemporary scientists? Can contemporary scientists perhaps offer a third view on the relationship of drug use and synesthetic perception?

During the 1950s and 1960s, there was much experimentation with LSD (lysergic acid dietrylamide). Some people reported side effects that sounded like synesthesia when they described their color perceptions. For example, some individuals reported that the LSD added color percepts to nonvisual stimuli such as pure tones. These reports were very similar to the descriptions of hyperesthesia and color hearing reported by Baudelaire and Gautier.

In the 1960s, a pharmacologist named Leo Hollister found that after subjects were given LSD, the addition of pure musical tone to the presentation of a visual flicker altered the color and patterns of the perceived flicker. Later in the 1980s, the British neurologist Peter McKellar observed that a subject who had been given mescaline responded to tactile stimulation by a sharp object by saying; "I've got concentric circles like around the top of a radio mast. If you touch me, jagged things shoot up; little sort of jagged things, from the center."

At the same time, the British perception researcher Richard Gregory subjected himself to an injection with ketamine, an anesthetic drug that was often used in plastic surgery, and reported his perceptions to his fellow-researchers. When they caressed the palm of his hand with a hairbrush, Gregory had "a sensation of red wool, woven in squares, like a tapestry," and when he moved his finger across the bristles he perceived "purple, red images, clear like hypnologic images that were highly saturated like Turkish tiles, orange and green and red." When a comb was swapped for the brush on his hand, he got "vivid green and red sensations as the comb moves."

These studies showed that hallucinogenic drugs led to a higher sensibility for physical stimuli, resulting in co-perceptions such as moving colors and forms. They confirm Gautier's view that drugs can evoke synesthetic perceptions that are hallucinatory.

The participants in these studies were not synesthetes.

What happens when a synesthete takes hallucinogenic drugs? After decades of incidental reports of synesthesia as a side effect of drug-induced hallucinations, drug-induced synesthesia started to become studied more systematically in the 1980s. One of the pioneers in this field is a Washington, D.C.–based neurologist, Richard Cytowic. In his popular book, *The Man Who Tasted Shapes* (1993), he describes the case of his patient Michael Watson, for whom a minty taste in his mouth evokes a tactile sensation that is as cool and fresh as the curve of a glass column in his hand. For Watson, flavors have shape. While he tastes the flavors in his mouth, he also feels the shapes all over his body, but mainly as sensations of objects rubbing against his face or in his hands.

Watson tells Cytowic that his synesthetic perceptions vary in intensity during the day. On mornings after some serious drinking, he hardly feels the flavors in his hands or elsewhere on his body. The neurologist learns that Michael drinks many cups of coffee in the morning to sober up and get over the hangover. Could the use of depressants such as alcohol and stimulants such as coffee affect synesthetic perceptions? Watson participates in an experiment by Cytowic with "socially accepted" drugs—alcohol and coffee. After the intake of alcohol, a taste of spearmint increases the sensation of glass columns in his hands, while after coffee, all that is left is the tactile sensation of some small columns further away.

Follow-up studies strengthened Cytowic's theory that the effect of drugs on synesthesia depends on which part of the brain area is stimulated. Stimulants, like coffee, stimulate the higher cognitive functions in the neocortex (the relatively thin multifold outside layer of the brain), whereas depressants, like alcohol, suppress the responses of the neocortex. Suppression of the rational cortical area lets activity of the emotional limbic system (more centrally located in the brain) emerge and pushes it into the foreground of experience. Cytowic locates the source of synesthetic processes in this limbic system, and thus his predictions that coffee will block and alcohol will enhance synesthetic perceptions were confirmed.

In Cytowic's studies, unlike in the experiments discussed earlier, synesthesia is not a temporary hallucination. Watson's synesthesia is permanent and can be slightly modified by taking drugs. Later studies into drug-induced hallucinations of nonsynesthetes confirm Gautier's reports, but the only study into the modification of synesthetic perception in a synesthete matches Baudelaire's view. In fact, drug-induced hallucinations and drug-modified synesthesia are two different phenomena.

Is Synesthesia a Hallucination?

After my long and somewhat bizarre journey reviewing literary and pharmacological experiments in the last two centuries, I have come to the conclusion that there is no direct relationship between synesthesia and drug-induced hallucinations. My argument is that though some overlap can be observed in both types of perception, the main principles are opposite.

First, drug-induced hallucinations are temporary, lasting only as long as the drug lasts, whereas synesthetic perceptions are always there throughout one's life. Second, the perceptions of sensory correspondences change in drug-induced hallucinations, whereas in synesthetic perceptions they are consistent. Third, drug users can distinguish hallucinations they have while under the influence of drugs from their normal states of mind, whereas synesthetes perceive their sensory correspondences while in a normal state of mind. In fact, no observations by others indicate that synesthetes show hallucinatory behavior. Fourth, whereas drug-induced hallucinations are often disruptive to a person's normal functioning, the "visions" seen by synesthetes don't interfere with normal life, and in some cases, they help the synesthete perform better, for example, in cases where synesthetes use colors to do mental arithmetic. Fifth, many synesthetes report that they first discover their synesthesia during childhood and not during their first drug experience.

The intensity of synesthetic perceptions can be modified by the use of several drugs, but also by mental techniques. You do not need to take drugs to alter your state of mind or synesthetic perceptions. An ancient and well-proven way to change your state of consciousness is through meditation. The psychiatrist Roger Walsh of the University of California Medical School surveyed practitioners of Buddhist meditation and found that synesthetic perceptions occurred more often to people when in meditative states than to people in normal states of mind. Furthermore, he found that the intensity of synesthetic perceptions increases with the duration of the meditation. Comparing the interviews of masters and pupils, it appeared that the synesthetic perceptions in experienced masters were stronger and covered more sensory domains than those experienced by the pupils.

Meditation is a well-known technique to suppress the rational thinking mode and heighten sensibility. This shift of consciousness from a rational attitude to a sensuous attitude goes along with a change in awareness of the environment, sometimes resulting in new perceptions and insights. In

meditation, the perceptual system is less driven by a rational agent and acts more autonomously. This state of mind comes close to preconscious perception described by Merleau-Ponty, which produces a holistic awareness of the environment.

Though this concept of perception was described by Merleau-Ponty in the twentieth century in Western Europe, it actually goes back to ancient Hindu and Buddhist theories of perception, as described by the Indian philosopher Bimal Krishna Matilal (1935–1991) in his book *Perception: An Essay on Classical Indian Theories of Knowledge*. According to classical Indian philosophy, all senses were originally related in one whole, which is different from the Western view of the senses as separate channels. Every perception of the world in which this unity of the senses is broken is considered a hallucination and therefore untrue. Though this theory has few adherents in the West, it is a nice thought to ponder.

Finally I feel that I am getting closer to the nature of synesthesia. In the first part of this book I explored the perceptions of synesthesia. In the second part I investigated the thinking of synesthetes. In the next and last part I want to "taste" scholars' current insights into the nature of synesthesia.

III

Insight

8

A Colored Brain?

The human brain is a deeply folded gray mass that weighs about three pounds and is about the size of two fists. How can this gray matter "see color"? Do parts of the brain turn color and become red, green, and other shades? This medieval thought (in fact it was thought that the eyeball changed color) was refuted by scientists centuries ago. Surprisingly, current popular science magazines, including *Scientific American* and *New Scientist*, present pictures of vividly colored brain parts in red, green, and blue. This is not a misconception, but a deliberate coloring scheme used by the designers to explain distinct processes in the brain. Brain areas have no color. When we perceive the color red, for example, the visual cortex, an area at the back of the brain that is responsible for that perception, remains gray.

How, then, does the perception of color work? How can the visual cortex perceive the deep red of a cherry? And how can the brain not only perceive but also feel an attraction to the deep red of a cherry and distinguish it from the frightening deep red of bloodshed? How does the brain of a synesthete distinguish the cherry's color from the deep red evoked by the sound of a piano? What can current brain theories of synesthesia tell us about these things?

The visual cortex is located just under the skull, against the back of your head and near your neck; it is the part of the brain that probably does most of the processing of color perceptions. Visual perceptions stem from the oval field you see in front of your eyes, which is called the visual field. The visual field is divided into two parts, the right part and the left part (see figure 8.1).

Figure 8.1 Schematic illustration of the processing of optical stimuli in the brain. (Illustration by Annemiek van Hove.)

The light entering the eyes from the left area of the visual field falls into the right parts of the left and right eyes. And the light from the right area of the visual field falls into the left parts of both the left and right eyes. The retina at the back of each eye registers the light stimuli and sends them, in coded form, through the nerve fibers to the visual cortex on the left and right sides of the brain. The visual cortex analyzes the information and, using knowledge from other brain parts, comes to a conclusion of what the colors of the objects are. This information is further processed in other parts of the brain in order to direct motor actions: Should I bend forward to pluck and eat the deep red cherry, or run for help in case the deep red I see is bloodshed?

A mysterious aspect of color is that it is created in the brain and seen to exist in the physical environment. But the physical environment contains only light waves and is in fact colorless. The colors are inside our brains, not outside.

The processing of light waves into color perceptions looks analogous to the processing of pictures by computers, but there are differences. The computer similarly scans the deep red cherry; it also analyzes the pixels, and sends a representation of the object to the internal screen where you can see the image of a deep red cherry that you like to eat. The failure of the computer metaphor is that it cannot explain why you also feel attracted to the deep red of a cherry. Color perception is more than an administrative process of color notation; it is a physical act, too. Color can create a stir in people and seems to be as much a physical sensation as a mental perception.

Oliver Sacks, a neurologist and writer, tells a tragic anecdote with a happy ending that shows how the registering of color is separate from the feeling of color. In an automobile accident a visual artist named Jonathan suffered a brain injury that deprived him of his ability to perceive color. His visual environment changed into something like a black-and-white movie. Yet a neurological examination of his perception showed that Jonathan's eyes were functioning normally. In addition, he was still able to choose the "right" colors on the basis of the shades of grays he perceived, and from his long experience as a painter, he knew most color numbers by heart. He could name the colors he saw by their numbers alone but he could no longer "feel" the colors, and this caused a severe depression. After some time, he happily recovered from his depression and started to "feel" the vitality of the shades of gray when he started to paint them.

Although Jonathan's eyes functioned normally, he could no longer see colors. This seems to be an inversion of synesthesia. With their eyes closed,

synesthetes can perceive color in sounds or smells or tastes or tactile impressions. Do synesthetes need eyes to perceive color? I turn here to some brain-related questions concerning color synesthesia.

Normal or Abnormal?

Color perception in the normal brain is still a bit of a mystery, so how easy is it for scientists to explain how color is processed in the brain of a synesthete? How is color perception linked to the perceptions of sounds, tastes, smells, and tactile impressions? These questions have been the subject of debate since the earliest studies of synesthesia. I will restrict myself here to theories put forward in the last two decades. What can they tell us about color synesthesia?

The most widely accepted view among scientists is that humans possess five or more separate sensory systems that are linked to separate brain parts. According to this view, sensations are received in a specific sense organ (eyes, ears, mouth, nose, and body skin), where those physical sensations are encoded into specific nerve energies that travel through nerve fibers to specific brain parts (visual cortex, auditory cortex, and so forth), where they produce perceptions. This is an automatic and unconscious process; we only become aware of its end products: an image, a sound, a taste.

In general, synesthetic perceptions are considered abnormal because they do not fit into the theory of separate sensory systems. Researchers have proposed several alternative ways to incorporate synesthetic perceptions into this brain theory of perception. One common idea is that synesthetic perceptions are the result of a miswiring in the brain of synesthetes. This "miswiring theory" assumes that everyone's brain is essentially designed the same way, and it is the miswiring that is responsible for the synesthetic mixture of perceptions such as colored sounds and colored tastes.

Another theory is the "leakage theory," according to which the explanation for synesthesia is that adjacent brain areas "leak" information to each other. For example, it is known that the brain area responsible for color perception is physically adjacent to the brain area responsible for number recognition, so it is assumed that information can leak across the two areas' boundaries. To borrow Nabokov's metaphor, if a synesthete's brain is less protected from leakage and drafts because of having less solid walls, this would result in perceptions of colored numbers.

A third theory is the "wrong feedback theory"; it is based on the feedback that normally occurs on an unconscious level of perception. By means of wrong feedback, abstract products of reasoning such as letters and numbers can be mixed up with perceptions of color on a unconscious level, producing conscious phenomena such as colored letters and numbers.

Each of these three ideas can readily explain specific types of synesthesia, such as colored numbers and letters, but may be less able to explain other types of synesthesia, such as colored odors, tastes of music, or tactilely felt tastes.

The brain has been developing over the whole period of humans' existence on earth, and in each individual life it continues to develop from birth until death. From the evolutionary point of view, the brain consists of three parts that differ in evolutionary age (see figure 8.2). The oldest part of the brain is the brain stem, which regulates basic functions such as breathing. Around the brain stem lies the limbic system, which globally deals with our emotions and instincts such as caring and fighting. The neocortex, as its name implies, refers to the newer part on the outside of our brain, and in general deals with rational processes.

Figure 8.2 Schematic representation of the three principal brain structures: the (reptilian) brain stem, the limbic system, and the neocortex. (*The Neurosciences: Second Study Program*, 1978, p. 338, © Rockefeller University Press; reprinted with permission.)

One theory of the origin of synesthesia, which I will refer to as the "limbic-system theory," states that synesthesia is a product of the limbic system. Unlike the neocortex, where the senses have their own separated domain, in the limbic system all sensory nerve pathways mingle and can produce mixed perceptions. This thesis posits that synesthetic perceptions are normal products of some older parts of the brain.

Another theory, which I will call the "neonatal-pruning theory," starts with the brain development of neonates. It is believed that the brain of a newborn consists of many intersensory connections, which are "pruned" as the senses become specialized in the first year of life. This theory states that in the brains of synesthetes, some nerve connections between sensory brain parts are not pruned because they have certain advantages in life and still produce inter-sensory, or synesthetic, perceptions in synesthetic adults.

The "brain-plasticity theory" is related to the "neonatal-pruning" thesis, and is based on the idea of the plasticity of the brain. Recent studies have shown that the organization of the human brain is not determined at birth, but adapts its functional organization to its environment throughout the life of a person. For instance, in scientific experiments with persons that lived blindfolded for over a week, the visual cortex was observed to respond to tactile stimuli. This reorganization of brain functions is also found in the visual cortex in blind-born persons, showing activity when the person reads Braille or listens to others. In this view, synesthetic perceptions are products of an adaptation of the brain to the environment the person lives in.

According to yet another theory, the "neural disinhibition theory," in adults, all sensory brain parts are structurally connected, but not all are activated. Intersensory transfer is normally inhibited because it does not serve a purpose in perception. In synesthetes, however, some intersensory nerve connections are permanently disinhibited and this produces synesthetic perceptions.

These theories fall into two general categories (see table 8.1). The "miswiring theory," the "leakage theory," and the "wrong-feedback theory" are in the first category of theories, whereby synesthesia is the product of a malfunctioning or abnormality in the brain. In the second category are theories proposing that synesthesia is an aspect of a normally functioning brain. The "limbic-system theory," the "neonatal-pruning theory," the "brain-plasticity theory," and the "neural disinhibition theory" say that synesthesia is a peculiar but normal outcome of human perception. They stress the individual differences

Table 8.1 Theories of Synesthesia in Terms of Brain Function

Theory	Cause of Synesthesia
Synesthesia as *abnormal brain function*	
"Miswiring"	Miswiring between sensory parts in the brain
"Leakage"	Leakage of information between adjacent brain parts
"Wrong feedback"	Wrong processing of feedback in the brain
Synesthesia as *normal brain function*	
"Limbic system"	Emotional structures in the limbic system of the brain
"Neonatal pruning"	"Pruning" of nerve connections in newborns
"Brain plasticity"	Functional reorganization of brain areas
"Neural disinhibition"	Permanent activation of formerly inhibited nerve connections

in human perception. Each person develops his or her own personal style of perception within certain neurological boundaries.

Most of these theories have been tested empirically in the last decades, especially since new technologies that can record activity in the brain of living persons have become available. In a small number of studies the brains of individuals with different types of synesthesia have been scanned, using several techniques such as the PET (position-emission tomography) and FMRI (functional magnetic resonance imaging) scans. Unfortunately, the studies are too few and too diverse in types of synesthesia studied to provide a clear evidence as to which theory of synesthesia comes closest to the truth or to compare the studies and to integrate the different theories into a larger theoretical framework.

Many scientific studies into synesthesia start from individual reports by synesthetes, and most studies are based on individual case histories, from which general principles are derived. Perhaps the conditions of the study narrow the view of the researchers to the type of synesthesia that is reported by their subjects. Since our scientific knowledge is based on the reports and behaviors of these persons, it might be interesting to have a closer look at the way they are selected. Who is chosen to participate in research? Do these subjects represent the average synesthete, or a specific subgroup?

Who Is a Synesthete?

Every scientific experiment on synesthesia, whether using brain scanning, reaction times, or other methods, starts with identifying synesthetes by distinguishing them from nonsynesthetes. How is the line drawn between persons who are labeled "synesthete" and "nonsynesthete" in the experiment? This process of labeling may seem to be a simple one, but in fact it has to be established for each experiment.

How do you know you are a synesthete? It is not an observable trait. How do you discover another person has synesthesia if you cannot observe it? You can ask the person, but the answer may not be reliable. It can better be derived from tests that have been developed to distinguish synesthetes. The consistency test, which is the most commonly used one, is based on the fact that synesthetic perceptions are consistent and stable throughout a lifetime. Once a synesthete perceives the letter *A* as red, that person's perception of *A* will remain red all of his or her life. For another synesthete, the *A* may be blue, but the same principle applies: *A* is blue for this synesthete throughout his or her life.

In the 1980s, the English neuropsychologist Simon Baron-Cohen and his colleagues examined a synesthete who perceived words in color. Since no diagnostic tests for synesthesia were available at that time, he and his colleagues developed the "test of genuineness" the first consistency test of synesthesia, recently revised by his colleague Julian Asher and others. The test uses an objective method to distinguish true synesthetes from nonsynesthetes, including people who make up stories of colored words.

The consistency test has been applied in various versions, but the basic form is this: A person gets a list of words. She is asked to name the color of each word. The names of the words or the codes of the color chips indicated are noted down by the researcher. Two weeks or more later, the person is invited again to take the same test; she gets the same list and is asked to name or indicate the colors of the words again. The researcher notes the answers again and now can compare the answers on the two lists of word-color associations. The researcher checks to see how many times the person associates the same color with the same word—whether, for example, the word "boat" is consistently yellow for that person. The resulting score on the test is the percentage of consistent word-color associations over the two sessions.

Baron-Cohen and his colleagues first tried this test on a single person, then with a large number of self-described synesthetes and nonsynesthetes. The synesthetes did far better on the test, with scores over 90 percent, in comparison to the nonsynesthetes, who had scores around 40 percent. This difference was significant enough to serve as a way to measure or distinguish "chromolexical" (colored words) synesthetes from both nonsynesthetes and synesthetes with other types of synesthesia.

From my personal experience, I have some remarks on the use of the consistency test to distinguish synesthetes from nonsynesthetes. In 1995, I translated this test into the Dutch language and have applied it since then on many occasions, including a series of experiments with the artist Clara Froger (discussed in chapter 9), and I also used the test in a study of 223 students in a fine arts academy in Boxtel, the Netherlands, in collaboration with a teacher, Florence Husen.

When I first used the test, it was quite rough. Participants had to name the colors of words, but no gradations were indicated; instead, say, cherry red and strawberry red were both considered "red."

Synesthetes told me afterwards that they perceived more colors in a word that had more letters. Often the first letter of a word is the dominant color in the "color image" of the word, and participants told me they often chose that color name or corresponding color chip.

Even when I changed the test so that instead of naming synesthetic colors in words participants selected color chips, they told me that the right color was not in the selection of colors, so they chose the nearest color, or two color chips where the color was somewhere in between. Participants had difficulty choosing from printed color chips when they perceived the colors of letters and words in "light colors."

I could improve the test results by replacing words referring to objects that typically were a certain color, like "cherry" (red) or a "elephant" (gray) with neutral words like "government" or nonsense words like "stroep." As a result, the differences in scores between synesthetes and nonsynesthetes increased. On the one hand, nonsynesthetes were prevented from increasing their score by memorizing by associating "elephant" with "gray." On the other hand, synesthetes were less confused by associations like grayness with the word "elephant," that influenced their own synesthetic colors. As one synesthete reports, "The word 'elephant' is mainly blue because the letter E is blue, but the gray of the elephant mingles with blue of the letter E."

Some of these methodological issues can be solved by using refined versions of the test. Two other findings, however, indicate further obstacles to proper measurement. I discovered the first one only recently, after I had tested many people whom I had interviewed about their synesthesia. In a number of cases people who were obviously very consistent in their verbal reports on synesthesia had low scores on the test. One of the reasons was that they often perceived letters and words in many colors in complex color images, which could also create a more movie-like colored pattern. Asked at two different times to select a color chip that matched their synesthetic word color, they choose different color chips that matched different aspects of their synesthetic image. As a result the two selected color chips did not match and their scores were low. On basis of their low test scores they were assigned to the group of non-synesthetes, although they actually were synesthetes.

A second problem concerns the assumption that the mean score of a group of synesthetes and that of a group of nonsynesthetes will differ significantly—say, that the mean of synesthetes' scores will be 90 percent consistent answers whereas nonsynesthetes' mean will be only 40 percent consistent answers. When I graphed the individual scores of the 223 students at the fine arts academy, I expected to observe two peaks in the distribution of scores: one at 40 percent and one at 90 percent. In fact I saw a gradual distribution of synesthesia scores ranging from 0 to 100 percent (see figure 8.3). To my surprise there was no clear dividing line between synesthetes and nonsynesthetes. On the basis of these figures, I suggest that the question "Are you a synesthete or a nonsynesthete?" should be reformulated as "How strong is your synesthesia?"

The consistency test is most often carried out with people who perceive letters and numbers in colors. As the linguist Sean Day reports, on the basis of more than 800 accounts by synesthetes, there is a great variety in the types of synesthesia (see table 8.2 on p. 131). Only a few individuals have been tested scientifically. Note that the table is constructed on the basis of self-reports. The figures may be skewed for several reasons.

First, certain types of synesthesia have been covered more in the media and these types may be reported more often. Some groups of people (for instance, artists and women) seem to be more willing to report on their synesthesia than others. And only people who have become consciously aware of their synesthesia are able to report it.

Another complicating factor is that one type of synesthesia, colored-letter synesthesia, covers a variety of individual differences, as we know from

Figure 8.3 Distribution of scores on synesthesia consistency test of 223 students at a fine arts academy in Boxtel, in Netherlands.

personal reports by synesthetes and as has recently been observed in brain-scan studies by the neurologist Ed Hubbard and his colleagues. In the popular press but also in scientific publications synesthetes are often presented as a homogeneous group with the same synesthetic gifts. It turns out that they vary a lot. In a recent review on the state of scientific synesthesia research, Jamie Ward and Jason Mattingley acknowledge that the variety in individual reports of synesthesia, which form the basis of most studies into synesthesia, is perhaps the thorniest issue for researchers and cannot be avoided. Dan Smilek and Mike Dixon add that synesthesia researchers have not yet bridged the gap between objective experimental findings and subjective reports by synesthetes.

To summarize, I have found it hard to distinguish synesthetes from non-synesthetes by scientific methods. The consistency test has isolated a certain type of color-letter synesthete, one who experiences a clear one-color-to-one-letter correspondence. Even this particular group has turned out to be quite heterogeneous. Finally, I have come to the conclusion that the typical synesthete and the typical nonsynesthete can be easily distinguished, but to categorize members of the remaining group as synesthetes and nonsynesthetes is hardly feasible.

How Many Synesthetes?

Given the challenge of reliably identifying synesthetes, can we say what is known for certain about the number of synesthetes? Or can we count synesthetes at all?

Counting synesthetes in the population is something of a gamble. Numbers that have been proposed range from one in 20 persons to one in 20,000. More than a century ago, Sir Francis Galton was the first to hazard a guess as to the frequency of colored hearing. He estimated that one in 20 persons has this type of perception. At the beginning of the new wave of interest in synesthesia, in the late 1980s, the prevalence of the phenomenon was thought to be very low. Richard Cytowic proposed a ratio of 1 synesthete per 25,000 people. Since then, the estimates have gone up rapidly, based partly on study results and partly on personal reports; in recent years synesthesia researchers have proposed ratios of synesthetes to nonsynesthetes of 1 in 500, 1 in 200, and 1 in 100.

Halfway through the 1990s, a first attempt was made to scientifically determine the prevalence of synesthesia, using epidemiological methods. Researchers in Cambridge, England, put an advertisement in the *Cambridge Evening News*, a newspaper with about 44,000 readers. The advertisement contained a description of colored-word synesthesia and a note asking readers who recognized the descriptions to please contact the researchers. The same advertisement was also placed in a student magazine with a circulation of about 11,000.

Very few people responded: twenty-eight responses came from the evening newspaper, and four from the student magazine. They all tested positive on the test of consistency. Though the response sounds disappointing, the results of the study were surprising. Dividing the number of readers by the number of "true" synesthetes gave a rate of about 1 synesthetes per 2,000 readers of the newspaper and 1 per 2,500 among readers of the student paper.

These rates are probably underestimates because not all readers will have read the advertisement, and synesthetes with other types of synesthesia—colored numbers, colored smells, or colored odors—probably did not recognize themselves in the descriptions. Another factor is the media coverage of synesthesia. Synesthesia was still an unknown phenomenon at that time. Since then, synesthesia has been described and explained in the media in a growing number of newspaper articles, popular science magazine articles, and radio

and television broadcasts. It is my experience and that of many other people in the field of synesthesia research that the number of people who have become aware of their synesthetic perception has been growing over recent decades.

A second pair of epidemiological studies was carried out in London and Edinburgh and published by Julia Simner and her colleagues in 2006. They were conducted independently, on different populations, but resulted in the same rate of synesthetes in the general population. In the first study, about one thousand visitors to the Science Museum in London were all tested for colored-word synesthesia. In the second study, five hundred students in Edinburgh were surveyed on several types of synesthesia. In both studies, 1 percent (or 1 in 100 persons) of the subjects had colored-letter synesthesia.

But this is only one type of synesthesia. A more important result of the Edinburgh study was that if all those who have one or more types of synesthesia were counted, the total rate of synesthetes in the population was about 4.4 percent (1 in 23 persons).

In the course of a century, the estimated proportion of synesthetes in the general population has gone up and come down again to the rate Galton proposed.

The variation in the estimates of the prevalence of synesthesia does not look very scientifically solid. Apart from personal guesses based on the impressions of the number of synesthetes one encounters (which are normally unreliable), even two epidemiological studies come up with very different results, ranging from 1 in 100 to 1 in 2,000 for one type of synesthesia. Are researchers measuring synesthesia with a rubber ruler? A number of factors make synesthesia a slippery subject to measure.

First, there is the problem of funding for research. Accurate statistics are available for life-threatening diseases because researchers get a lot of money to screen broadly for these diseases. Synesthesia is not a disease and is far from life-threatening, fortunately. That is one reason why researchers have little money to survey and screen populations for synesthesia. The statistics they provide are the best they can do, given the limited circumstances of the research and the way it is carried out. With larger research budgets, more accurate and convincing synesthesia rates can perhaps be demonstrated, but evidently, currently no government is interested in investing large sums of money in research on synesthesia.

A second factor, already mentioned, is media coverage, which makes people, aware of their synesthesia. The increase in estimates of synesthesia rates seems

to reflect the trend that ever more people are becoming aware of their synesthetic perceptions.

A third factor is that researchers use different definitions of synesthesia, resulting in different rates of prevalence. For instance, some estimates are based on clinical criteria while others are based on psychological testing. When researchers reach consensus on the definition of synesthesia and on the characteristics that distinguish it from other perceptual phenomena, a start can be made to develop a method that accurately assesses the prevalence of synesthetes. It is important not only that it be accurate in distinguishing synesthetes from nonsynesthetes, but also that it not include pseudo-synesthetes and not exclude true synesthetes, as occurs with the current methods such as the test of consistency.

A fourth and related factor is the variety in synesthetic perceptions. For many years, Sean Day has kept track of types of synesthesia on his Web site http://home.comcast.net/~sean.day/html/types.htm. These types and numbers are based on self-reports of synesthetes, and cases from the scientific literature. Table 8.2 (put together in February 2007) shows forty-five types of synesthesia and their relative frequency in the pool of 871 personal reports by synesthetes available to day.

Looking at the reported types of synesthesia, I started to see another reason why it is so difficult to measure synesthesia and present accurate statistics on its prevalence. Starting with a number of very clear types of synesthesia, such as colored graphemes and colored sounds, as one goes down the list types of synesthesia appear on it that are more common experiences, and I ask myself whether such perceptions—for example, touch evoking a feeling of temperature—are still synesthesia. The point I want to make is that there are many kinds and types of synesthetic perceptions, and also that the line between synesthesia and common perceptual phenomena such as smelling and tasting food as one undivided perception is not very sharp.

An earlier version of this table (accessed March 2005) showed five hundred and twenty-nine reports from female and two hundred and nine reports of male synesthetes. Is synesthesia more common among women? Or do women report more often on their synesthesia? The London and Edinburgh studies by Julia Simner and her colleagues found an equal number of female and male synesthetes. This suggests that the prevalence of synesthesia among women and men is equal and that women simply report it more often. I have pondered this difference. Is it because women are more open and therefore are more apt

Table 8.2 Types of Synesthesia Reported by Synesthetes

Type of Synesthesia	Percentage Reporting	Type	Percentage Reporting
Graphemes → colors	64.9	Smells → temperatures	0.1
Time units → colors	23.1	Smells → touch	0.6
Musical sounds → colors	19.5	Sounds → kinetics	0.5
General sounds → colors	14.9	Sounds → smells	1.6
Phonemes → colors	9.2	Sound → tastes	6.1
Musical notes → colors	9.0	Sound → temperatures	0.6
Smells → colors	6.8	Sound → touch	3.9
Tastes → colors	6.3	Tastes → sounds	0.1
Pain → colors	5.5	Tastes → temperatures	0.1
Personalities → colors	5.4	Tastes → touch	0.6
Touch → colors	4.0	Temperatures → sounds	0.1
Temperatures → colors	2.5	Touch → smell	0.3
Orgasm → colors	2.1	Touch → sounds	0.3
Emotions → colors	1.6	Touch → tastes	1.1
Emotion → Smell	0.1	Touch → temperatures	0.1
Emotion → Taste	0.1	Vision → smells	1.1
Kinetics → sounds	0.3	Vision → sounds	2.6
Lexeme → Taste	0.6	Vision → tastes	2.8
Musical notes → tastes	0.2	Vision → temperatures	0.2
Personalities → smells	0.3	Vision → touch	1.5
Personalities → touch	0.1		
Smells → sounds	0.5		
Smells → tastes	0.1		

Note: Types of synesthesia found in 871 case reports.

Source: Sean Day, http://home.comcast.net/~sean.day/html/Types.htm, accessed February 2007.

to speak about their synesthetic perceptions? Are they more aware of their synesthesia? Do women read more magazines with articles on synesthesia? Are they more involved with color?

The last question brings me to a final striking difference in synesthesia rates. It has been suggested and confirmed in several studies that the prevalence of synesthesia is higher among people who are engaged in creative work and activities. In the late 1980s, George Domino, a psychology professor at the University of Arizona, interviewed 358 fine arts students at three universities and 84 (23 percent) of them reported experiencing synesthesia. In our study of a group of 223 fine arts students from Boxtel, the Netherlands (see figure 8.3), Florence Husen and I found that 6 percent of the art students experienced colored-letter synesthesia and 13 percent perceived weekdays in colors. Recently, Anina Rich and her colleagues at the University of Melbourne interviewed 192 synesthetes in Australia and they found that 24 percent of them was involved in artistic professions. That is far above the average proportion of the general population. According to national statistics, less than 2 percent of the general Australian population are in artistic professions. In addition, two psychologists at St. Edward's University in Austin, Texas, Sarah Sitton and Edward Pierce, found significant correlations between synesthesia and verbal creativity in a study of 210 students.

A Slippery Subject

My purpose was to learn what current research can tell me about the neuropsychological nature of synesthesia and its effect on brain function in human perception.

First, I have seen that brain-scan technology has improved a lot in recent decades and has provided physical proof of the existence of synesthesia as a measurable phenomenon in the brain. At the same time, a number of theories of synesthesia have emerged in this young science. I have not found convincing empirical evidence to support one of the theories over the others, so it is still unclear which theory may turn out to explain synesthesia. Regarding the current empirical facts, they seem equally promising and I expect the views on synesthesia will converge in the coming years, though I refer the reader to the experts in the field for more informed predictions (see the bibliography).

Second, brain research cannot proceed effectively until some basic questions on the definition of synesthesia are tackled. It is hard to draw a sharp line

between synesthetes and nonsynesthetes, but an effort must be made not only to define synesthesia but also to develop tests to define a range of types of synesthesia.

Third, studying synesthetes as a group implies that they have something in common that distinguishes them from nonsynesthetes. The group of synesthetes looks like a very heterogeneous group. Not only do group members exhibit a variety of types of synesthesia, but there are significant variations among individuals with one type of synesthesia, say colored-letter synesthesia.

Fourth, the prevalence of synesthesia varies according to social group. Women and creative individuals report synesthesia more often than other people with less creative jobs and activities. In general, the large variation in synesthesia rates reported by researchers indicate that synesthesia is a slippery subject to measure. The synesthesia rate is influenced by awareness of synesthesia in the population, subjective reports, and methodological issues.

Looking back, I feel a bit disappointed. I expected to get a clearer view of the nature of synesthesia from neurologists and psychologists. After reviewing the literature, my conclusion is that synesthesia is not a clear-cut phenomenon and synesthetes are not a well-defined group of people.

But perhaps I am too eager to jump to conclusions. Research needs time, and taking the long perspective, from Galton to now, progress has been made very rapidly in certain areas. Shouldn't I explore the phenomenon of synesthetic perception in more detail? To take an example from history, starting in the early Renaissance it took visual artists centuries to explore and master several aspects of reproducing depth in paintings before they found the right technique, linear perspective. Only then did scientists start to search for explanations of the optics and brain mechanisms involved in perceiving depth in converging lines on a flat picture plane.

Perhaps we need to explore the whole variety of synesthetic perceptions in more detail before we can formulate a general theory on the nature of synesthesia. Let me take one central feature that seems to be at the core of many synesthetic perceptions, and that is color. In synesthetic perceptions, a variety of color experiences are triggered, as synesthetes have reported on many occasions. What do we know about this aspect of synesthesia? Different synesthetes report responses with different colors to the same stimuli. Some see the color introspectively, others externally projected onto letters. Some see painted colors, others see colors of light. Some see the colors in patterns or forms, others as vague patches or cloudlike substances.

A Colored Brain?

133

Understanding color in synesthesia might provide a key to the whole phenomenon. Color is an often recurring subject in my conversations with synesthetes, although color itself has received only little attention in scientific research into synesthesia. Studies have shown profound insights into some mechanisms of synesthesia, but of the color aspect on which every synesthete can speak lyrically, little is known. About eight years ago, I had the luck to meet Clara Froger, a color expert and synesthete from Rotterdam, who initiated me into the world of color and, in particular, the world of synesthetic color. In recent years we have collaborated in a series of artistic and scientific experiments in order to study the color experiences of synesthetes, a subject I will discuss in the next chapter.

9

Dark Double Bass and Purple Piano

Why does a double bass sound "darker" than a violin? Why is the sound of a bassoon more "full" than that of a flute? And why does the sound of a piano, which is purple with orange spots, sound different from a saxophone, which evokes a red glow with yellow coils?

These are not common questions for everyone. Most people can imagine an answer to the first and second questions, but asked for an answer to the third and fourth question, many assume the questioner is teasing them. Yet synesthetes give factual answers to the third question. As you read in chapter 2, the synesthete Floor Eikelboom perceives sounds of a synthesizer as an intense luminous purple with orange stripes that travel through his visual field. Patrick Heller, also mentioned in chapter 2, perceives the sound of an electric guitar as jagged blue lines. The two synesthetes automatically and involuntarily see these abstract images when listening to music attentively.

Their synesthetic perceptions are not an effect of drug use. They perceive their colored sounds whenever they hear music. You can wake them up in the middle of the night, play a sound, and they will see exactly the same colors as when you play the sound in the daytime. Every sound has a specific color. Just as fresh grass has a bright soft green color for most people, every time synesthetes "see sound," it has a specific color. The colored sounds are just facts for them, even though their facts may differ, that is, they might see different colors for the same sound.

Color, a Multifaceted Experience

What is color for a synesthete? Can you compare synesthetic colors to the colors perceived by nonsynesthetes? Does the sound produced by the striking of a piano key evoke a cobalt blue in a synesthete in the way other people see the same shade of cobalt blue in the feathers of a peacock?

Every synesthete is different. One synesthete perceives the piano sound as luminous transparent cobalt blue in front of his eyes; another synesthete sees a painted blue color in his mind's eye; and a third synesthete sees a shining metallic red in her mind's eye. And there is even more variation in the shape and movement of the colors among different synesthetes: one sees sharp lines, another sees rough blobs, and a third sees clouds.

Synesthetes normally disagree on the correct colors of a sound, but on one thing they agree: their colors are real and not fantasy colors. Synesthetic colors can be so specific that some are rarely found in the usual physical world. Once a synesthete told me in delight that after years of searching, she finally found the yellow color of the letter *K* on the wrapper of a glass jar of vegetables.

The perception researchers Thomas Palmeri, Randolph Blake, and their colleagues at Vanderbilt University in Nashville, Tennessee, discovered in a series of laboratory experiments that the brains of synesthetes process synesthetic colors produced by letters in the same way that they process true colors produced by physical objects everyone can see. The experiments showed that synesthetic colors follow the perceptual laws of normal color vision. For instance, synesthetic perceptions can produce afterimages. These are the quivering color images in front of your eyes after you have looked intensely into a strong light source like the sun.

This is another proof that synesthetic colors are not metaphoric labels or memories but true vivid colors. They are true like the specific turquoise of a leaf, the silky rose of a tulip petal, or the transparent beige of a muddy pond.

Like normal color, synesthetic color has many faces. Compare, for instance, the yellow-painted timber of a door, the yellow metallic of a car, a yellow spotlight, a yellow flame in Venetian glass, the yellow of the skin of a lemon and the yellow of its juice. We label them all "yellow," but anyone can see the range of nuances that appear under this single label. Yellow can vary from light yellow in young cheese to dark yellow in old cheese, can vary from pastel yellow in a painted wall to the hard yellow of a lemon skin. Several color systems have been developed to capture this variety in colors. Most color

systems are made for mixing color pigments for the paint industry. In Sweden, a special color system was developed by the Scandinavian Color Institute based on the perceptions of colors. This Natural Color System (NCS) describes the wide range of perceivable colors in three dimensions. As you look at all types of yellow in your surroundings, you can perceive that the yellows differ from yellow-green to yellow-orange in "color tone" (first dimension), but also from light yellow to dark yellow in "lightness" (second dimension), and from pastel to hard full yellow in "saturation" (third dimension). The NCS can describe any color that is perceivable for the human eye in three characteristics: color tone, saturation, and lightness.

By quantifying these three dimensions, a color space is constructed that contains almost all colors perceivable by the human eye, according to the NCS. Figure 9.1 (plate 13) shows the color space and its three dimensions. The circular dimension is a color circle with the four pure perceivable colors: yellow, red, blue, and green. (Note that for the human eye, green is seen as a pure color, whereas in painting green is derived from a mixture of yellow and blue paints.) A vertical axis runs from black to white through the middle point of this circle. This axis of lightness adds light and dark varieties to the color tones. Finally, from the middle point of the color circle axes of saturation are drawn in all directions. Close to the center, the saturation is low, while at the extremes the saturation is high. Technically, saturation is also expressed in the percentage of pure color. The red of a cherry has almost 100 percent redness, while pastel rose has only about 10 to 20 percent redness. The three axes create a color space of almost all perceivable colors and every spot in this space contains a unique color that can be described in a three-value code: one for color tone, one for lightness, and one for saturation.

One of the first things I learned from the Natural Color System was that color has more aspects than synesthesia researchers usually realize. In many scientific reports of synesthesia studies, color is a simple label: yellow stands for yellow and that's it. When a synesthete reports that a letter, a sound, or another sensory stimulus is yellow, it opens a range of possible yellows. Two synesthetes may report that the letter A is yellow, yet they may perceive very different yellows, say, the orangish yellow of old cheese and the greenish yellow of a lemon.

Learning about these subtle differences was a rather painful lesson for me, one that touched on the core of the synesthesia test I was using at the time. As described, I translated the English test of consistency into Dutch and used

color space =

color tone + saturation + lightness

Figure 9.1 Scope of perceivable colors, according to the natural color system and its constituent dimensions: the round system of color tones, the horizontal axis of saturation, and the vertical axis of lightness. (Adapted from www.ncscolour.com; used with permission.) See plate 13 for color version.

it to test Dutch synesthetes on the consistency of their synesthetic colors with letters and words. I had asked participants to write color names of the synesthetic colors they perceived. But if the color name "yellow" could stand for both cheese orange-yellow as well as lemon green-yellow, I was not assessing consistency at all. To refine the test I had to find a way to measure the subtle differences in color.

The Natural Color System offered a method to quantify these subtle color differences. Clara Froger and I designed the Netherlands Color Synesthesia (NeCoSyn) method, a new consistency test with a refined measurement of synesthetic color. Instead of writing color names, we asked synesthetes to point to their color in a selection taken from the color space of the NCS. This way, we could describe and analyze the synesthetic colors far more accurately in three dimensions: color tone, lightness, and saturation.

Colors in Odors, Flavors, and Music

After refining the description of colors in the consistency test, we expanded the test to apply to colored music, colored odors, and colored flavors. We asked ourselves questions like these: Are synesthetic colors of odors different from the colors of letters? Do synesthetes perceive colors in a certain areas of the color space? We decided to start a series of explorative experiments with synesthetes.

From 2000 to 2003, we extensively tested several groups in a total of twenty-eight persons. They were selected from a larger group of people who thought of themselves as synesthetes and had responded to announcements in the newsletter "Synesthesie in Nederland" (*Synesthesia in the Netherlands*). We invited them to participate in experiments with the new Netherlands Color Synesthesia (NeCoSyn) method. This method is a consistency test for four types of synesthesia—colored letters, music, flavors, and odors—and provides a consistency score for each of the three aspects of color: tone, lightness, and saturation. The three scores are calculated for each of the four types of synesthesia, resulting in set of twelve scores for each person that together form the NeCoSyn profile of this person (for an example see figure 9.2).

In separate sessions, we exposed the participants to sounds of words, sounds of musical instruments, flavors, and odors. Flavors and odors were tasted and smelled blindfolded by the participants. After each stimulus, the participant choose three color patches from a representative selection of color patches from

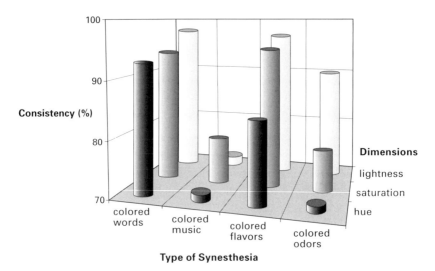

Figure 9.2 NeCoSyn profile of a synesthete. This graphic representation shows a personal profile of four types and three dimensions of synesthetic perceptions in one person: colored words, colored music, colored flavors, and colored odors. The dimensions are hue, saturation (chroma), and lightness. The consistency, or strength, of each type of synesthesia on each dimension is given as a percentages (at left). More than 90 percent indicates a strong synesthetic perception. This person has strong synesthetic perceptions for the color of words on all dimensions and for saturation and blackness, but not the hue, of tastes. (Van Campen and Froger 2003; used with permission.)

the NCS. When a subject said that the exact color was missing, we asked him or her to choose the next best match.

As we expected, the results showed that we had a selected group of synesthetes. Most participants were "colored-word synesthetes," which might have to do with the fact that this type of synesthesia gets more media attention than other types. The results of the series of the tests showed that seventeen of the twenty-eight participants had very strong consistent correspondences between letters and colors. Only seven participants had "colored-music synesthesia," five had "colored-flavor synesthesia," and four had "colored-odor synesthesia."

A surprising result came forward when we compared our results with the outcomes of the Dutch version of the Test of Genuineness (ToG). As said before, we measured synesthetic color in three dimensions instead of in one dimension, as we had done in the original ToG, and we could compare the

results of the ToG test and the NeCoSyn test for the same group of participants. The NeCoSyn discovered more synesthetes, 74 percent, than the ToG, 57 percent colored-letter synesthetes (the music, flavor, and odor types are not assessed by the ToG).

The reason for these higher percentages is that the NeCoSyn is a more refined instrument because it not only assesses synesthetic tone color, but also color lightness and color saturation. Synesthetes who consistently chose colors with the same lightness with a letter were discovered by the NeCoSyn test but not by the test of Genuineness. The same holds for consistency in saturation. This too can be explained using the NCS. According to the NCS, lightness and saturation together are the "nuance" of a color. The NeCoSyn method reveals that some persons perceive a sound of a double bass consistently in a certain nuance (of lightness and saturation) without having a specific color in mind (since they were not consistent in their choices of the color of the double bass).

In addition to the color-tone synesthetes who perceive a purple piano sound, the NeCoSyn test also discovers color-nuance synesthetes, who, say, perceive consistently a dark and filled sound of a double bass. To return to the three questions stated at the beginning of this chapter, this finding matches common sense. Few people perceive the color tones of musical instruments, but more people perceive the nuances of instruments. The larger group cannot tell whether a piano sounds purple or yellow, but they can tell the difference in darkness and saturation between, say, a double bass and a violin, and the same holds for flavors (say, honey and lemon) and odors (say, mint and fresh-baked bread).

Varieties in Form and Dynamics

Synesthetic perceptions vary not only in color nuance but also in form and dynamics, as we found out from a new session that we added to our series of synesthesia experiments. Before and after testing a group of participants on colored letters, colored music, and colored flavors, we asked them to paint their synesthetic perceptions. In a gallery, we created a laboratory setting with painting equipment where participants could translate their synesthetic perceptions evoked by letters, music, and flavors into a painting for each stimulus.

Figures 9.3 and 9.4 consist of two pairs of paintings by synesthetes. The first pair of pictures was painted by the two synesthetes Pauline Jansen and

Dorine Diemer after hearing the Dutch nonsense word "*stroep*" (English "strup"). Comparing the two pictures (figure 9.3, plate 14), you notice immediately that whereas Dorien's letters are colored, Pauline's painting shows patches of colors. Afterwards, Dorien told me that the letters *S* en *T* have no color. For her, the *O* is white and the *E* green, but because *OE* form one sound in Dutch (Similar to the long U sound in English) the green of the *E* mixes with the white of the *O* and dominates the color.

Figure 9.4 (plate 15) shows two paintings by Pauline Jansen and Katinka Regtien who both scored very high on the NeCoSyn test of "colored flavors" and are therefore considered "colored-flavor synesthetes." The stimulus for these paintings was the taste of coffee (The women were blindfolded). The pictures show interesting forms and a visual dynamic. Katinka painted an amorphous image in which two dark red points seem to rise. Pauline painted the taste of coffee as a definite blue-gray mass with a sharp line. Notice that

Figure 9.4 Colored flavors. Paintings by synesthetes Kalinka Regtien, above, and Pauline Jansen, below, after tasting coffee. (Collection of Cretien van Campen and Clara Froger.) See plate 15 for color version.

the color tone in both pictures deviates from the well-known dark brown color of coffee.

To summarize, our experiments showed that synesthetic perceptions not only vary in color dimensions but also in spatial aspects. We developed the NeCoSyn method to capture the color dimensions, but the artistic experiments showed that we should also develop a method to assess the consistency of formal and dynamic aspects of synesthetic perceptions to get a better picture.

However, to truly capture the range of expressions of synesthesia in individuals, one might be inclined to design a personal test for each individual synesthete, but then one would lose the opportunity to compare synesthetes, which is one of the main reasons for scientific research.

Nonetheless, a problem rises with the testing of synesthetes in general. The variety in synesthetic perceptions is very large, and the line between synesthetes and nonsynesthetes is getting more diffuse as research proceeds, as I argued in the former chapter. The failure to find a sharp distinction between synesthetes and nonsynesthetes does not, however, mean there are no differences between the two groups. The differences are obvious from self-reports and scientific reports. Perhaps I should look for answers that are less "black or white" and see the differences more as a gradual changing of dimensions and in terms of individual variation.

Matching Sensory Qualities

The initial questioning on the "dark" sound of a double bass already showed that a larger group in the population has an understanding or sensibility for what I call common synesthesias. Many people, not only synesthetes, are good in matching two stimuli from different sensory domains.

As early as the 1930s the Austrian ethnomusicologist Erich von Hornbostel (1877–1935) experimented with the perception of "brightness" in colors, sounds, odors, and tastes. He showed that people can match very well and consistently the perception of brightness in different sensory domains (see table 9.1).

At the Berlin Psychological Institute, which was housed in a former imperial palace in Berlin, von Hornbostel exposed his participants to an odor and asked them to choose a corresponding shade of gray on a card of grays varying from white to black. Then he asked them to chose a pitch from a series of sounds that matched the same odor. Finally, they chose a gray from the card to match the pitch. Von Hornbostel found that the grays chosen for the odor and the pitch were almost identical for all participants.

Table 9.1 Examples of Brightness Dimensions in Different Sensory Domains

Bright	Dull
Smooth	Rough
Hard	Soft
Sharp	Blunt
Light	Heavy
Cold	Warm

Several of his contemporaries found other types of sensory correspondences. The scientist A. Juhász discovered in psychological experiments that the odor of a banana corresponded with a certain high-pitched tone and that the odor of oil of cloves corresponded with a lower-pitched tone. The German psychologist Karl Zietz investigated if sounds could influence after-images. He discovered that the colors of after-images become stronger and brighter, and the flickering of the after-images increased when a high-pitched sound was heard.

Many people, not only synesthetes, can match sounds to visual shapes, as the German psychologist and physicist Wolfgang Köhler discovered in the 1940s. He asked test subjects to link the made-up words "takete" and "maluma" to one of the forms shown in figure 9.5. Almost everybody linked "maluma" to the rounded form and "takete" to the angular form. I asked my six-year-old son to draw these sounds and without having ever seen Köhler's forms he made the drawing in figure 9.6.

After the Second World War, psychologists' interest in relating such abilities to synesthesia diminished, and interest didn't start to grow again until the 1970s, when the American psychologist Lawrence Marks of Yale University pioneered a new stage in the research of synesthesia. He continued the line of German Gestalt research and revitalized the art of matching studies. Even before the renaissance of neurological interest in synesthesia in the late eighties, Marks wrote a classic on the topic, *The Unity of the Senses: Interrelations among the Modalities* (1978).

Marks and his colleagues have carried out a range of studies, in a number of which they discovered a synesthetic system in the colors associated with spoken letters, specially with vowels. By comparing and compiling many studies into vowel-color associations of synesthetes and nonsynesthetes, Marks found the

Figure 9.5 Which form do you think corresponds to the word "takete" and which one to the word "maluma?"

Figure 9.6 Drawings of the words "maluma" and "takete," by a six-year-old boy.

following order of vowels in a gradient from dark to light: *U* (in "mule") *O* (in "moat")—*A* (in "mat")—*E* (in "meet"). This order of vowel lightness seems universal: Marks found, with little variation, the same range in cultures worldwide, ranging from the language of the Huastec Indians in Mexico to African languages such as Ewe, Twi, Guang, Temne, Nmebe, and Kisi.

Common and Particular Synesthesia

These experiments show that nonsynesthetes are also capable of consistently matching stimuli from different sensory domains, which suggests that many nonsynesthetes are able to perceive some correspondences between sensory domains, just as synesthetes do.

What, then, is the difference between synesthetes and nonsynesthetes? I have discussed this difference several times with the neuropsychologist Robert Hulsman of the University of Amsterdam and he has suggested distinguishing between two types of perceptions, synesthesia and synchronesthesia. A *synesthetic* perception is the result of a stimulation of one sense that results in a multisensory perception, such as when a sound evokes a perception of color. A *synchronesthetic* perception is the result of a synchronous stimulation of two or more senses, resulting in a multisensory perception, such as when the

Synesthesia

stimulus: perceptual perception:
1 modality processing 2 modalities experience

Synchronesthesia

stimulus: perceptual perception:
2 modalities processing 2 modalities experience

Figure 9.7 Schematic representation of synesthesia and synchronesthesia, by Robert Hulsman. (Reproduced with permission.)

simultaneous perception of a melody and a visual animation on a screen evoke the feeling of a match of music and image in a person. Robert made a sketch to show me some differences in information processing by the brain in synesthesia and synchronesthesia (see figure 9.7).

This scheme shows nicely, on the one hand, why a synesthete like Floor does not like music video clips in general, and on the other hand, why a child does not need to be synesthetic to understand music animations by Malinowski and Turetsky.

When the synesthete Floor hears music (the medium gray arrow) his brain adds colors and forms (light gray arrow), so he experiences music in color and form (dark gray field in the smiley face). When he watches a music video clip, his senses are stimulated as in synchronesthesia (two arrows). But his brain is already producing a visual perception. So on top of his musical perceptions he gets two visual perceptions (two light gray arrows). If these arrows interfere with each other—say, one is producing a green color and the other a purple color—Floor gets an awkward experience of music that is green and purple at the same time. He will perceive this as a mismatch.

On the other hand, the nonsynesthetic children need the stimulation of hearing and vision to perceive a match. For instance, first they only hear a funny melody (medium gray arrow) that is going up and down in pitch. They find it hard to follow and do not really understand what is happening. Then a video (light gray arrow) is played synchronously with the music. They see colored marbles going up and down the screen in the rhythm of the melody. Their brains connect the melody and the visual movement and the children have the experience that the movements of the marbles match the musical movement. Here a mismatch can be perceived too, when, for instance, either the music or the video is played a bit slower, and the children miss the match.

I guess that synchronesthesia is a more common form of synesthesia. That children can follow classical music better with the aid of synchronic animations is due to the fact that children use their matching ability to keep track of the complex auditory dynamics of a piece of classical music by synchronizing it with their perception of a visual animation movie that was easier to follow.

So, at an early age, children already have the ability to perceive correspondences in synchronous events. But some children are synesthetic, and these children develop their personal matching programs in a very strong way. In the case of colored music, they internalize a screen. The internal screen is always at hand and helps them to structure the sounds they hear.

In several respects the internal screen of a synesthetic child who perceives sounds in color is different from a typical classroom screen, which shows a visual animation video of music. First, the internal screen of the synesthetic child is natural and not designed by an artist. The internal screen and its contents are there and act like a fact. Second, it has personal colors and forms that are only understood by the child and not by other children. The "dark" colors of the sound of double bass in a classroom video may be understood by many children, but the specific yellow color of the same instrument on the internal screen is only understood by the synesthetic child.

These differences may seem clear, though on a second look, synesthesia and synchronesthesia appear related on several dimensions of perception. Synesthesia looks like an extended form of synchronesthesia. If nonsynesthetic children can match sound and color presented externally, synesthetic children can do it internally. If nonsynesthetes can match the nuance (lightness and saturation) of a sound, the synesthetes can perceive the match of nuance and (color) tone of a sound. If nonsynesthetes can perceive the match with the aid

of a screen, synesthetes perceive it continuously with an internal screen always available. I believe the differences between synesthesia and synchronesthesia are rather more gradual than discrete.

In order to understand better the mystery of synesthesia, I would suggest not isolating synesthesia by demarcating it sharply from other perceptual phenomena, but relating it to them. Maybe perceiving music in colors is a particular type of a more common ability to match colors and sounds.

Dark Double Bass and Purple Piano

The Hidden Sense

After my wanderings in search of the meanings and functions of synesthesia, I am finally able to draw up the balance sheet, though doing so leaves me sadder but wiser. The missing link in the brain's functioning that explains synesthesia has not yet been found. Brain research proceeded quickly in the eighties and nineties, but the early successes that confirmed the physiological bases of synesthesia have not been followed up by decisive insights into the nature of synesthesia, or in practical applications in education or audiovisual technology. I learned from my wanderings through a wide range of artistic and scientific disciplines what synesthesia is not (an audiovisual performance, a trend in art or music, a drug-induced hallucination, a kind of methapor), and discovered some fascinating new aspects of synesthesia (as a tool for visual artists, musicians, and poets; as a kind of visual thinking for scientists and laymen). After closing some old windows on what synesthesia is not and opening new windows on what synesthesia might turn out to be in the future, I would like to make a short excursion into history to shed a light on the philosophical background of our current thinking of synesthesia, before presenting my current view on the nature and function of synesthesia.

A Particular Common Sense

The ancient Greek philosophers observed that humans have separate sense organs—eyes, ears, nose—but at the same time also have one undivided experience. This raised the question of how sensory experiences are unified. The

ancient philosophers did not define synesthesia in our current neurological and psychological terms, but they expressed a notion of synesthesia in posing the philosophical question: How can human beings perceive a unity in the multitude of sensory impressions?

The answer offered by the Greek philosopher Aristotle (384 BC–322 BC) not only was original then but has stayed valid to our day. Behind the exterior senses, he assumed the existence of what came to be called a *sensus communis*, which perceives the common qualities in the different exterior senses. For instance, we perceive brightness, rhythm, and intensity in images, sounds, smells, odors, and tactile sensations. By the way, our notion of *common sense*, though the modern definition is slightly different, nonetheless is derived from this concept.

Aristotle's ideas had a great influence on medieval thought at the time when a theory of the working of human perception was established known as the "three-chamber theory." The medieval Italian theologian Thomas Aquinas (1225–1274) posited the existence of three chambers in the human brain (see figure 10.1). In the first chamber the sensory impressions, sent by the exterior senses, were perceived by the common sense (*sensus communis*), which stimulated imagination (*imaginativa* and *fantasia*). In the second chamber, cognition (*cogitativa*), reason (*ratio*), and judgment (*aestimativa*) determined value with the help of former perceptions from memories (*memorativa*), which were housed in the third chamber.

This theory, which retained its power for centuries, entered Renaissance thought with only slight changes. The Italian renaissance artist Leonardo da Vinci shared the Thomist principles but he located the *sensus communis* in a more central position, within the second chamber.

The idea of a common sense explains a large part of human multisensory perceptions, but it does not explain synesthetic perceptions nor its variety among individuals. One, it is not common to perceive sounds in color; and two, the disagreement of synesthetes on, say, the "right" color of a musical tone cannot exactly derive from common sense.

During the Enlightenment and, later, the Romantic period, a number of philosophers acknowledged individual differences in the common sensory perception of the physical environment. The eighteenth-century German philosopher Alexander Gottlieb Baumgarten (1714–1762), who was the founder of aesthetics as a philosophical discipline, stated that not only the human intellect but also the human senses have the ability to know. The cognition

Figure 10.1 The human mind as concerned by Thomas Aquinas and other medieval philosophers. By Gregor Reisch, around 1503.

of the senses, however, differs from rational cognition by the human intellect because whereas the intellect uses rational principles such as logic, the senses immediately perceive aesthetic qualities in sensory impressions.

One example is the ability to perceive a melody in a series of sounds. A melody is a form that is perceived by the common sense as a meaningful unity, or *Gestalt*, as it would later be named by German philosophers. In France, the philosopher Jean-Jacques Rousseau made a similar distinction between the *raison sensitive* and the *raison intellectuelle*.

For the first time in history, philosophers regarded the senses as active, creative organs of human perception. And it was recognized that humans

differed in their abilities to use the common sense. Some people are more gifted, more creative, and more susceptible to qualities of nature than others.

In the late eighteenth century, the German philosopher Immanuel Kant (1724–1804) made an important distinction between the *sensus communis*, which he said was equal for all humans, and the *sensus communis aestheticus*, which he said showed individual differences. All people have the common sense to perceive the rhythm in a film's sequence of images or in the percussion in a musical piece, and even that these rhythms may match. Fewer people, however, have the aesthetic sense to perceive color nuances in the sound of a cello. Though these examples are taken from the present, the conceptual distinction by Kant gave room to categorize what I have called synchronesthetic and synesthetic perceptions. The *sensus communis* is a common gift to perceive matching qualities in different sensory domains (common synchronesthesia). The *sensus communis aestheticus* is a personal gift to perceive special aesthetic qualities in multisensory domains (as in personally colored sound synesthesia). The German poet and naturalist Johann Wolfgang von Goethe (1749–1832) drew on Kant's idea of the *sensus communis aestheticus* and considered it an autonomous creative force of the human imagination.

These theories were developed in the field of aesthetics. Synesthetic perceptions are not always beautiful or aesthetic according to numerous reports by synesthetes. In the beginning of the twentieth century, the aesthetic theory of gestalt perception was reformulated as a more general theory of human perception. In this view, not the idea of universal beauty was considered central to gestalt perception but rather the inner necessity of the perception. For instance, the perception of a melody is a fundamental component of anyone's perception, whether you like the melody or not.

Gestalt psychologists such as Max Wertheimer, Wolfgang Köhler, and Erich von Hornbostel and others whom we encountered in earlier chapters proposed a radical new view of human perception in the first decades of the twentieth century. According to this new view, when you look out of your open window, you do not compose your perception as from a mosaic of optical, auditory, olfactory, and tactile little precious stones, but rather you immediately perceive your view as an integral image a gestalt, of, say, horses, trees, and flowers. Only when you focus on a detail—distinct colors, figures, sounds, and smells—do you notice the component elements.

Still, this gestalt theory does not yet satisfy all the questions raised by synesthetic perceptions. Some people are more sentient than others in

perceiving gestalts in the environment, but how does one explain that one synesthete perceives the sound of a piano as a purple haze while another perceives it as the taste of a strawberry-flavored ice cream?

Around the 1950s, the French philosopher Maurice Merleau-Ponty elaborated on the individual differences in gestalt perceptions. According to his view, all human experiences are based in the human body, which explains the unity of the senses. The body is not only a physical thing but is also a subjective sense organ for each person. All kinds of stimulation of your body create responses that mingle in a flux of impressions before you become aware of them. In fact, your body shapes your sensory experience on an unconscious level (under "sea level," so to speak) and you are aware only of the tip of the iceberg. Unconscious body experience is essentially synesthetic, according to Merleau-Ponty. All sensory impressions correspond and talk to each other on a preconscious level. Out of this preconscious flux of impressions some gestalts emerge. And since everybody's body experience is personal, the emerging gestalts are similarly personal, and thus different from each other.

These gestalts are human experiential facts. Only when you start to consider them, you become aware that they are different from others, according to Merleau-Ponty. A synesthete may perceive a deep blue K, but only when he abstracts from this experience does he observe separately the color blue and the letter K and can think of the fact of their correspondence. In his initial experience, the color-and-letter combination is a gestalt, a necessary unity.

Several contemporary thinkers have articulated this philosophy of the unity of the senses in light of self-reports by synesthetes and results of scientific experiments. The American psychologist Lawrence Marks has adopted the Aristotelian idea of common sensualities, such as brightness, in his matching studies. He adheres to the theory that all sensory systems have evolved from the skin and are in fact still interconnected with this large sense organ that forms the basis for the unity of the senses.

The American neurologist Richard Cytowic has searched for a brain equivalent of this bodily unity of the senses and suggested the limbic system. This part of the brain has evolved as a function of general bodily functions such as nurturing, caring and fighting.

Finally, as heirs of Goethe's theory of the organical creative power of human perception, the German neuropsychologist Hinderk Emrich and the American neuropsychologist Vilayanur Ramachandran have pointed to the plasticity of

the brain as responsible for making possible the autonomous organization and reorganization of sensory information.

A New View

I have reached a new view on synesthesia, or, more accurately, a new perspective on a field of synesthesias, as I think that the plural form suits the variety in descriptions by synesthetes better.

Not only in my interviews but also in the discussion lists on the Internet you can observe the great variety in synesthetic descriptions. Table 8.2, listing types of synesthesia, contains more than forty categories. And even if you ask synesthetes within one category to describe their experience of, say, colored letters, the results may differ greatly in intensity, form, and location. For instance, some synesthetes will tell you that colored letters appear before their inner eye, whereas others report projections of color that lie as shadows on printed letters. The perceived colors differ in form, spatial arrangement, transparency, and solidity, intensity, and nuance. Instead of being a well-defined area of perception, synesthesia appears in these reports as a set of related perceptual phenomena that show a great variety in form and intensity.

As a consequence, syneshetes report myriad uses and advantages of synesthesia—at least, the number of reported advantages far exceeds the number of disadvantages. And although brain-scan studies have shown that synesthesia is the result of a neurological aberration, few synesthetes find their experiences to be disabilities in their daily functioning.

Nonetheless, the wide variety in types of reported synesthesia shows a cultural bias. As far as I know, no synesthete has reported odored-taste synesthesia, since that is common experience in Western culture. Westerners normally do not distinguish sharply between smells and tastes. But Western synesthetes would report colored-smell synesthesia, which is generally uncommon in Western culture. Conversely, the Desana in the Amazon area commonly experience smell in color ("color energies") and so they would not report that as an uncommon synesthesia. This example shows that reports of synesthesia may be partly biased by the culture one lives in.

Not all synesthetes are equally aware of their synesthetic perceptions. We rely on the reports by self-conscious synesthetes. Obviously, you need to be aware of your synesthetic perceptions to report them. Many synesthetes only become aware of their synesthesia when, in the course of social interaction with

family and peers at an early age—when they are about five or six years old—they realize that it is a perceptual oddity. After this first sudden discovery, synesthetes become aware of more aspects of their synesthesias, often in social exchange with other synesthetes. Some grown-up synesthetes report that they still discover new layers in their synesthetic perception of the physical environment.

Inspired by the theory of Merleau-Ponty, I picture the wide variety of synesthesias as conscious or semiconscious sustainable, solid, perceivable gestalts that emerge like shapes in the stream of a river. They are layered, come clear to the surface, or lie just beneath it. When they make sense, they are solidified, are fixated as gestalts in daily perception, like a familiar melody. Once you have perceived a melody in separate notes, each time you hear this sequence of notes you perceive the melody forever as a unity instead of its constituents parts.

In general, people are not aware of all their perceptions. And synesthetes are not aware of all their synesthetic perceptions, either. When you get older you become more aware of the layeredness of the tangible world. As a child you perceive, say, red and blue. As you get older you learn to distinguish many kinds of blues and reds. Your awareness of the perceptible world is deepened and refined. In this way, not all synesthesias will be perceptible from childhood. Not that you were not able to see them as a child, but as you grow up you are more aware of their existence. Many synesthetes remember their synesthesias in childhood, but only became aware of them as such when they, say, read an newspaper article on synesthesia.

Our awareness of the number of sensory organs might serve as an analogy. Most people are aware of five senses: vision, hearing, taste, smell, and touch. When additional senses, such as movement and equilibrium, are mentioned, people easily become aware of more sense organs. They have always used these sense organs, but they were not really aware of them.

The same holds for synesthesia and other multisensory perceptions. To a certain extent, people can become aware of the "darkness" of sounds or of the musical rhythm in visual animations. To a limited extent people are simply not aware of many synesthesias because they have never paid serious attention to them. Most people are only familiar with a small number of provinces of the empire of the senses. It is as though your conscious perception were limited to a little garden in the middle of a jungle. You taste the five types of vegetables that you grow in the garden and overlook the exotic fruits in the surrounding jungle.

I do not think that every person can become aware of all types of synesthesia. There are obviously brain constraints on that. But I do think that many persons are not aware of their synesthetic potential, simply because they use only a portion of their senses.

In general people link their sensory perceptions to exterior senses; color perceptions to their eyes or sound perception to their ears. Synesthesia is not connected to an exterior sense organ. Synesthetic experiences do not enter the body at one point, whence they flow to consiousness. Synesthesia is not grounded in an external sense organ. It is not an ordinary sensory function. Synesthesia operates in the area between the senses. Its etymology—*syn* together; *esthesia*-perceiving—refers to this function. The sense of synesthesia is not observable at the exterior human body but lies hidden beneath the senses. It remains hidden in most people who do not have synesthetic perceptions. But in some it stands up and they perceive synesthesia consciously.

Finally, these and other observations served me as steps to a new view on the wide panorama of personal reports of synesthesias. I have become to see them as personally developed abilities to perceive uncommon multisensory gestalts in the physical environment. I would compare this ability to a hidden sense. However, it may take a person a lifetime to unvell the hidden sense that allows her to perceive synesthesias in the physical environment.

Enjoying, Knowing, and Creating

So far, my discussion has been quite theoretical. At this point I would like to show how my view of the nature of synesthesia brings a number of more or less known functions of synesthesia into perspective. These functions can be applied in daily uses of the senses by children and grown-ups.

We are all familiar with the functions of the five well-known senses. The ears draw our attention to relevant and pleasant auditory patterns, the nose smells danger in noxious odors, and the tongue prevents us from poisoning ourselves. But what can be the function of synesthesia?

One can approach this question from a philosophical angle. We already encountered several philosophers who have written on the aesthetic functions of the *sensus communis aestheticus*. First, there is the hedonic function of pleasure and joy from the experience of synesthetically perceiving music in three-dimensional colored and textured patterns, for instance. Second, there is the cognitive function of perceiving meaningful gestalts that remain hidden to

other persons. Think of calculating in colored numbers or planning an agenda in colored shapes of months, weeks, and days. And third, there is the creative function of perceiving a set of elements in a different gestalt with new meanings and then using this as an input for artistic expression.

In my interviews with synesthetes, I nearly always asked them what they thought the functions of their synesthetic perceptions were in their daily lives. I liked using that practical approach, in addition to the philosophical approach. I met Patrick, who loves the music of Prince because of the beautiful images that the sounds evoke for him, which illustrates the aesthetic function of synesthesia. Later, I spoke with Dorine, who uses her synesthesia to analyze musical structures in her study at the academy of music. Primary school teachers told me that children do something like what Dorine does when they are introduced to classical music in school. Children learn very quickly to perceive corresponding music and visual animations. The physicist Richard Feynman perceived formulas in color and used these perceptions in his visual thinking. By the way, you do not need to be a Nobel Prize winner to use them that way: Katinka and David use their colored-number forms in mental arithmetic and in planning their agendas. These are all examples of the cognitive function of synesthesia.

The creative function is illustrated by a number of examples of poets and novelists who use synesthesia as a source of inspiration. Vladimir Nabokov is the most famous novelist among those who have discussed using their synesthesia in this way. I found several poets, including Hans Andreus and the poets of the Group of Fifty in the Netherlands, who considered synesthesia as a self-evident kind of perception. Earlier, the visual artists Wassily Kandinsky and Paul Klee discovered synesthetic perception as a source of original art forms. They developed a visual language based on their synesthetic perceptions and explorations of multisensory perceptions. Their contemporary Piet Mondrian experimented with the correspondences of visual line patterns and auditory rhythms in jazz.

These and other examples from the preceding chapters might give you a taste or let you feel what the philosophers have meant when they spoke of the hedonic, cognitive, and creative functions of the synesthesia.

Awareness of Synesthesia

Can you become aware of synesthesia? Yes indeed, though it may take a long time and a lot of concentration. You have to learn without examples, because

synesthesia is personal, and there is no educational program available to help you. You will have to find it all by yourself. You cannot imitate another synesthete or follow his or her suggestions, either.

One way to begin is to become aware of common sensual correspondences like those in the rhythms in music and film or the correspondences in the "brightness" of the sound of vowels and colors. Once you have trained yourself to be aware of these common sensualities, you can start to explore your personal sensualities and perhaps discover your synesthesias, though no guarantees can be given, of course.

It may sound strange to hear that you can become aware of a neurological phenomenon that seems fixed and hand-wired. To the contrary, the brain is flexible and will develop multisensory connections that are meaningful and are used by you. Synesthesia is hidden in your senses. You will have to explore and go looking for it to consciously experience it.

Though the awareness of synesthesia most commonly emerges in childhood, I believe you can become aware of it and start to use it at any age. Synesthetes report that they have become aware of their synesthesias in all stages of life. Some discover their synesthetic gifts as preschool children, some in the years when they learn language and math in school, and some as grown-ups. Nonetheless, when adults become aware of it, they report that it was already existent in their childhood.

Presumably everyone is born with a kind of synesthesia, the experience of the primordial sensory soup. During the first year of life, this general synesthesia apparently is cut back or pruned to fewer intersensory connections. In the second year and later, the synesthetic connections will only survive when they probably are useful to the child; otherwise they are pruned away. So at a young school age everybody will have a number of neural synesthetic connections, some more than others, and some people are more aware of it than others. Several children know already at the age of seven that their numbers are colored, whereas other children only realize it decades later, when they are tested with a consistency test for colored numbers, for instance.

For a number of children in the ages of about three to six, it is quite normal for music to have colors, tastes, or smells. You can ask young children and perhaps they will tell you about it. Children make beautiful paintings based on these perceptions, like the ones we saw in chapter 3.

When children go to primary school and start to learn cognitive skills such as writing and calculating, their synesthetic gifts seem to subside into the

background. The cognitive training asks much of their concentration and energy. Little energy is left to explore their sensory skills. Take, for example, the decrease in drawing skills and imagination at that age, which is reported by teachers and child psychologists alike.

Learning the letters of the alphabet and counting numbers is an important moment in the development of children and in particular of synesthetes, because at this phase the symbols get their solidified colors. It is the earliest age synesthetes can remember consciously when numbers and letters have their particular colors and shapes.

During the school years and adolescence, socialization becomes a factor in the awareness of synesthesia. Children do not like to be different from their peers. They do not want to be ridiculed. Announcing that you perceive letters and numbers in color may seem rather deviant in the eyes of the other children your age. Little is known of the social processes that influence the awareness of synesthesia. So far, scientists have been more interested in the neurological and perceptual aspects and less in the social development of young synesthetes.

Even among adults, the reactions of others play an important role in the way synesthetes deal with their perceptual gifts. Only a few decades ago synesthetes would regularly consult neurologists for medical advice concerning their "deviant perceptions." In this medical setting, synesthesia was often considered a neurological deviance or a rare disease by nonsynesthetes. The neurological label that has been attached to synesthesia might still inhibit a number of synesthetes from speaking freely about their synesthetic perceptions. In this light, it is revealing that relatively more synesthetes in liberal and artistic communities report in public on their synesthetic abilities.

In general, people's reactions to the confessions by synesthetes are still stigmatizing. Do not underestimate the number of people who think that synesthesia is a mental handicap. Moreover, because synesthesia is not visible, people often doubt the veracity of what synesthetes report: "Behave normally" is a common reaction.

The fact is that synesthetes do behave normally. It is people in their social surroundings who react strangely to their confessions. Hopefully, once synesthetes get recognition. Eventually they may be compared to late medieval artists who started to see and use linear perspective in their paintings, and who were stigmatized and ridiculed at that time. Now, we honor them as innovators who taught us to see the visual world in new ways.

Awakening to the multisensory perceptions is one key to synesthesia, but other keys are exposing yourself to new sensations, not being ashamed, expressing your synesthesia, communicating it to others, being able to experiment with it—all are important in the learning process that starts somewhere in childhood with the neurological development of multisensory connections and continues as a lifelong journey in becoming aware of all synesthesia's sensory aspects.

What Is Learned in the Cradle Lasts Till the Tomb

Young children look at the world differently than adults do. For preschool children, the boundaries between themselves and their surroundings are less sharp than for grown-ups. As we know, preschool children and even some children of the primary school age perceive their environment as a magical world where puppets and castles come alive. The same holds for their bodies and the incorporated senses. Compared to grown-ups, children are less aware of their body as an entity separate from the environment. In their perception, an "angry castle" may move forward and make growling sounds when it smells the dragon in the mountains. This is an example of a perception that can be very vivid for a young child. I do not say that children cannot distinguish between images and sounds, but only that the boundaries between the senses, their bodies, and the outside world can be more or less sharp from day to day, and from one mood to another. The child can even act out being the "angry castle."

Grown-ups are more analytical. If they sense their synesthesias, they will analyze their perceptions into the well-known sensory categories. Saying that you perceive colored sounds implicitly contains the analysis of the original perception into two categories: colors and sounds. Young children do not yet perceive in an analytical way and an adult might have great difficulty explaining to a young child that his or her perceptions consist of separate elements like colors and sounds. For the child, the color and sound form an indivisible whole, a gestalt that cannot be separated into elements without losing its meaning and sense. And I must say, the child is right. The adult sticks to a theory of synesthesia, while the child sticks to the original perception. Young children do not often distinguish between sensory domains in their perceptions: a smelling sound may be as real for a child as a green rectangle—who knows?

Once children go to school, their sensory development is squeezed between the main lessons in cognitive development and the less-valued lessons in

physical development. In the end, children are judged in school on their cognitive skills, not on physical and sensory skills. Most schools pay little attention to the sensory development of their children. The ability of children to know the world not only by means of words and numbers but also by their own senses, let alone the awareness of their synesthetic abilities, is hardly developed at school. Consequently, multisensory development is in effect halted by neglect. I believe that children would profit from a rebalancing of cognitive and physical-sensory skills in the school program. They would have more opportunities to preserve their synesthetic talents and develop them.

For a long time we have taught our children at school that sensory experiences are separated into five senses according to the Western division, which is based on the exterior characteristics of eyes, ears, mouth, nose, and skin. We do not teach children to follow their own senses and we do not encourage them to explore their multisensory experiences of the environment. How different is it for the children of the Desana, who grow up in a culture where they are familiarized from the cradle with the multisensory color energies of objects? It is this difference that makes the Desana children more aware of the "synesthetic" color energies of sounds, tastes, and odors than their North American and European peers.

When Western children enter adolescence they start looking for new stimuli, to explore and test their environments. New and experimental art forms are challenges for their brains. Experimental art forms disorder the regular ways of perceiving via the five sensory domains that they have learned in school and open ways to multisensory perceptions in audiovisual art forms, for example. It is easier to discover colored patterns in a new piece of electronic music by Jan Boerman than in the well-known *Four Seasons* by Vivaldi because they have learned from their parents and teachers how to listen to Vivaldi, but not how they should listen to Boerman's work. Experimental art forms have a viable function in helping people find new ways of experiencing and perceiving.

As I have said, the school system has a large share of the responsibility for how children and adolescents develop their senses and awareness. In addition, the social surroundings of the youngsters play a role in the way uncommon sensory perceptions such as synesthesia are accepted. The social surroundings can make the difference between accepting and hiding your synesthesia, between joy and shame, between the experience of having a gift or having a handicap. Youngsters like to belong to significant groups, so when

your friends laugh at you because you see numbers in colors, you might hold these confessions back. And this socialization of synesthesia starts in family life. Sometimes, mothers who understand their synesthetic children figure in the stories of the discovery of their synesthesia by synesthetes, who are not afraid to talk in public about their unusual perceptions. Think of how lovingly Vladimir Nabokov describes his mother, who patiently questions her son on his synesthetic gifts, which she partly shares with him.

Synesthesia can become a gift when someone knows how to use it in daily life. It can become a handicap when the person cannot do something significant with it and he or she experiences it as a burden. And of course there is an unknown number of synesthetes who are not or do not want to be aware of their synesthesias.

Even in older age, it is still possible to learn how to become aware of synesthesia. Tony di Caprio, whom we met in chapter 2, had a long career as a musician before he became aware of the specific colors of musical notes. But since that time he has used the colors in his music making and he finds composing and performing music easier now.

The very old may discover, when the mechanical apparatus of the senses starts to fall, that new synesthetic resources may open up. The mechanics of the senses may show hitches, but the sensitivity of the senses continues to develop until a very advanced age. Think of the famous conductors of symphony orchestras who in their seventies and eighties find new interpretations of classical pieces. Perhaps they have discovered new colors and textures in the notes they have had been playing for decades? No one is never too old to enjoy life and discover new sensualities in the rich multisensory environment.

My Synesthesia

Since synesthesia is so personal, my ideas remain humble pieces of pedagogical advice. I cannot predict how a synesthete will become aware of his or her synesthesias. In fact, I can only speak for myself.

It took me many years to become aware of my synesthesias; it was a sensibility hidden under many layers of daily perceptions. One of the reasons it took so long to reveal itself was that I was misled at first by the Western theory of the senses and later by scientific theories of synesthesia. Since I grew up with the belief that the senses are separate, I concentrated on developing my sensory awareness within the five well-known categories. I taught myself

to distinguish more nuances of color or I taught myself to distinguish the musical styles of classical composers, but I never combined these interests in the nuances of colored sounds of classical pieces.

Then I learned about synesthesia and became fascinated by its theory linking color tones like blue and red to musical notes like A and F. And still, I did not notice my own synesthesia, because scientific research articles had taught me that synesthetes perceived musical notes in color tones. And I did not perceive that type of synesthesia. Only when I left the theories aside and reconsidered my musical experiences introspectively did I realize that sounds have nuances, textures, and forms for me. These perceptions did not strictly fit into the then-accepted synesthetic combinations like colored letters or colored sounds reported in journals, magazines, and Web sites under the heading "genuine synesthesia." I was also misled by the theory that synesthesia is congenital, that you either have it at birth or not at all. In addition, the accepted theory implied that every synesthete was aware of his or her synesthesia early on, in childhood. Now, I realize that the assumed sharp line between the group of "synesthetes" and "nonsynesthetes" is in fact blurred. Moreover, even within the group of synesthetes, not all individuals are aware of their synesthesia in childhood. Some people recognize it in early childhood, while others recognize it decades later. In addition, even among synesthetes who recognize it early, there are other forms of synesthesia they have that they only slowly become aware of over time, according to biographical reports. Synesthesia is not like a digital bit in a computer that is either zero or one. It is a personal ability that can turn from a slumbering state of being half awake to a sudden full, bright, conscious awareness. In addition, certain types of synesthesia may follow different time paths and may take decades to reveal themselves.

In my case, it took me decades to become aware of my first type of synesthesia, the perception of textured music. Once I cognized that one, however, others followed more rapidly: textured taste and textured odors. Then, nuances and spatial forms of sounds followed. The sounds lack distinct colors, but have some nuances, such as wrinkling in a ray of light. I have looked for colors, but when I see them, they are always very light or very dark, so it is hard for me to distinguish a hue. They move to the foreground against a lighted cloudy background and are always in movement, like coils in the wind, or, when slower, as if the coils were under water, but they seldom come to a standstill. This play of textured sounds is situated in a mental space and not in front of my eyes. Only when I close my eyes does it feels as though the images are before my eyes.

Sometimes I ask myself why I have discovered synesthesia only after so many years. If I had not read about synesthesia, would I still be unaware?

Many synesthetes are aware of their synesthetic gifts and only learn they have a scientific name when they read about the phenomenon or meet other synesthetes who talk about their perceptions. As I said, my type of synesthesia had not been described in the media when I started to study the subject. In a way, this lacuna postponed my awareness, and the same may be true for more synesthetes who read about it now that it is frequently discussed in the media. But I notice that the media mention only a narrow range of the possible synesthesias. Most of the time, only colored letters and numbers are described. Therefore, possibly a number of synesthetes watching and reading these publications could think as I did in the beginning: that it is an interesting subject but one that does not apply to me.

Looking backward, my awareness of my own synesthesia has been a gradual process of awakening that has occurred during the search that I have described in this book. By consciously analyzing my sensory perceptions, comparing them with those of other synesthetes, by testing my senses and exposing them to new artistic stimuli and carefully observing how they responded, by reviving memories of some childhood experiences, I have been slowly finding a track that leads me to my personal conclusions and views on synesthesia—or, better, synesthesias. In little leaps of understanding, I have come to realize what my synesthesias mean to me and how they are related to my broader perception of the physical environment.

By taking uncommon perceptions for granted and not automatically pushing them aside as irrational moments or as hitches in the system, the meanings of my synesthesias had the time to blossom and show their beauty. By my questioning of my sensory perceptions of the world, by means of my testing them in little experiments, the synesthetic perceptions were able to grow to full stature and acquire sharp and distinct features.

When I started my search for the meaning and use of synesthesia I could not imagine how it feels to be a synesthete—for instance, to perceive a purplish piano sound. Now that I have been seeing how the sound produced by a bow on a violin string can scratch edged lines in a white hazy space, I have a better understanding.

Bibliography

Sources are listed by chapter. Publications that are sources for more than one chapter are under the "General" heading. For further reading, a survey of over four hundred books, articles, and Web links on synesthesia and art is available online at the Leonardo Bibliography: Synesthesia in Science and Art Web site, http://lbs.mit.edu/isast/spec .projects/synesthesiabib.html.

General

Adler, H., and U. Zeuch. *Synästhesie: Interferenz, Transfer, Synthese der Sinne.* Würzburg: Königshausen & Neumann, 2002.

Baron-Cohen S., and J. E. Harrison, eds. *Synaesthesia: Classic and Contemporary Readings.* Cambridge: Blackwell, 1997.

Brougher, B., J. Strick, A. Wiseman, and J. Zilczer, eds. *Visual Music: Synaesthesia in Art and Music Since 1900.* London: Thames & Hudson, 2005.

Cytowic, R. E. *The Man Who Tasted Shapes.* Cambridge, Mass.: MIT Press, 1998.

—. *Synaesthesia: A Union of the Senses.* Cambridge, Mass.: MIT Press, 2002.

Duffy, P. L. *Blue Cats and Chartreuse Kittens: How Synesthetes Color Their World.* New York: Henry Holt, 2001.

Dann, K. T. *Bright Colors Falsely Seen: Synaesthesia and the Search for Transcendental Knowledge.* New Haven: Yale University Press, 1999.

Emrich, H. M., U. Schneider, and M. Zedler. *Welche Farbe hat der Montag?* Stuttgart: Hirzel, 2002.

Harrison, J. *Synaesthesia: The Strangest Thing.* Oxford: Oxford University Press, 2001.

Marks, L. E. *The Unity of the Senses: Interrelationships Among the Modalities.* New York: Academic Press, 1978.

Maur, K. von. *The Sound of Painting.* Munich: Prestel, 1999.

Ramachandran, V. S. *A Brief Tour of Human Consciousness: From Impostor Poodles to Purple Numbers.* New York: Pi Press, 2004.

Robertson , L. C., and N. Sagiv, eds. *Synesthesia: Perspectives from Neuroscience.* New York: Oxford Press, 2004.

Ward, J., and J. B. Mattingley. "Synaesthesia: An Overview of Contemporary Findings and Controversies, " *Cortex* 42, no. 2(2006): 129–36.

Chapter 1 Introduction

Brougher, B., J. Strick, A. Wiseman, and J. Zilczer, eds. *Visual Music: Synaesthesia in Art and Music Since 1900.* London: Thames & Hudson, 2005.

Cytowic, R. E. *Synaesthesia: A Union of the Senses.* Cambridge, Mass.: MIT Press, 2002. General introduction to the neurology of synesthesia.

Gage, J. "Making Sense of Colour: The Synaesthetic Dimension." In *Colour and Meaning: Art, Science and Symbolism.* Oxford: Thames & Hudson, 1999.

Harrison, J. *Synaesthesia: The Strangest Thing.* Oxford: Oxford University Press, 2001. General introduction to the neurology of synesthesia.

Maur, K. von. *The Sound of Painting.* Munich: Prestel, 1999.

Chapter 2 Music Video Clip without TV

Aleman, A. et al. "Activation of Striate Cortex in the Absence of Visual Stimulation: An fMRI Study of Synesthesia." *Neuroreport* 12, no. 13(2001): 2827–30.

Berman, G. "Synesthesia and the Arts." *Leonardo* 32, no. 1(1999): 15–22.

Bernard, J. "Messiaen's Synaesthesia: The Correspondence Between Colour and Sound Structure in his Music." *Music Perception* 4, no. 1(1986): 41–68.

Boerman, J. *Vlechtwerk.* Compact disc. NM Classics, 1988. See Boerman's notes on the composition *Tellurisch.*

Duffy, P. L. *Blue Cats and Chartreuse Kittens: How Synesthetes Color Their World.* New York: Henry Holt, 2001.

Floros, C. *György Ligeti: Jenseits von Avantgarde und Postmoderne.* Vienna: Lafite, 1996.

Grout, D. J., and C. V. Palisca. *A History of Western Music.* New York: Norton, 1996.

Leonardo Online Bibliography: Synesthesia in Art and Science. Web Site. http:// lbs.mit.edu/isast/spec.projects/synesthesia.bib.html.

Mahling, F. "Das Problem der 'Audition colorée': Eine historisch-kritische Untersuchung." *Archiv für die gesamte Psychologie* 57(1926): 165–301.

Mattingley, J. B., J. M. Payne, and A. N. Rich. "Attentional Load Attenuates Synaesthetic Priming Effects in Grapheme-Colour Synaesthesia." *Cortex* 42, no. 2(2006): 213–21.

Messiaen, O. *Music and Color: Conversations with Claude Samuel.* Portland, Oregon: Amadeus Press, 1993.

Sagiv, S., J. Heer, and L. Robertson. "Does Binding of Synesthetic Color to the Evoking Grapheme Require Attention?" *Cortex* 42, no. 2(2006): 232–42.

Tonecolor–Visual, Music, Arts Web site. http://www.imaja.com/change/tonecolor. On "music visualizers."

Vanechkina, I. L. "Musical Graphics as an Instrument for Musicologists and Educators." *Leonardo* 27, no. 5(1994): 437–39.

Chapter 3 Children Draw Music

Maurer, D., and C. Maurer. *The World of the Newborn.* Basic Books, 1988.

Maurer, D., and C. J. Mondloch. "Neonatal Synesthesia: A Re-evaluation." In *Synesthesia: Perspectives from Neuroscience*, edited by L. C. Robertson and N. Sagiv. New York: Oxford University Press, 2004.

Maurer, D., T. Pathman, and C. J. Mondloch. "The Shape of Boubas: Sound-Shape Correspondences in Toddlers and Adults." *Developmental Science* 9(2006): 316–22.

Maurer, D. "Neonatal Synesthesia: Implications for the Processing of Speech and Faces." In *Developmental Neurocognition. Speech and Face Processing in the First Year of Life*, edited by B. D. Boysson-Bardies et al. Dordrecht: Kluwer, 1993.

Mondloch, C., and D. Maurer. "Do Small White Balls Squeak? Pitch-Object Correspondences in Young Children." *Cognitive, Affective, and Behavioral Neuroscience* 4(2004): 133–36.

Paashuis, E. et al. *The Taste of Mother's Voice*. Television documentary. Broadcast 26 June 2002 on Dutch public television (VPRO). Available online at http://noorderlicht.vpro.nl/afleveringen/6506792.

Pascual-Leone, A., and R. Hamilton. "The Metamodal Organization of the Brain." *Progress in Brain Research* 134(2001): 427–45, 2001.

Smilack, Marcia. Web site. http://www.marciasmilack.com.

Steen, C. "Visions Shared: A Firsthand Look into Synesthesia and Art." *Leonardo* 34, no. 3(2001): 203–8.

Sur, M., S. L. Pallas, and L. Roe. "Cross-Modal Plasticity in Cortical Development: Differentiation and Specification of Sensory Neocortex." *Trends in Neuroscience* 13(1990): 227–33.

Vanechkina, I. L. "Musical Graphics as an Instrument for Musicologists and Educators." *Leonardo* 27, no. 5(1994): 437–39.

Sur, M., and C. A. Heamey. "Development and Plasticity of Cortical Areas and Networks" *Nature Reviews Newoscience* 2(2001): 251–62.

Sur, M., P. E. Garraghty, and A. W. Roe. "Experimentally Induced Visual Projections into Auditory Thalamus and Cortex." *Science* 242(1988): 1437–41.

Chapter 4 Visual Music

Collopy, F. "Color, Form, and Motion. Dimensions of a Musical Art of Light." *Leonardo* 33, no. 5(2000): 355–60.

—. Rhythmic Light. Web site. http://rhythmiclight.com/ index.html.

Düchting, H. *Farbe am Bauhaus: Synthese und Synästhesie*. Berlin: Gebrüder Mann, 1996.

Evers, F. "Muziek en de eenheid der kunsten." In *Muziekpsychologie*, edited by F. Evers, M. Jansma, and B. de Vries. Assen, Netherlands: Van Gorcum, 1995. See pp. 313–38.

Ferwerda, R., and P. Struycken. *"Aristoteles" Over kleuren*. Budel, Netherlands: Damon, 2001.

Franssen, M. "The Ocular Harpsichord of Louis-Bertrand Castel. The Science and Aesthetics of an Eighteenth-Century Cause Célèbre." *Tractrix* 3(1991): 15–77.

Gage, J. "Making Sense of Colour: The Synaesthetic Dimension." In *Colour and Meaning: Art, Science and Symbolism*. Oxford: Thames & Hudson, 1999. See pp. 261–68.

—. *Colour and Culture: Practice and Meaning from Antiquity to Abstraction*. London: Thames & Hudson, 1993.

Galeyev, B., and I. L. Vanechkina. "Was Scriabin a Synesthete?" *Leonardo* 34, no. 4(2001): 357–61.

Gombrich, E. H. *Art and Illusion: A Study in the Psychology of Pictorial Representation*. Oxford: Phaidon Press, 1960.

Gouk, P. *Music, Science and Natural Magic in Seventeenth-Century England*. New Haven: Yale University Press, 1999.

Struycken, P. et al. *Skrjabins visioen (Scriabin's Vision)* and *Prometheus: een gedicht van vuur (Prometheus: A Poem of Fire)*. Documentaries. Broadcast on Dutch Public Television (NPS), 26 September 1999, and 3 October, 1999.

Hahl-Koch, J. "Kandinsky, Schönberg und der 'Blaue Reiter.'" In *Vom Klang der Bilder*, edited by K. von Maur. Munich: Prestel, 1985.

Heyrman, H. "Art and Synesthesia: In Search of the Synesthetic Experience." Paper presented at the First International Conference on Art and Synesthesia in Europe, University of Almería, Spain (25–28 July 2005).

Ione, A. "Kandinsky and Klee: Chromatic Chords, Polyphonic Painting and Synesthesia." *Journal of Consciousness Studies* 11, no. 3–4(2004): 148–58.

Ione, A., and C. W. Tyler. "Was Kandinsky a Synesthete?" *Journal of the History of the Neurosciences* 12(2003): 223–26.

—. "Neuroscience, History and the Arts. Synesthesia: Is F-sharp Colored Violet?" *Journal of the History of the Neurosciences* 13(2004): 58–65.

Jewanski, J. "What is the Color of the Tone?" *Leonardo* 32, no. 3(1999): 227–28.

Jewanski, J., and N. Sidler, eds. *Farbe, Licht, Musik: Synaesthesie und Farblichtmusik*. Bern: Peter Lang, 2006.

Haverkamp, M. "Synästhetische Wahrnehmung und Geräuschdesign. Grundlagen: Verknüpfung auditiver und visueller Attribute." In *Subjektive Fahreindrücke sichtbar machen II*, edited by K. Becker. Haus der Technik Fachbuch 12. Renningen-Malmsheim, Germany: Expert-Verlag, 2002.

Kandinsky, W. "Der gelbe Klang: Eine Bühnenkomposition von Kandinsky." In *Der blaue Reiter*, edited by Wassily Kandinsky and Franz Marc. Munich: Piper, 1912.

Klein, A. B. *Colour Music. The Art of Light*. London, 1926.

Maur, K. von. *The Sound of Painting*. Munich: Prestel, 1999.

Mondriaan, P. "De jazz en de neoplastiek." In *Internationale Revue i10*. 1927; reprint, The Hague: Bert Bakker, 1963.

Moritz, W. *Optical Poetry: The Life and Work of Oskar Fischinger*. Bloomington: Indiana University Press, 2003.

Myers, C. S. "A Case of Synaesthesia." *British Journal of Psychology* 6(1914): 228–32.

Newton, I. "An Hypothesis Explaining the Properties of Light." 1675. Text available at http://www.newtonproject.ic.ac.uk/texts/viewtext.php?id=NATP00002&mode=normalized.

Peacock, K. "Alexander Scriabin's Color Hearing." *Music Perception* 2, no. 4(1985): 483–506.

—. "Instruments to Perform Color-Music: Two Centuries of Technological Experimentation." *Leonardo* 21, no. 4(1988): 397–406.

Poling, C. V. *Kandinsky—lessen aan het Bauhaus: kleurentheorie en analytisch tekenen*. De Bilt, Netherlands: Cantecleer, 1983.

Révész, G. *Inleiding tot de muziekpsychologie*. Amsterdam: Noord-Hollandsche Uitgevers Maatschappij, 1944.

Sweeney, J. J. "Piet Mondrian." In *Piet Mondrian*. Pamphlet. New York: MOMA, 1945.

Uitert, E. van. "Beeldende kunst en muziek: de muziek van het schilderij." In *Kunstenaren der idee: symbolistische tendenzen in Nederland*, edited by C. Blotkamp. The Hague: Haags Gemeentemuseum, 1978. See pp. 67 and 69 for quotes by Delacroix and De Winter.

Chapter 5 Calculating in Colors

Arnheim, R. *Art and Visual Perception: A Psychology of the Creative Eye*. Berkeley: University of California Press, 1954.

—. *Visual Thinking*. Berkeley: University of California Press, 1969.

Cytowic, R. *Synaesthesia: A Union of the Senses*. Cambridge, Mass.: MIT Press, 2002. See pp. 181ff.

Dehaene, S. *The Number Sense. How the Mind Creates Mathematics*. New York: Oxford University Press, 1997.

Dixon, M. J., et al. "Five Plus Two Equals Yellow." *Nature* 406, 27 July 2000: 365.

—. "The Role of Meaning in Grapheme-Colour Synaesthesia." *Cortex* 42, no. 2(2006): 243–52.

Duffy, P. L. *Blue Cats and Chartreuse Kittens: How Synesthetes Color Their World.* New York: Henry Holt, 2001. See pp. 70–71.

Feynman, R. *What Do You Care What Other People Think?* New York: Norton, 1988. Quote on page 59.

Galton, F. *Inquiries into Human Faculty and Its Development.* London: Macmillan, 1883.

Jepma, M. *Colours Count for Synaesthetes: Evidence for Bidirectionality in Colour-Graphemic Synaesthesia.* Unpublished paper. University of Groningen, 2006.

Kadosh, R. C., et al. "When Blue Is Larger Than Red: Colors Influence Numerical Cognition in Synesthesia." *Journal of Cognitive Neuroscience* 17(2005): 1766–73.

Knoch, D., et al. "Synesthesia: When Colors Count." *Cognitive Brain Research* 25(2005): 372–74.

Mills, C. B., et al. "Digit Synaesthesia: A Case Study Using a Stroop-Type Test." *Cognitive-Neuropsychology* 16, no. 2(1999): 181–91.

Ramachandran, V. S., and Ed Hubbard. "Psychophysical Investigations into the Neural Basis of Synaesthesia." In *Proceedings of the Royal Society of London* B 268(2001): 979–83.

—. "Synaesthesia: A Window into Perception, Thought and Language." *Journal of Consciousness Studies* 8, no. 12(2001): 3–34.

Sagiv, N., et al. "What is the Relationship between Synaesthesia and Visuo-Spatial Number Forms?" *Cognition* 101(2006): 114–128.

Wertheimer, M. *Productive Thinking.* New York: Harper, 1945.

Chapter 6 Poetic Synesthesia

Ackerman, D. *A Natural History of the Senses.* Vintage, 1990.

Andreus, H. *Verzamelde gedichten.* Amsterdam: Bert Bakker, 2001.

Brems, H. *Lichamelijkheid in de experimentele poëzie.* Hasselt, Belgium: Heideland-Orbis, 1976.

Classen, C. *Worlds of Sense.* London: Routledge, 1993.

Dann, K. T. *Bright Colors Falsely Seen: Synaesthesia and the Search for Transcendental Knowledge.* New Haven: Yale University Press, 1999.

Day, Sean A. "Synaesthesia and Synaesthetic Metaphors." *Psyche* (online journal) 2(1996), http://psyche.cs.monash.edu.au/ v2/psyche-2-32-day.html.

Draaisma, D. *Metaphors of Memory: A History of Ideas About the Mind.* Cambridge: Cambridge University Press, 2000.

Durie, B. "Senses Special: Doors of Perception." *New Scientist* 29 (January 2005).

Evers, F. "Muziek en de eenheid der kunsten." In *Muziekpsychologie*, edited by F. Evers, M. Jansma, and B. de Vries.Assen, Netherlands: Van Gorcum, 1995. See pp. 313–38.

Hettinga, T. *Vreemde kusten / Frjemde kusten.* Amsterdam: Atlas, 1995.

Howes, D. (ed.) *Empire of the Senses. The Sensual Culture Reader.* Oxford: Berg, 2005.

Lakoff, G., and M. Johnson. *Metaphors We Live By.* Chicago: University Of Chicago Press, 2003.

Lemaire, T. *Met open zinnen: Natuur, landschap, aarde.* Amsterdam: Ambo, 2002.

Nabokov, V. *Speak, Memory!* New York: Putnam, 1966.

Révész, G. *Inleiding tot de muziekpsychologie.* Amsterdam: Noord-Hollandsche Uitgevers Maatschappij, 1944. See p. 156.

Soesmans, A. *De twaalf zintuigen: Poorten van de ziel.* Zeist, Netherlands: Vrij Geestesleven, 1998.

Vloet, C. "Een zwak voor havens. Gesprek met de Friese dichter Tsjebbe Hettinga." Interview. NRC, November 28, 2003.

Chapter 7 Exploring Drug-Induced Synesthesia

Baudelaire, C. "Correspondences." In *The Flowers of Evil*, edited by W. Aggeler. Fresno, Calif.: Academy Library Guild, 1954.

—. *Les paradis artificiel.* 1860. Paris: Gallimard, 1961.

—. *The Poem of Hashish.* Translated by Aleister Crowley, http://cannabis.net/hashish/index.html.

Berge, J. ten. "Delacroix, Baudelaire en de hasjiesjclub." *Jong Holland* 3(1995): 22–30.

Cytowic, R. *Synaesthesia: A Union of the Senses.* Cambridge, Mass.: MIT Press, 2002. See pp. 99ff.

De Quincey, T. *Confessions of an English Opium-eater.* 1821; reprint, London: Penguin, 1971.

Dunning, A. J. "Opium: een oude geschiedenis." *Nederlands Tijdschrift voor de Geneeskunde* 139(1995): 2629–32.

Gautier, T. "Le hachisch." *La Presse*, July 10, 1846.

Gregory, R. L. "Journey to Unconsciousness with Ketamine." *Odd perceptions.* London: Routledge, 1988.

Hayter, A. *Opium and the Romantic Imagination.* Berkeley: University of California Press, 1968.

Huysmans, J. K. *Against Nature.* Translated from French by Robert Baldick. London: Penguin classic. 1959. See p. 58.

McKane, J. P., and A. M. Hughes. "Synaesthesia and Major Affective Disorder." *Acta Psychiatrica Scandinavica* 77(1988): 493–94.

Poe, E. A. "Al Araaf." *Complete Poems.* 1829; reprint, Champaign: University of Illinois Press, 2000.

—. "A Tale of the Ragged Mountains." In *Complete Stories and Poems.* 1844; reprint, New York: Doubleday, 1984.

Rizzo, M., and P. J. Eslinger. "Colored Hearing Synesthesia: An Investigation of Neural Factors." *Neurology* 39(1989): 781–84.

Siegel, R. K. *Intoxication: Life in Pursuit of Artificial Paradise.* New York: Dutton, 1989.

Chapter 8 A Colored Brain

Aleman, A. et al. "Activation of Striate Cortex in the Absence of Visual Stimulation: An fMRI Study of Synesthesia." *Neuroreport* 12, no. 13(2001): 2827–30.

Asher, J. E., et al. "Diagnosing and Phenotyping Visual Synaesthesia: A Preliminary Evaluation of the Revised Test of Genuineness TOG-R." *Cortex* 42, no. 2(2006): 137–46.

Baron-Cohen, S., et al. "Synaesthesia: Prevalence and Familiality." *Perception* 25(1996): 1073–79.

Harrison, J. *Synaesthesia: The Strangest Thing.* Oxford: Oxford University Press, 2001.

Ramachandran, V. S., and E. Hubbard. "Psychophysical Investigations into the Neural Basis of Synaesthesia." In *Proceedings of the Royal Society of London* B 268(2001): 979–83.

Grossenbacher, P. G., and C. T. Lovelace. "Mechanisms of Synesthesia: Cognitive and Physiological Constraints." *Trends in Cognitive Sciences* 5, no. 1(2001): 36–41.

Marks, L. E., and E. C. Odgaard. "Developmental Constraints on Theories of Synesthesia." In *Synesthesia: Perspectives from Neuroscience*, edited by L. C. Robertson and N. Sagiv. New York: Oxford University Press, 2004.

Maurer, D., and C. J. Mondloch. "Neonatal Synesthesia: A Re-evaluation." In *Synesthesia: Perspectives from Neuroscience*, edited by L. C. Robertson and N. Sagiv. New York: Oxford University Press, 2004.

Nunn, J. A., et al. "Functional Magnetic Resonance Imaging of Synesthesia: Activation of V4/v8 by Spoken Words." *Nature Neuroscience* 5(2001): 371–75.

Paulesu, E., et al. "The Physiology of Coloured Hearing: A PET Activation Study of Colour-Word Synaesthesia." *Brain* 118(1995): 661–76.

Ramachandran, V. S. *A Brief Tour of Human Consciousness: From Impostor Poodles to Purple Numbers*. New York: Pi Press, 2004.

Ramachandran, V. S., and E. Hubbard. "The Emergence of the Human Mind: Some Clues from Synesthesia." In *Synesthesia: Perspectives from Neuroscience*, edited by L. C. Robertson and N. Sagiv. New York: Oxford University Press, 2004.

Rich, A., J. L. Bradshaw, and J. B. Mattingley. "A Systematic, Large-Scale Study of Synaesthesia: Implications for the Role of Early Experience in Lexical-Colour Associations." *Cognition* 98(2005): 53–84.

Root-Bernstein, R. S. "Music, Creativity and Scientific Thinking." *Leonardo* 34, no. 1(2001): 63–68.

Sacks, O. W. "The Case of the Colorblind Painter." *An Anthropologist on Mars*. New York, Alfred A. Knopf, 1995. See pp. 3–41.

Sagiv, N., et al. "What Is the Relationship Between Synaesthesia and Visuo-Spatial Number Forms?" *Cognition* 101, no. 1(2005): 114–28.

Simner, J. et al. "Synaesthesia: The Prevalence of Atypical Cross-Modal Experiences." *Perception* 35 (2006): 1024–1033.

Sitton, S. C., and E. R. Pierce. "Synesthesia, Creativity and Puns." *Psychological Reports* 95(2004): 577–80.

Smilek, D., and Mike J. Dixon. "Towards a Synergistic Understanding of Synaesthesia: Combining Current Experimental Findings with Synaesthetes' Subjective Descriptions." *Psyche* (online journal) 8(2002), http://psyche.cs.monash.edu.au/v8/psyche-8 -01-smilek.html.

Ward, J., and J. B. Mattingley. "Synaesthesia: An Overview of Contemporary Findings and Controversies," *Cortex* 42, no. 2(2006): 129–36.

Weiss, P. H., K. Zilles, and G. R. Fink. "When Visual Perception Causes Feeling: Enhanced Cross-Modal Processing in Grapheme-Color Synesthesia." *Neuroimage* 28(2005): 859–68.

Chapter 9 Dark Double Bass and Purple Piano

Blake, R. et al. "On the Perceptual Reality of Synesthetic Color." In *Synesthesia: Perspectives from Neuroscience*, edited by L. C. Robertson and N. Sagiv. New York: Oxford University Press, 2004.

Campen, C. van. "Verrassende resultaten synesthesie-experiment." *Kleurenvisie* 5(1998): 5–7.

—. "De kleur van woorden." *Kleurenvisie* 6(1999): 12–14.

—. "Oranje tuba's, volle sprot en groene woorden." *Psychologie Magazine*, October 2001, 24–26.

—. "Helderheid, verzadiging en toon van kleursynesthesie." *Kleurenvisie* 8(2001): 5–7.

—. "Personal Profiles of Color Synesthesia: Developing a Testing Method for Artists and Scientists." *Leonardo* 36, no. 4(2003): 291–94.

Dixon, M., D. Smilek, and P. M. Merikle. "Not All Synaesthetes Are Created Equal: Projector Versus Associator Synaesthetes." *Cognitive Affective and Behavioral Neuroscience* 4, no. 3(2004): 335–43.

Duffy, P. L. "Personal Coding: The Variety of Linguistic Experience." *Folio* 10, no. 1(2005): 14–17; *Folio* 10, no. 2(2005): 42–44.

Hornbostel, E. M. von. "Die Einheit der Sinne." *Melos, Zeitschrift für Musik* 4(1927): 290–97.

—. "Ueber Geruchshelligkeit." *Pflügers Archiv für die Gesamte Physiologie* 227(1931): 517–38.

Hubbard, E. M., et al. "Individual Differences Among Grapheme-Color Synesthetes: Brain-Behavior Correlations." *Neuron* 45(2005): 975–85.

Kim, C. Y., R. Blake, and T. J. Palmeri. "Perceptual Interaction Between Real and Synesthetic Colors." *Cortex* 42, no. 2(2006): 195–203.

Köhler, Wolfgang. *Dynamics in Psychology.* New York: Liveright, 1940.

Marks, Larry E. *The Unity of the Senses: Interrelationships Among the Modalities.* New York: Academic Press, 1978.

Martino, G., and Larry E. Marks. "Synesthesia: Strong and Weak." *Current Directions in Psychological Science* 10(2001): 61–65.

Palmeri, Thomas J., et al. "The Perceptual Reality of Synesthetic Colors." *Proceedings of the National Academy of Science* 99(2002): 4127–31.

Ward, J., B. Huckstep, and E. Tsakanikos. "Sound-Colour Synaesthesia: To What Extent Does It Use Cross-Modal Mechanisms Common To Us All?" *Cortex* 42, no. 2(2006): 264–80.

Ward, J., and J. B. Mattingley. "Synaesthesia: An Overview of Contemporary Findings and Controversies," *Cortex* 42, no. 2(2006): 129–36.

Werner, Heinz. "Unity of the Senses." In *Developmental Processes: Heinz Werner's Selected Writings,* edited by S. S. Barten and M. B. Franklin. Volume 1. 1934; reprint, New York: International Universities Press, 1978.

Zietz, Karl. "Gegenseitige Beeinflussung von Farb- und Tonerlebnissen." *Zeitschrift für Psychologie* 121(1931): 257–356.

Chapter 10 The Hidden Sense

Adler, H., and U. Zeuch (eds.). *Synästhesie: Interferenz, Transfer, Synthese der Sinne.* Wurzburg: Königshausen & Neumann, 2002.

Hornbostel, E. M. von. "Die Einheit der Sinne." *Melos, Zeitschrift für Musik* 4(1927): 290–97.

Kant, I. *Analytik des Schönen.* 1790; reprint, Amsterdam: Boom, 2002.

Lemaire, T. *Met open zinnen: Natuur, landschap, aarde.* Amsterdam: Ambo, 2002.

Marks, L. E. *The Unity of the Senses: Interrelationships Among the Modalities.* New York: Academic Press, 1978.

Merleau-Ponty, M. *Phenomenology of Perception.* 1945; London: Routledge, 2002.

—. *Oog en geest.* 1964. Translation of *L'Oeil et l'esprit,* by R. Vlasblom. Baarn, Netherlands: Ambo, 1996.

Werner, H. "Unity of the Senses." In *Developmental Processes: Heinz Werner's Selected Writings,* edited by S. S. Barten and M. B. Franklin. Volume 1. 1934; reprint, New York: International Universities Press, 1978.

Name Index

Subject Index